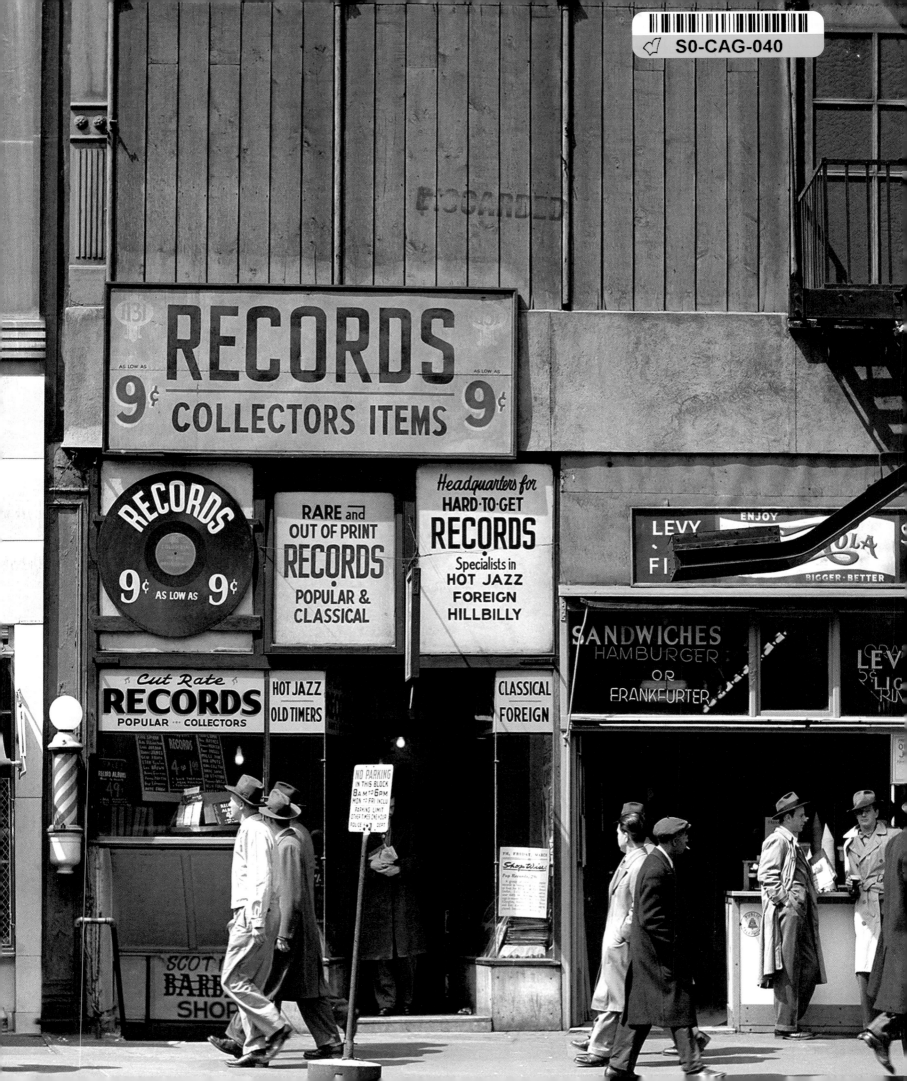
S0-CAG-040

I SEE A CITY
TODD WEBB'S NEW YORK

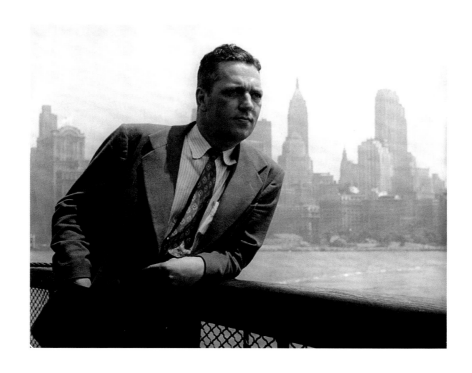

*Presented to
the Santa Cruz
Public Libraries by*

JAMES B. RICHARDSON

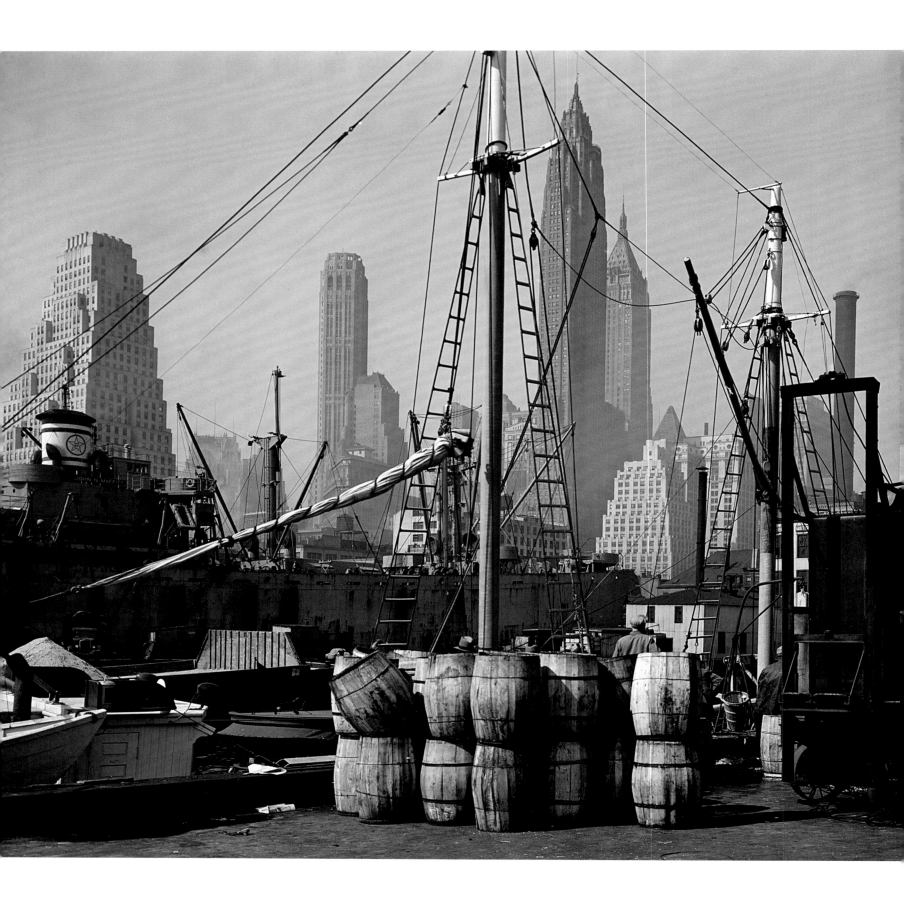

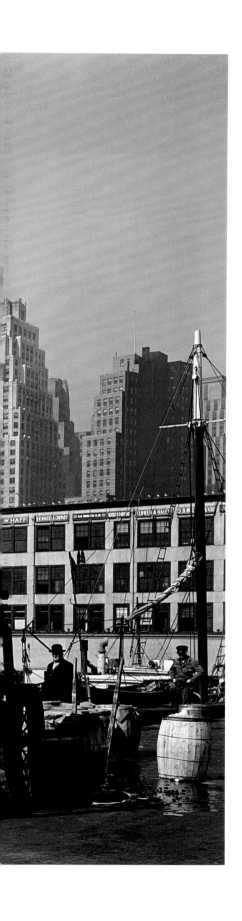

I SEE A CITY
TODD WEBB'S NEW YORK

SEAN CORCORAN
DANIEL OKRENT

EDITED BY BETSY EVANS HUNT

Thames & Hudson

In memory of my brother, Peter, who was my inspiration and loving guide.

—BETSY EVANS HUNT

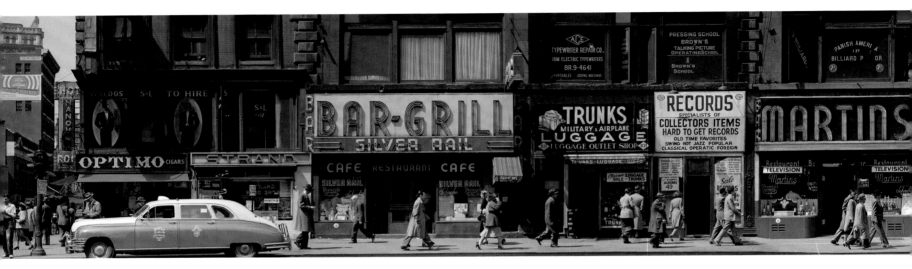

Design: BTDNYC

Photographs and text © 2017 Betsy Evans Hunt and the Estate of Todd Webb
Essay © 2017 Sean Corcoran
Essay © 2017 Daniel Okrent

All Rights Reserved. No part of this publication may be reproduced or transmitted in any
form or by any means, electronic or mechanical, including photocopy, recording or any other
information storage and retrieval system, without prior permission from the publisher.

First published in the United States of America in 2017 by
Thames & Hudson Inc.
500 Fifth Avenue
New York, New York 10110
www.thamesandhudsonusa.com

LIBRARY OF CONGRESS CONTROL NUMBER: 2017934848

First published in the United Kingdom in 2017 by
Thames & Hudson Ltd
181A High Holborn
London WC1V 7QX

www.thamesandhudson.com

British Library Cataloguing-in-Publication Data
A catalogue record for this book is available from the British Library

ISBN 978-0-500-54488-4

Printed and bound in China

CAPTIONS FOR PAGES:

1—Yolla Niclas, promotional photo of Todd Webb for "I See a City" exhibition, Museum of the City of New York, 1946
2–3—Fulton Fish Market Wharf, 1946
4–5—Sixth Avenue between 43rd and 44th Streets, 1948

CONTENTS

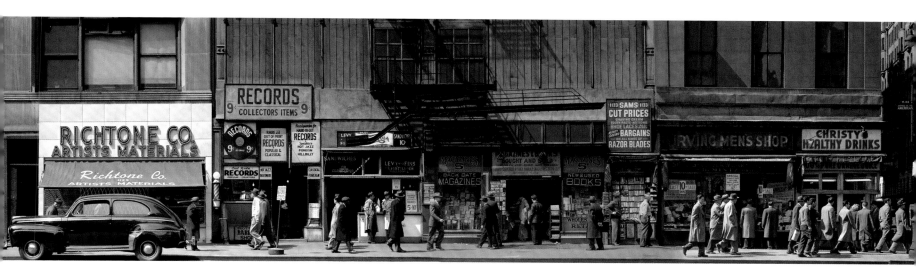

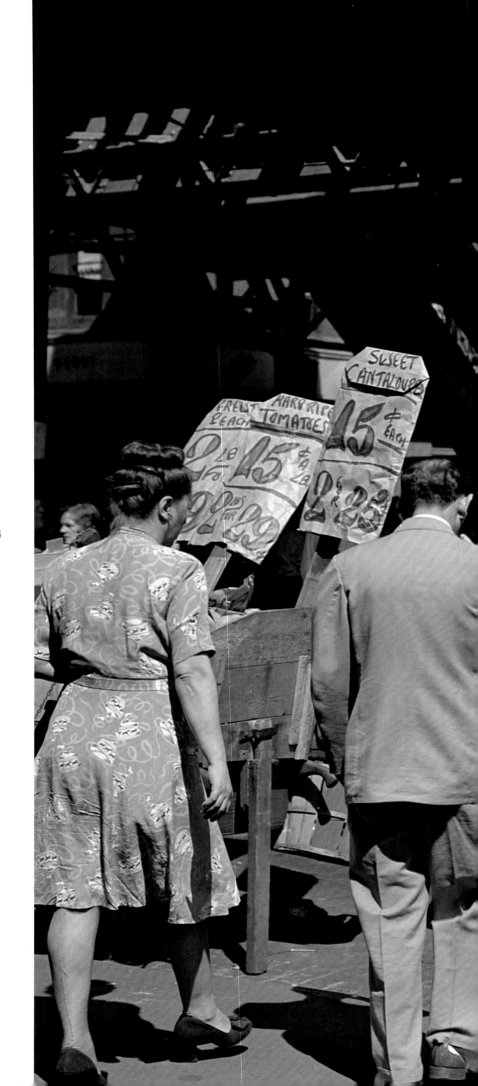

Harlem, 1946

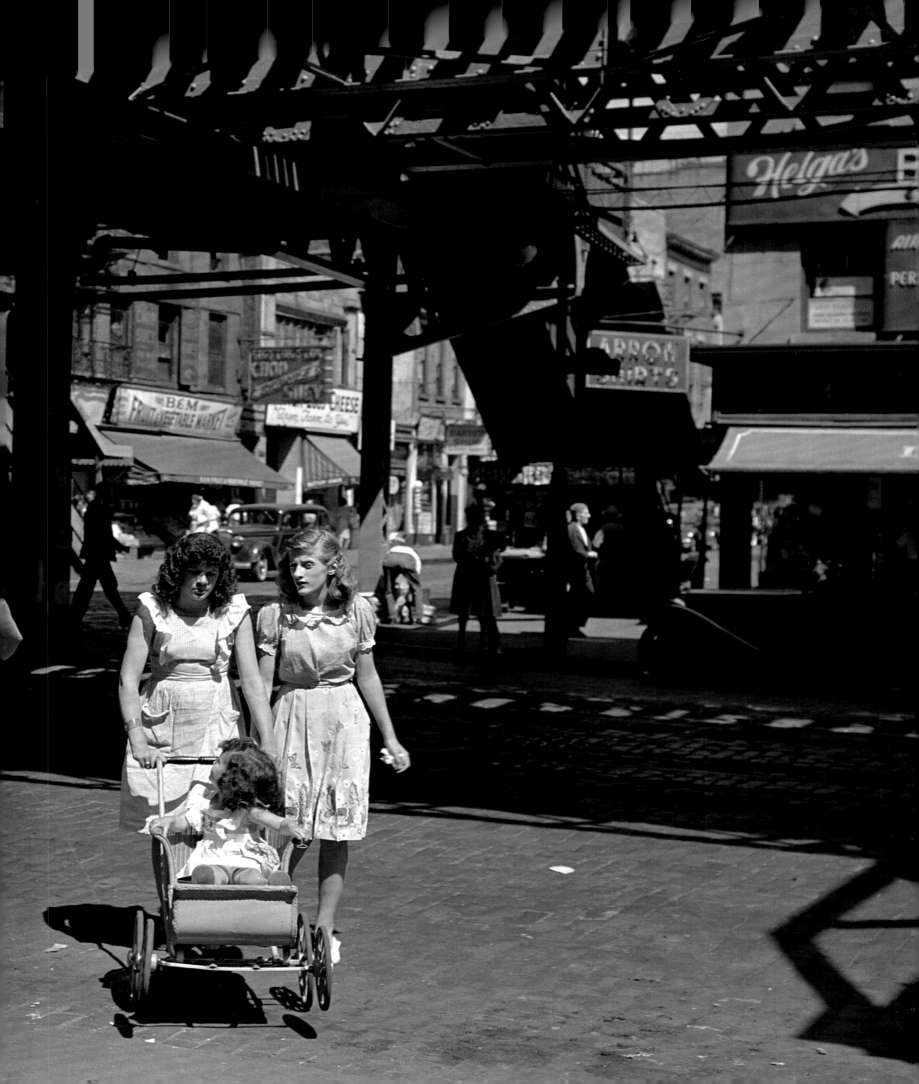

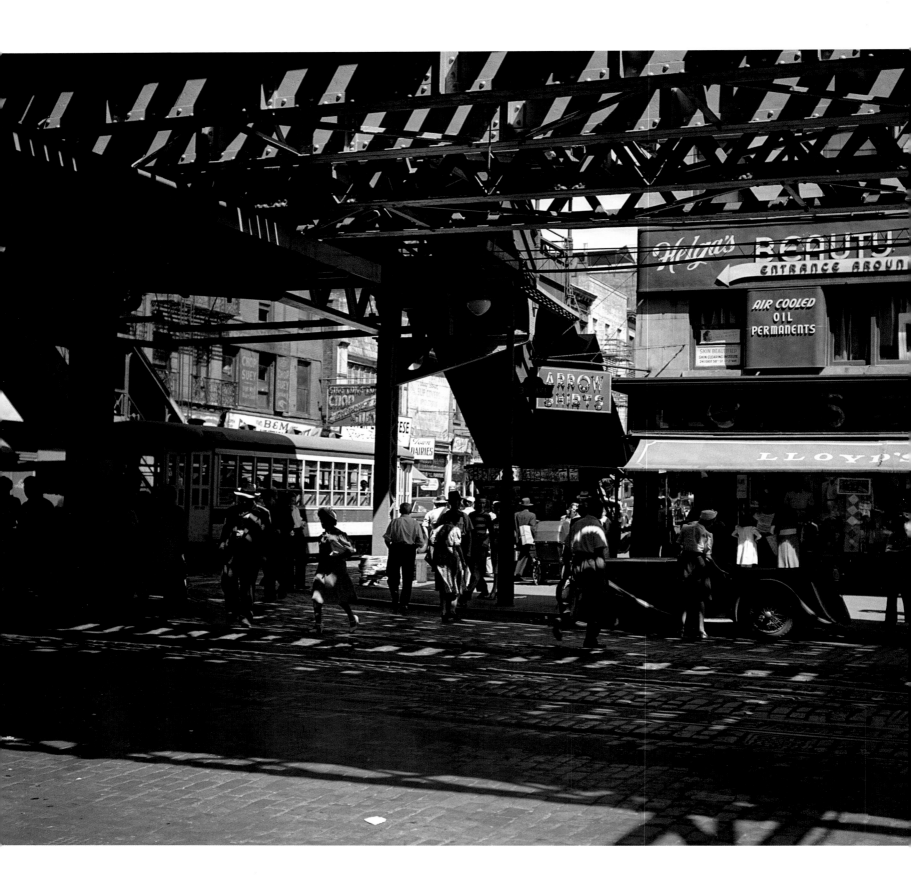

A CITY SEEN: TODD WEBB'S POSTWAR NEW YORK

SEAN CORCORAN

I N NOVEMBER OF 1945, Todd Webb began a journey that would change his life. Newly discharged from the Navy, he resolved to move to New York City and give himself over to his passion for photography. It was time for him to test his mettle—to see if he had what it took to become more than just a hobbyist. Ultimately, Webb proved up to the challenge he set for himself: photography became not just a vocation, but his life's calling. New York after World War II was the center of American culture, a cauldron of creativity and a place where modernism rubbed shoulders with the old world. It was also the "capital" of photography—home to many of the country's preeminent practitioners as well as some of the leading pictorial magazines and journals that published on a weekly basis. The city, both intellectually and visually, provided everything that an ambitious person needed to remake himself. For several years, Webb photographed the city intensely, getting to know its distinct neighborhoods intimately. This was his first mature body of work and the launching point for a career as an internationally known and respected photographer.

Webb was forty years old when he moved to New York and had already experienced much in life. Prior to his three years of enlistment during the war, Webb had been a stockbroker until the crash of 1929 and the subsequent Great Depression; he prospected for gold several times in California, Mexico, and Panama; he was a surveyor for the United States Forest Service; and he worked for the Chrysler Corporation in his hometown of Detroit. It was in Detroit that Webb's serious interest in photography began. In 1940 he joined the Detroit Camera Guild and the Chrysler Camera Club, where he befriended Harry Callahan. The younger, but more experienced, Art Siegel also became a close comrade, and Webb learned a great deal from their informal get-togethers. He also took an inspirational ten-day master class with Ansel Adams, stating, "The enthusiasm generated by Ansel's visit made photography something we had to do, not just wanted to do."[1] Soon after that workshop came the attack on Pearl Harbor, and in the fall of 1942, Webb was headed to boot camp. En route he stopped in New York to meet with the

OPPOSITE:
Third Avenue and 59th Street, 1946

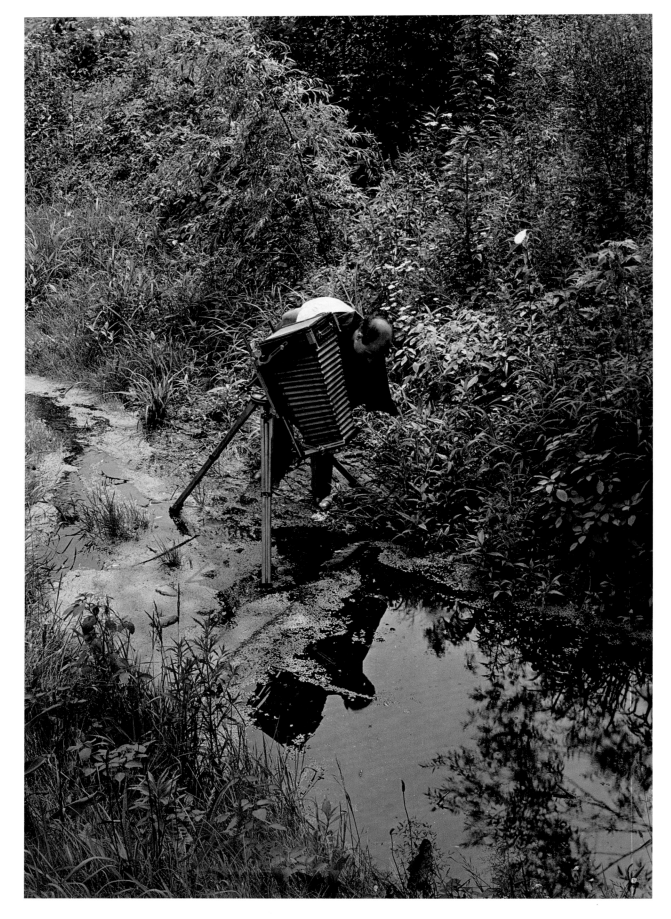

Harry Callahan,
Detroit, 1941

Ansel Adams, Detroit, 1941

Harry Callahan, New York, 1945

photographer and arts patron Dorothy Norman at Alfred Stieglitz's gallery, An American Place. A meeting with Stieglitz must have been an ulterior motive for the trip, and while there, he was lucky enough to strike up a conversation with the impresario and share his work. The trip was a success, and Norman included Webb's portrait of a young African American boy from Detroit as the frontispiece of the next issue of her literary journal, *Twice a Year.* More important, Stieglitz spoke warmly and encouragingly about the photographs. Webb was now determined to make a new beginning and dedicate himself to photography. Throughout the war, he saved his military pay with the intention of living off of it for as long as possible before having to get paying work. He wanted to photograph unencumbered by distractions. At the conclusion of his tour in the South Pacific, Webb returned to the United States; as soon as he was discharged, he headed straight for New York.

Webb moved into a small apartment on 123rd Street near Amsterdam Avenue (on the northern edge of Morningside Heights) along with his friend Callahan and Callahan's wife, Eleanor. The living quarters were tight and the furnishings Spartan—Webb slept on a roll-out cot in the kitchen, a situation probably not too different from his military days—but they managed to build a tiny darkroom in a closet.[2] Callahan had brought Webb's 5x7 Deardorff large-format camera from Detroit, and although film was scarce (the war effort had led to a shortage of silver), Webb managed to find enough to hit the streets right away. At the same time, he began to keep a journal, and his entries, along with the early photographs, reveal a wide-eyed newcomer's experience of the city. Though he was fully immersed in the city, he sometimes struggled to get it down on film:

Callahan Home, Harlem, 1945

> The light was beautiful and I was full of New York. I took the subway down to the Village at Houston Street, walked east to Mulberry Street and made a few negatives en route. I had never worked down there and I was excited by a new view of New York. On Mott and Mulberry Streets, north of Chinatown, the streets are literally teeming. There are street markets, pushcarts parked end to end in front of endless rows of small stores. Both the stores and the pushcarts sell fruits, vegetables, neckties, fish, and everything under the sun. The smells, the noise, and the whole feel of the place are just not describable and I couldn't photograph it. But I want to go back and try.[3]

Among Webb's earliest successes were his photographs of the "Welcome Home" signs displayed around the city in support of the men and women returning from the war. Both handmade and mass-produced, the signs were mounted above doorways or in windows, with messages like "Welcome Home Jim & Henry" or "Welcome Home G.I. Joe." As a veteran living apart from his family, it is understandable why he would create a sensitive series of photographs documenting the outpouring of emotion for returning loved ones. These signs became a way for him to personally connect with, and become a part of, the city. While reflecting on photographing in the Lower East Side, Webb wrote in his journal: "You see more American Flags displayed down there than anyplace else I know of. They sent a lot

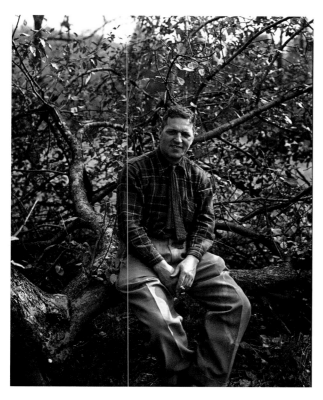

Self-Portrait, 1946

of boys to war as evidenced by the Honor Rolls that each neighborhood displays—lots of gold stars too. I think of the boys I knew in the service that were from New York—I understand them better now."[4] The doorways and surrounding architecture reflected the character of the people of the neighborhoods.

By the end of 1945, Webb had photographed storefront churches and shops, street scenes viewed from the railway station platforms of the Third Avenue Elevated line, and the Third Avenue streetcar at 125th Street (subsequent attempts proved more fruitful). In these early New York pictures, there is an evident image-making strategy that persists throughout his New York work of the late 1940s, and even in his photographs of Paris in the 1950s. Webb consistently employed four frameworks in his picture making: architectural storefront views; details of architecture, graffiti, or signage; street views with people as the focus and the city's architectural curtain as backdrop; and, occasionally, skyline views with a grandeur evoking the "mythic city." Webb scouted locations on endless walks, and he would often return to a spot again and again to determine the right time of day to make a photograph. Once he had selected the ideal time, he would set up his camera and tripod and wait for the right instant, fine-tuning the frame. Because of the film shortage, he was very discriminating about actually tripping the shutter.

It is not surprising that Webb began photographing along the Third Avenue El—he would have likely taken the crosstown streetcar on 125th Street and the elevated rail line downtown to visit Stieglitz in his gallery at Fifty-Third Street and Madison Avenue. By 1942 the El was the last train operating aboveground in Manhattan, and the steel infrastructure looming over the city streets provided plenty of visual drama. From the train stations, Webb could look down onto the streets at oblique angles that allowed perspectives encompassing building facades and street life. Occasionally, he trained his camera on the skyline, taking in the skyscraper ziggurats towering over the Financial District or the Lower East Side tenements looking toward the Brooklyn Bridge. More often, however, Webb preferred to work at street level—near or under the train tracks from a more human vantage point. Several of his best images take advantage of the light and shadow cast by the steel infrastructure. For example, his photograph of the Fifty-Ninth Street and Third Avenue intersection has a game-board-like quality, with pedestrians zigzagging through the light-dappled street. He also created a number of studies of storefront windows displaying corsets, antiques, and other wares. Many of these photographs are devoid of people, yet they exude a human presence.

The reputation of the Lower East Side as the epicenter of street life in New York was well established by the time Webb arrived in 1945, but he was eager to record his own experience of the atmosphere on film. In his journals he wrote: "The buildings are old and they wear their years with an air. The layer on layer of paint on the storefronts give a good feeling to the eye. It is a section with a great lived-in feeling. The people are mostly poor, I think, but somehow they have a dignity that you do not expect to find with poverty. Even the kids seem to be proud. It seems to be an area of different ethnic groups. I saw Spanish stores, Greek coffee houses, and Italian and Polish shopping centers."[5] By the end of the summer of 1946, Webb had acquired a Graflex Speed Graphic camera, which greatly expanded

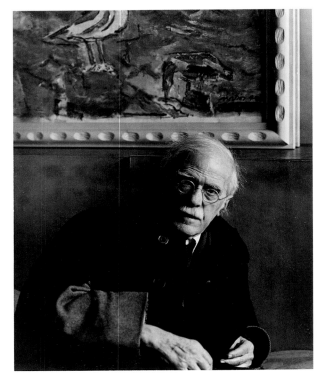

Alfred Stieglitz at An American Place, 1946

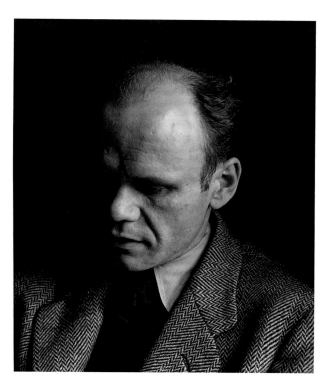

Beaumont Newhall, 1946

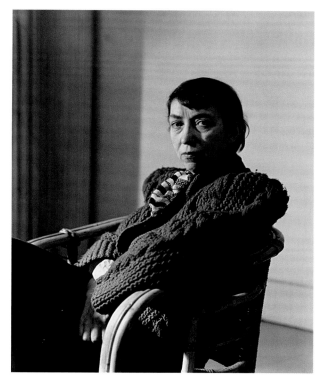

Berenice Abbott, 1946

his picture-making possibilities. This new equipment was handheld, making it easier to capture candid moments, and he used it to great effect on the streets of the Lower East Side. On Suffolk Street, he photographed the flurry of vendors hawking their wares: a solidly built man with a cigarette dangling from his mouth looks at scales, appraising the weight of grapes to be sold, while an older woman in a plaid jacket stands patiently nearby; or a handful of neighborhood women determinedly browse the goods from a pushcart on the crowded street.

About twice a week, Webb would visit Stieglitz at An American Place. He regarded Stieglitz as a mentor and a source of profound inspiration, not only because of the older man's own photographic work, but for the greater understanding and appreciation of art that the two men shared. Stieglitz spent hours looking at Webb's work while sharing photographs he had created over his own long career, from the early *Camera Work*–era material to the later Lake George photographs. They also admired and discussed at length the work of many of the gallery's mainstays: John Marin, Arthur Dove, and Georgia O'Keeffe, to name just a few. An American Place had a constantly revolving door, and as a result, Webb encountered many luminaries of the arts during his visits, including William Carlos Williams, Beauford Delaney, William Saroyan, Richard Wright, and Mary Callery.

Two relationships in particular, born out of An American Place, had a lasting impact on Webb's career. The first was the rapport he developed with O'Keeffe, which would result in a lifelong friendship. When Webb moved to New Mexico in the 1960s, he created a long-term portrait project of O'Keeffe at her home in Abiquiu. The second, and more immediately beneficial, relationship was with Beaumont and Nancy Newhall. Webb became very close to the Newhalls, meeting for dinner and attending their many soirees—where photography was always at the center of the discussion. The Newhalls introduced Webb to the wider social circles of the New York photography world, including Berenice Abbott, Minor White, Helen Levitt, Lisette Model, and Gordon Parks, among many others. Beaumont Newhall helped Webb land his first museum exhibition—at the Museum of the City of New York in the fall of 1946—and wrote favorably of the exhibition in *Art-News*. This early exhibition attracted the attention of Edward Steichen, director of the Department of Photography at the Museum of Modern Art, who included Webb in several exhibitions, including *Diogenes with a Camera II* (1952–53) and *The Family of Man* (1955).

There is a natural temptation to compare Todd Webb's New York work with that of Abbott's massive *Changing New York* project of the 1930s. The two were close friends, with a standing weekly lunch date, and Webb certainly knew her work intimately. Indeed, there are some similarities: both Abbott and Webb were interested in documenting the changing city with their own artistic viewpoint, and both mainly used large-format cameras. But the way they approached their subjects was quite different. Webb focused more on capturing the last vestiges of old New York and was not nearly as interested as Abbott in the juxtaposition of the old and new. His subjects were typically things from the past, or soon to be lost. He documented the streetcars running on tracks throughout the city just before they were replaced by buses in 1948; the Third Avenue El before it was demolished in

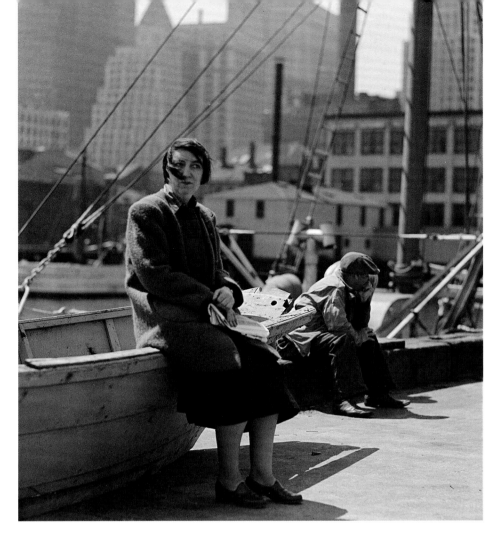

Berenice Abbott at Fulton Fish Market, 1946

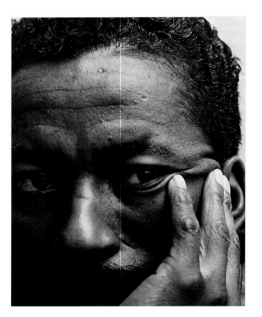

Gordon Parks, 1951

Manhattan in the 1950s; and the disappearing street vendors on the Lower East Side as they were being edged out by a newly dominant car culture. He was less interested in the intersections of old tenements and towering skyscrapers. Webb's primarily concern was the human presence in the city—even when there might not be an actual person in the frame. In his statement for the *Diogenes with a Camera II* exhibition, he wrote, "Often, I find subject matter with no visible persons to be more peopled than the crowded street scene. Every window, doorway, street building, every mark on a wall, every sign, has a human connotation. All are signs and symbols of people—a way of life—living in our time." In this sense, Webb was likely more influenced by the work of Eugène Atget, whose work Abbott introduced him to soon after they met.

Rather than concentrating on the glamorous nightlife and modern, shining towers often seen in magazines such as *Life* or *Look* in the postwar years, Webb was interested in finding the remarkable in the quotidian. At the same time, he was conflicted about how to continue to create meaningful personal work while making enough money to survive. Nevertheless, he wrote: "I am a hell of a lot more interested in making fine photographs than I am in making dough. I feel like the great American misfit. I am sure if I had my choice of making fine photographs for a very small living or making corny photographs for a lot of money I am sure I would choose the former. That doesn't make sense in America."[6] Eventually, he did a number of assignments for magazines like *Fortune*, photographing traffic in

1. Todd Webb, "Looking Back: The Memoirs of Todd Webb" (unpublished manuscript. ca. 1989), p. 15.
2. Ibid., p. 22.
3. Ibid., p. 26.
4. Todd Webb, "Todd Webb Journals" (unpublished manuscript), March 21, 1946, p. 8.
5. Webb, "Looking Back," p. 30.
6. Webb, "Todd Webb Journals," April 12, 1946, p. 13.

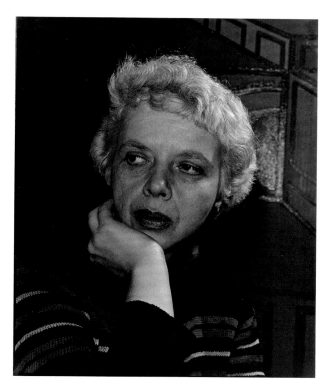

Lisette Model, 1946

midtown Manhattan, views from the Empire State Building, and several other projects. In the late 1940s, he was hired by Roy Stryker of the Standard Oil Company, who sent him on photo assignments across the United States and Western Europe. Still, Webb maintained a surprising amount of independence.

In 1949, Webb moved to Paris and dedicated himself to photographing that city much as he had done in New York. The result is a remarkable body of work that he produced while still taking occasional assignments for Stryker. After four years in France, where he also met and married his wife, Lucille, Webb returned to New York in 1953 and won a Guggenheim Fellowship two years later to make a cross-country trek photographing on foot. He was awarded a continuation of his fellowship in 1956. At the end of 1959, the Webbs decided to leave New York for the calm and affordability of New Mexico, ending this deliriously prolific chapter in Todd Webb's photographic career.

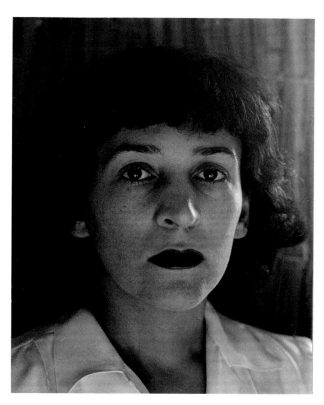

Helen Levitt, 1945

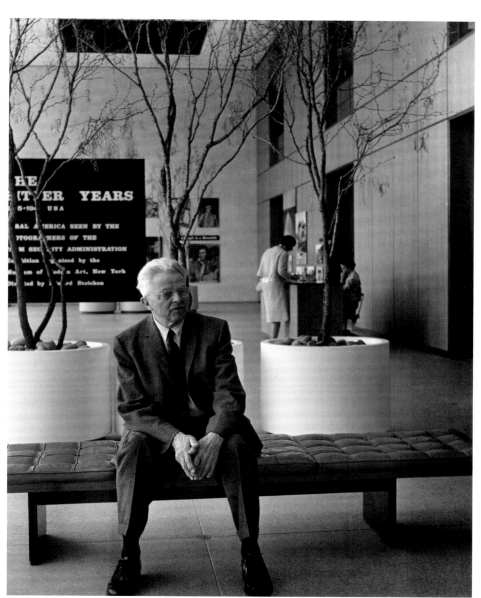

Roy Stryker, 1964

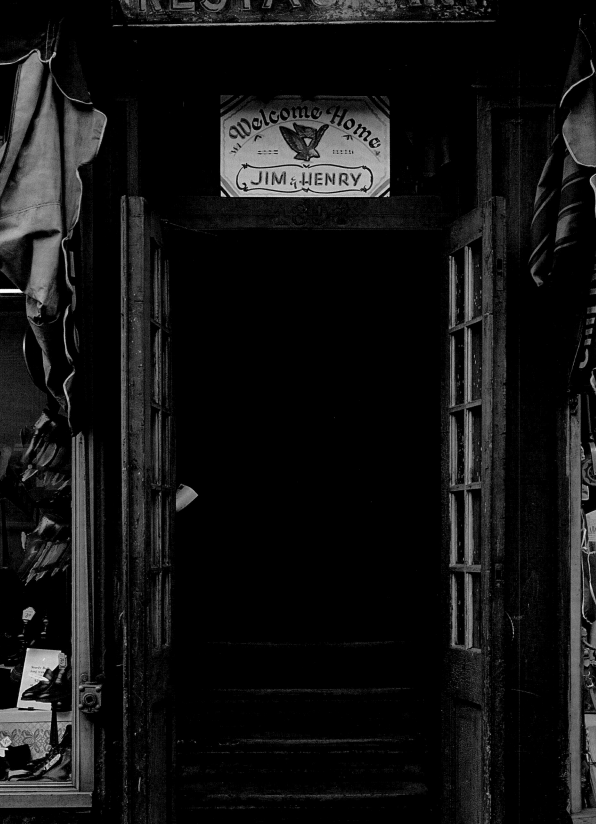

MY CITY, LOST AND FOUND

DANIEL OKRENT

TODD WEBB'S NEW YORK DIDN'T DISAPPEAR ALL AT ONCE. It's impossible for me to look at these pictures and not think of my arrival in New York from the Midwest as a young man in the late 1960s, when much of the city Webb had photographed two decades earlier was still present. The subway cost twenty cents, and there were still cushioned seats and porcelain-covered handholds for the straphangers (a word I first encountered in print and pronounced as "straffindger" until it provoked giggles from a colleague). The Third Avenue El had come down several years earlier, but many of the Irish bars and small-scale retail and service shops that had grown like mosses in the shadows of its tracks were still present. Chinese food was still Cantonese (the chop suey parlor would have been right at home in 1960s New York). On West Forty-Third Street, in the building that had housed the offices of the *New Yorker* for more than three decades, I found—and cherished— a small shop called Music Masters, which sold hard-to-find classical albums, including many of its own manufacture that were available nowhere else. Every block, it seemed, had a store like that, and it was impossible for a newcomer not to embrace the old city that, for me, still exists in black-and-white memory. It was swiftly receding, but its grip was—and is—strong.

In Webb's time, particularly in the richly productive period that he spent in New York immediately after World War II, the city had not yet begun its cosmetic reconstruction, much less the more profound transformation yet to come beneath the surface of its skin. In fact, the face of Webb's city had not changed much since the early '30s. Because of the intervention of depression and war, the city's only private high-rise construction between the completion of the Empire State Building in 1931 and the arrival of the Universal Pictures Building on Park Avenue and Fifty-Sixth Street in 1947 was at Rockefeller Center. The "Empty State Building" earned its nickname from the effects of the Depression on its rental program. Rockefeller Center avoided similar sneers only because the man who built it could afford to charge cut-rate rents, and wait until good times returned.

In the years immediately after Webb moved to the city in 1945, the postwar boom had barely begun to paint its changes on the city's face. Even over the next several years, the glass-and-steel curtain wall buildings of the International Style had yet to transform Manhattan's avenues, obliterating the extensive, low-rise city that had not given way to the building boom of the 1920s. The balance began to tip

OPPOSITE:
Third Avenue (Welcome Home Jim & Henry), 1945

in the late 1950s with Mies van der Rohe's epoch-defining Seagram Building on Park Avenue. Until then, the social and commercial worlds the new towers would soon both signify and glorify hadn't arrived either. My guess is that Todd Webb would have been oblivious to the rush of the new. Walking New York's streets day after joyous day ("I see wondrous things!" he told his diary), Webb found his affinities in a city that remained intensely human—small-scale, apprehensible, immediate.

Webb was drawn to the parts of that city that remained humble in their pretensions and their ambitions. To me, this is what separates Webb's New York from the city his contemporaries saw. The celebrated Arhur Fellig, a.k.a. Weegee, whose connection with the city's underside was enduring, instinctive, and at times exploitative, would take his Speed Graphic to the doors of the Metropolitan Opera, even if only to satirize the bejeweled and behatted heiresses, heirs, celebrities, and socialites who frequented the place. In all of Webb's pictures, this New York is more than invisible: it simply doesn't exist.

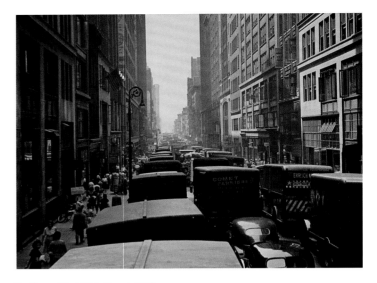

Traffic on West 37th Street, 1946

Instead he revealed a workaday city inhabited by people who ate at luncheonettes or bought their provisions from street peddlers, who labored in its small shops and its still-thriving garment factories (the view down West Thirty-Seventh Street suggests how vibrant that industry still was). Except for the material wealth implied in his magisterial views of the skyline, Webb's New York is not even remotely upscale (a neologism that itself didn't come into its current meaning until 1966). Neither had gentrification begun, or even been conceived (it didn't enter the language until the mid-'70s). His New York is bustling—look particularly at the vivid life he found on 125th Street in Harlem—but there's nothing either aspirational or demonstrative about the bustle: these are real people, living real lives.

IN FACT, Webb didn't need people in his pictures to show the presence of life. "I have an intense interest in and feeling for people," he wrote in one of his journals. "Often, I find subject matter with no visible persons to be more peopled than the crowded street scene. Every window, doorway, street, building, every mark on a wall, every sign, has a human connotation." Thus his profound engagement with shop windows, and signage, and even the peeling and fading posters clinging tenaciously to forgotten walls, fragments of urban archaeology redolent of hopes and dreams.

The signs—including signs *about* signs—entranced Webb. The incandescent lights in the Broadway theater district that had given it the name "the Great White Way" had been replaced by neon a quarter century earlier, and by the '40s the colorful new signs had spread around the city. But hand-painted signs, like one in the process of being born in Times Square, were as natural to the New York cityscape as the brick buildings they adorned. Even their language tells us something about the city at that time: Few would dispute that, for all its technological advances, twenty-first-century discourse is coarser, more vulgar, more in-your-face than the language our parents and grandparents spoke. Yet the signs in Webb's pictures tell us that the city of the late '40s was not merely a humbler place, but a

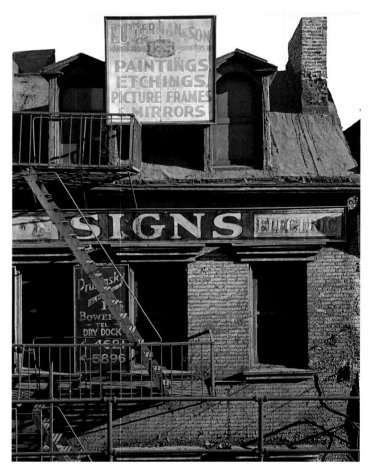

From a Third Avenue El Station, 1946

more plainspoken, even honest one, free of cant, coyness, and euphemism. Could you possibly encounter a store today using the words that Sig Klein employed to advertise his shop on Third Avenue near Tenth Street, instead of today's blandly acceptable "Big & Tall"? (The advertisement for "Extra Beer" on the Klein wall only makes his simple sales pitch that much stronger.) Is "athletic supporters," the current term of art, nearly as informative as the simpler phrase employed by the proprietors of an East Side medical supply store? Dr. Hirshfield's sign echoes the eyes on Dr. Eckleburg's billboard in *The Great Gatsby* ("They look out of no face," Fitzgerald wrote, "but, instead, from a pair of enormous yellow spectacles which pass over a nonexistent nose"). But it does more than that: I can't even imagine the circumlocution a modern Dr. Hirshfield would use to hint decorously, if obscurely, at the availability of "artificial human eyes."

Third Avenue, 1946

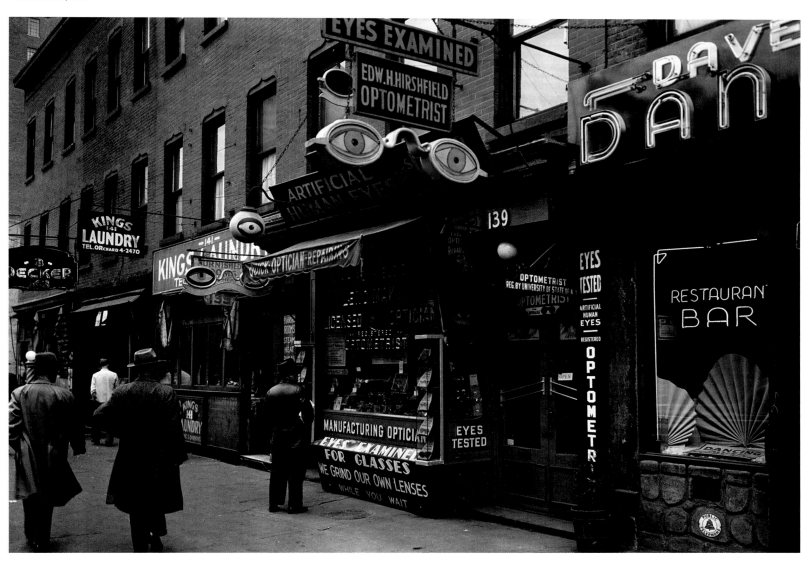

IN NEARLY EVERY INSTANCE, the people in Webb's pictures are anonymous. His mahogany-clad 5x7 Deardorff camera was hardly made for the snap-and-run style used by photographers with speedy 35 mm cameras and film, but he rarely needed to ask people to pose for him. Webb generally eschewed street portraiture, save for a central-casting cop, some street peddlers, and a whole bunch of kids: the kids were his neighbors; both the wishfully menacing and menaced boys on 123rd Street and the girls romping in a hydrant's spray lived around the corner from Webb up in Morningside Heights. He had chosen to shoot a city that by and large moved too fast for portraiture.

But one irresistible exception did step forward during his extensive explorations of a piece of New York territory that he returned to again and again. This territory, which provided an ideal chiaroscuro palette for black-and-white street photography, was the city that existed beneath and alongside the Third Avenue Elevated line; the person he found there was Mazie P. Gordon.

The Third Avenue El was nearly seventy years old when Webb began to explore its literal underbelly (and its less mysterious but no less photogenic topside) barely a decade before the El's demise. It was around this time that the El played a role in the 1948 Jules Dassin film, *The Naked City*. There were, the narration said, seven million stories in the naked city, and the eleven-mile-long structure, at once graceful and lumbering, was a useful backdrop for scores of them. It was particularly useful for filmmakers who wanted to convey a grittier Manhattan than would have been represented by the usual signifiers, like the Empire State Building or the Rockefeller Center skating rink. The El may have made its most notable, and maybe most characteristic, appearance in 1945 in Billy Wilder's *The Lost Weekend*, as the drunken Ray Milland stumbled through its shadows, lurching his way to an Oscar for best performance by an actor.

In Webb's pictures, the El itself is an actor, playing both leading and supporting roles. Simultaneously shadow and substance, vertical and horizontal, populated and empty, it was an ideal foil for Webb. Originating at Gun Hill Road in the Bronx, it crossed into Manhattan near East 129th Street in Harlem and rumbled downtown to South Ferry, along the way affording the photographer a constantly changing set of moods: romance, mystery, muscular commerce, essences of noir—even, as unlikely as it seems for so ungainly a creature, a facsimile, at least, of streamlined speed as the train charged around the curve near the Fulton Street station.

It was beneath the El that Webb found Mazie, ticket seller at (and, with her sisters, part owner of) the ragged Venice Theater, a dime-a-picture movie house just off Chatham Square. Today Chatham Square is one of the pulsing centers of Manhattan's ever-expanding Chinatown; in Webb's day, it was the terminus of the Bowery when "Bowery" signified more than just the name of the avenue that entered the square from the north. Mazie was a bighearted sort who may have handed out as many dimes to the neighborhood's unfortunates (or, in Webb's picture, to an obviously mugging companion) as she took in at the Venice's ticket cage.

Not that the Venice didn't do good business; it was a comfortable place for the neighborhood's down-and-outs—"bums," they were called back then—to spend

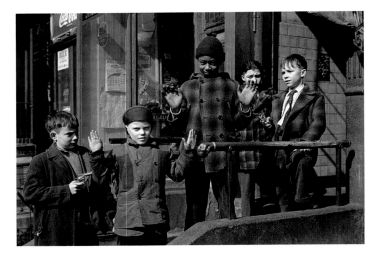

123rd Street, 1946

OPPOSITE:
From the Fulton Street El Station
Looking South, 1948

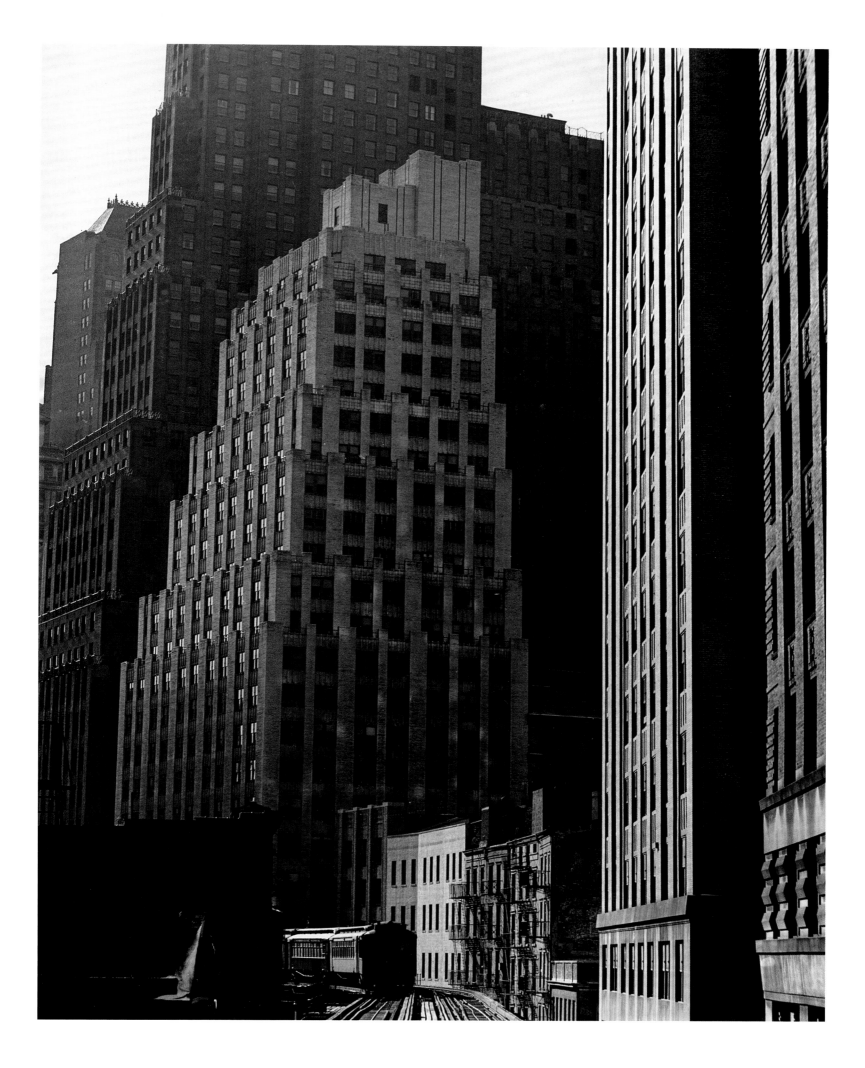

a few hours, except when showing a shoot-'em-up. I think Todd Webb may have sought out Mazie, who was fairly well-known by the time they met, because he saw some of himself in her. She relished the humanity in the anonymous, and had no apparent interest (even after becoming semi-famous herself) in posher Manhattanites. Mazie said movies with shooting in them "are bad for business. They wake up the customers."

WHAT REMAINS OF TODD WEBB'S NEW YORK? The El is gone, of course. The once ubiquitous Schulte Cigar Stores are gone. Pawnshops have become Starbucks or, as current advertisements for the one at 157 Bowery near Broome Street inform us, "coworking space for independent designer/devs." Tom, Dick, and Harry—or at least their heirs—are still selling shoes, now way uptown on Third Avenue, but with not nearly so stylish a sign. Not only are there no pushcarts at the intersection of Hester and Suffolk Streets any longer, there is no Hester and Suffolk—the intersection itself has ceased to exist, lost years ago to impending development.

But McSorley's still hugs the sidewalk on East Seventh Street as it has for more than a century and a half, somehow surviving even after being compelled by city law to serve women in 1970. Barbetta continues to reign over Restaurant Row on West Forty-Sixth Street: same building, same sign, same family ownership—possibly the same recipes, if not the prices. On MacDougal Street, a slightly different Caffe Reggio is still dispensing cappuccino, which (its owners claim) it introduced to America in 1927. Gaze at the grim exterior of the Manhattan Detention Center—a.k.a. the Tombs—downtown on White Street, and you might feel the same chill Todd Webb did. Look at the Manhattan Bridge from the corner of Pike and Madison Streets and you'll perceive the same power in its upward thrust that must have inspired Webb. The city changes, but many of its verities do not.

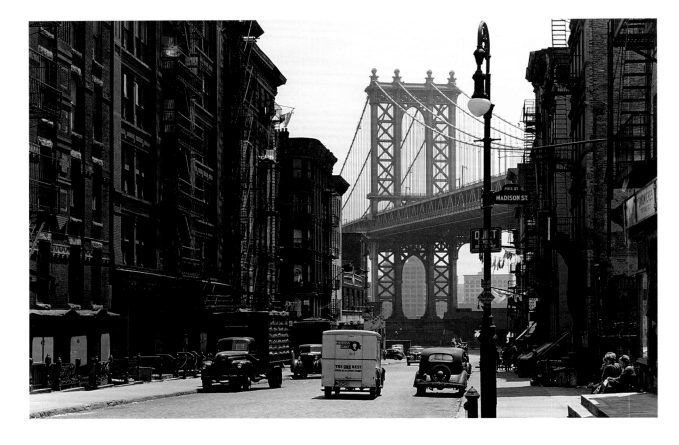

Madison Street at Pike Street,
Lower East Side, 1946

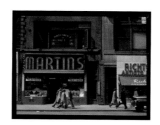
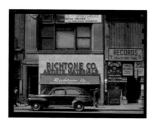
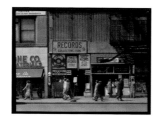
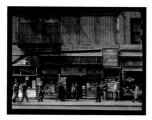
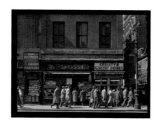

Sixth Avenue between 43rd and 44th Streets, prints 1–8, 1948

FOLLOWING SPREAD:
42nd Street El Station, December 1945

OF ALL THE PHOTOGRAPHS WEBB LEFT BEHIND—not just his New York work, but the pictures he made in Paris and Detroit and at his friend Georgia O'Keeffe's Ghost Ranch, in New Guinea and Italy and England—his most famous piece is an essential urban panorama. He made this single image of one Sixth Avenue block from eight separate frames of film he exposed on a mild spring day in 1948. Not long before, he had been asked by *Life* magazine, which was experimenting with color photography, to shoot a 4x5 transparency of Prince Michael of Romania as he came down the gangplank of the *Queen Mary*. "I was appalled," Webb wrote in his journal, "as I could not see how I could make an interesting photograph of something like that."

Of course not: European royalty and the grandeur of the oceangoing ships that still steamed into the West Side piers were the sort of phenomena that repelled him. He consequently returned to the one-block project, which he had long been contemplating. Webb approached the task with the care, the discipline, and the reverence of an old master painting the facade of a cathedral. The image required eight separate, strategically calibrated camera setups, each carefully demarcated on the sidewalk. Webb had to endure frustratingly long pauses after each successive relocation of his camera and tripod, as he waited for traffic to pass: "You can't use part of a car in one section," he pointed out. "You must have all of it or nothing." (You must also shoot, as Webb did, on a Sunday.)

Today, the block is occupied by 1133 Sixth Avenue, which in 1970 rose to its forty-four-story height above the ruins of buildings that had been home to S&L Tuxedo Rentals, the Silver Rail Bar & Grill, a "pressing school," and other humble enterprises. This ordinary, aggressively bland office tower was designed by the firm of Emery Roth & Sons, which was probably responsible for more of Manhattan's anonymous glass-and-steel monoliths than any other architectural practice (the critic Paul Goldberger once called the Roths "purveyors of bargain-basement Mies for the masses").

I mean no disrespect to the Roths, or to the Durst family, which built 1133 and still owns it today (it's a New York truism: buildings may disappear, but real estate families endure). Still, it's almost impossible not to wish that people were still shooting pool at the Spanish-American Billiard Parlor, bringing their Remingtons to Ace Typewriter Repair, and pricing a suit (with two pairs of pants, of course) at Irving Men's Shop. There are still blocks that look something like this in Manhattan today, even if typewriter repair has been supplanted by discount wireless equipment; there just aren't enough of them.

The contemporary New Yorker, or a visitor to the city, has two choices. He can hit the streets and look for them—there are still several along Broadway between Herald Square and Madison Square, and a walker under the elevated tracks in distant parts of Queens or the Bronx is likely to find them as well. In fact, though, neither the historian nor the sentimentalist (I happen to be both) really has to expend so much energy. Instead, we can find the New York of the 1940s close at hand: just turn the page, see what Todd Webb left behind, and you'll find it's all still here.

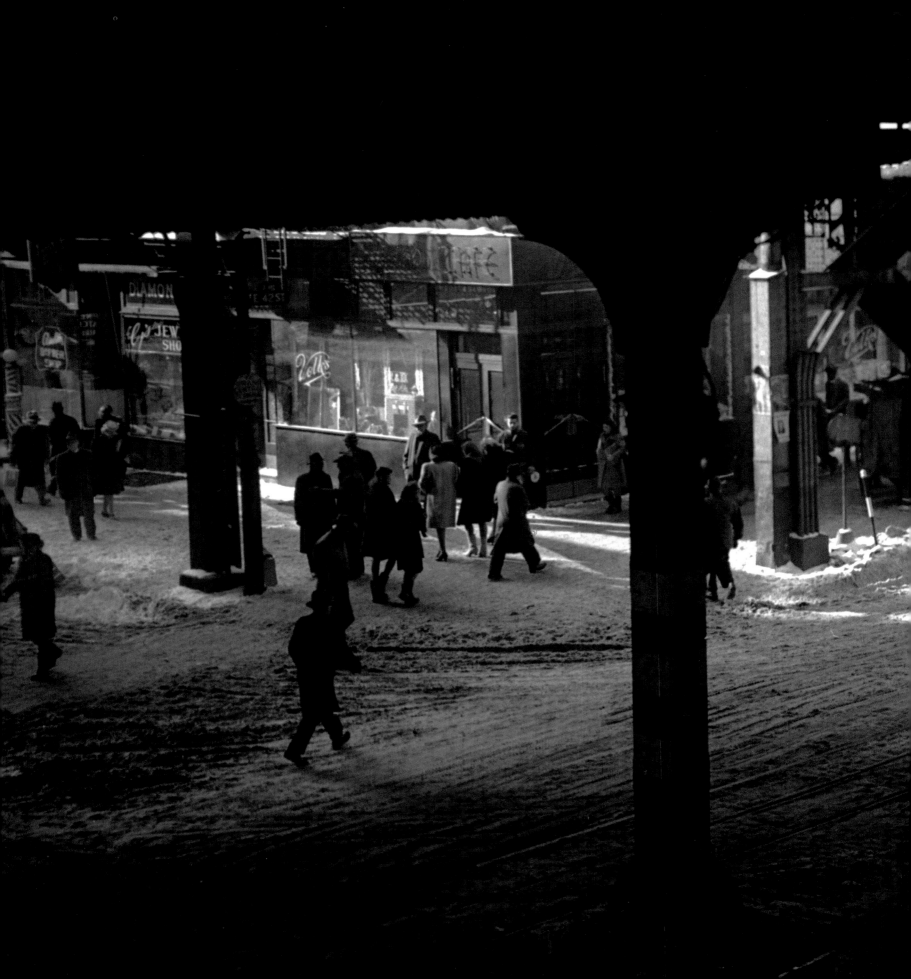

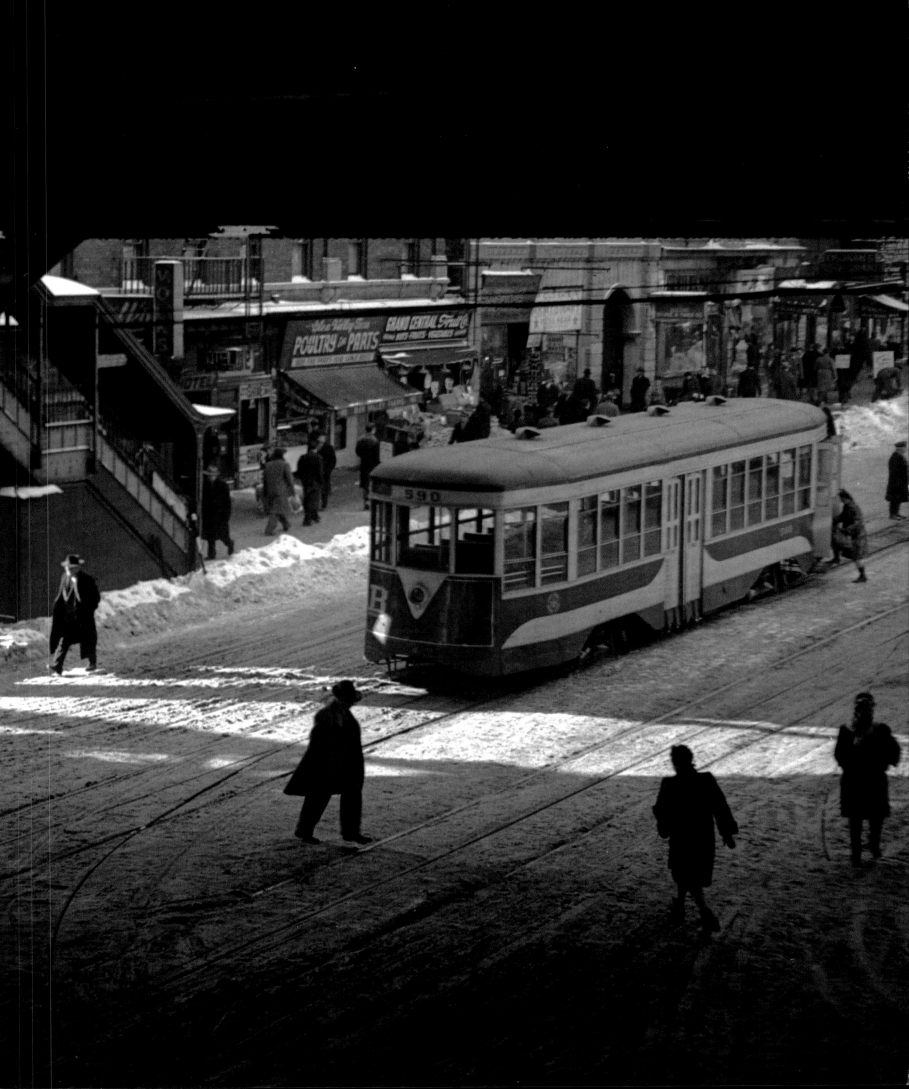

Lexington Avenue near 110th Street,
Harlem, 1946

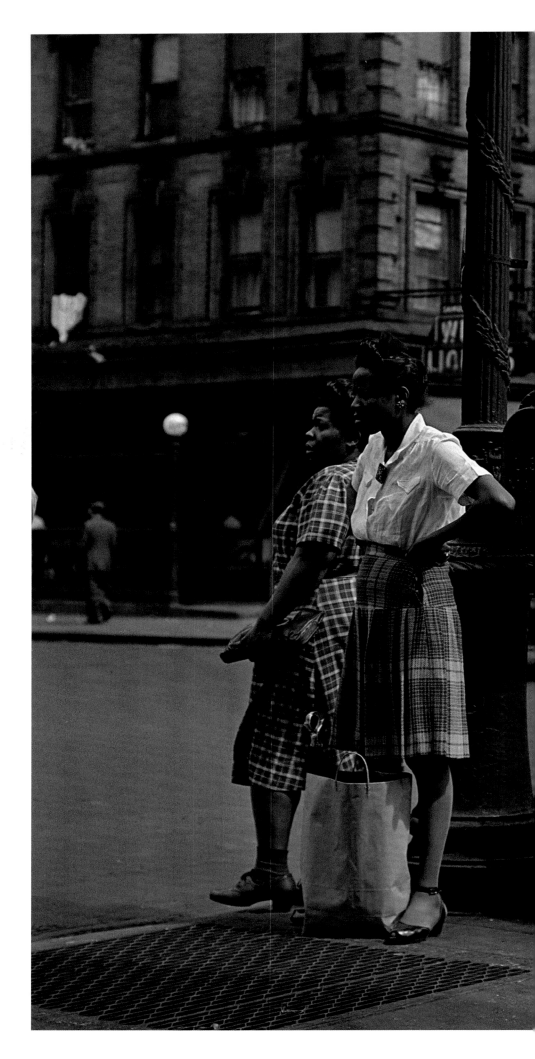

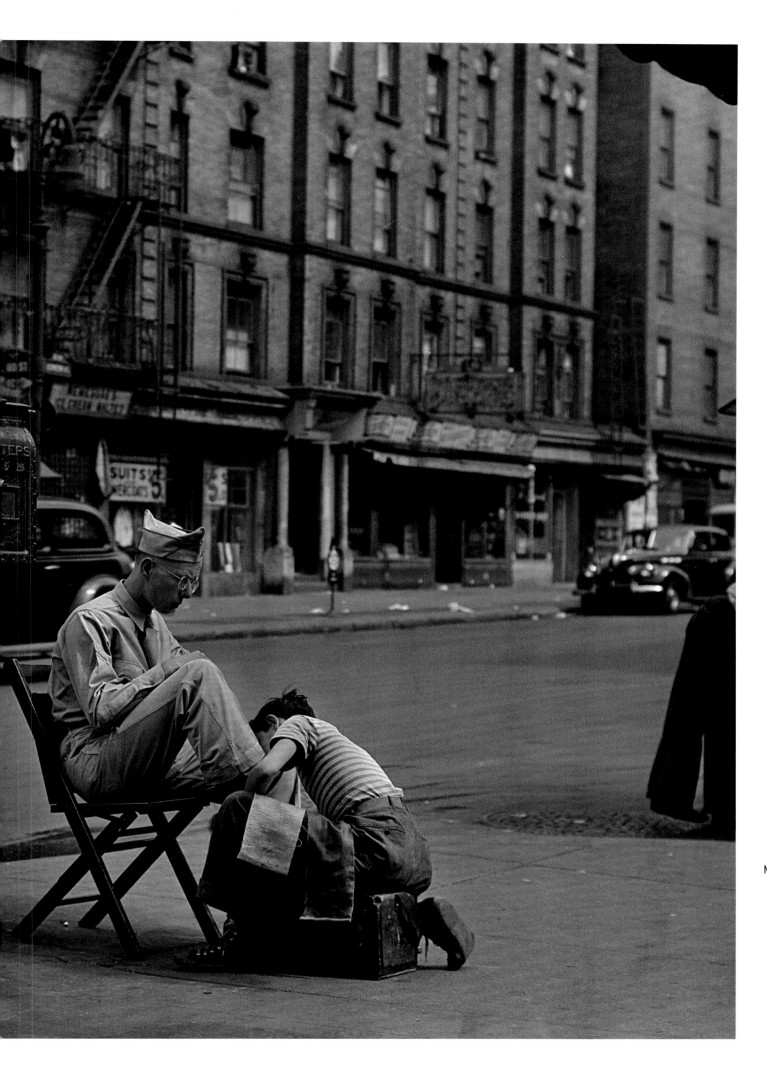

FOLLOWING SPREAD,
LEFT PAGE, CLOCKWISE
FROM TOP LEFT:
Third Avenue
(Welcome Home
Gerald), 1945;
Third Avenue
(Welcome Home
Bill, Jack, Jim,
Larry, John), 1945;
Third Avenue
(Welcome Home
Jim & Henry), 1945;
Third Avenue
(Welcome Home
Walter), 1945
RIGHT PAGE,
CLOCKWISE
FROM TOP LEFT:
Third Avenue
(Welcome Home
Nickie & Sal, Welcome
Home Joie), 1945;
8th Street
(Welcome Home
G.I. Joe), 1946;
Third Avenue
(Welcome Home
Vito), 1945;
Third Avenue
(Welcome Home
Leo), 1945

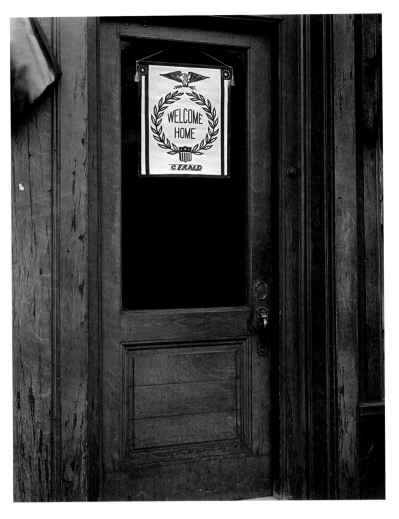
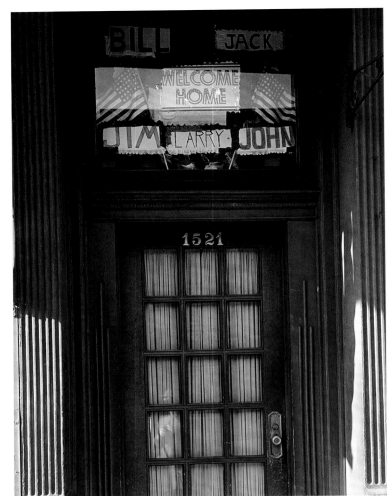
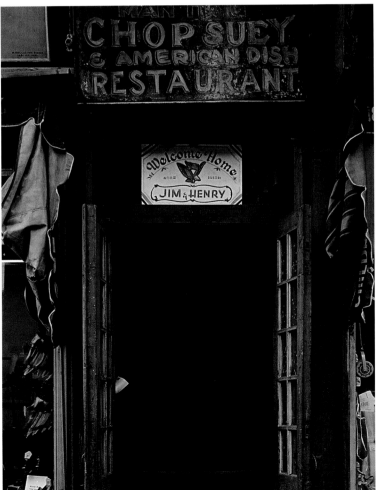
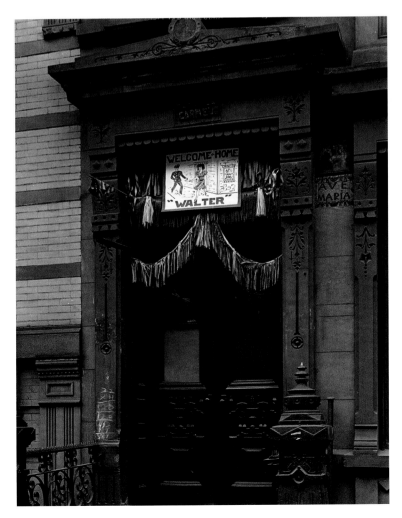

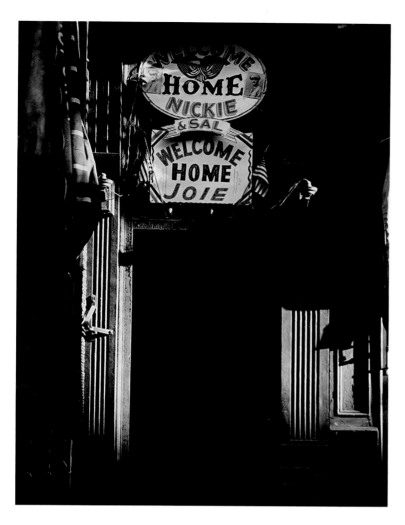
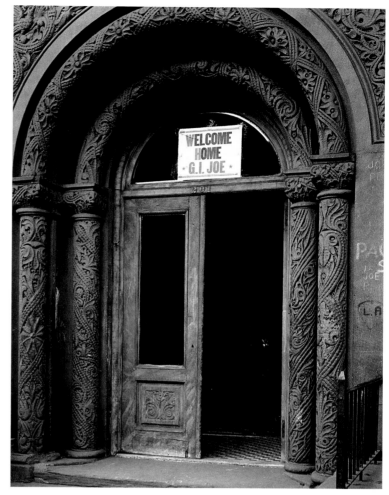
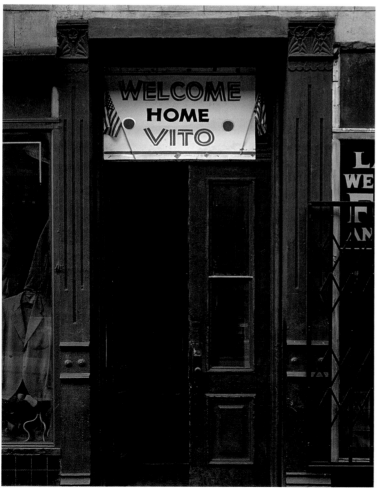
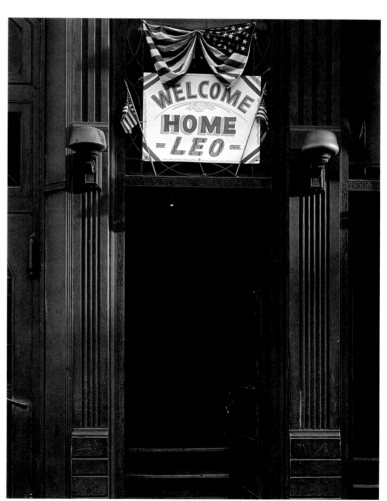

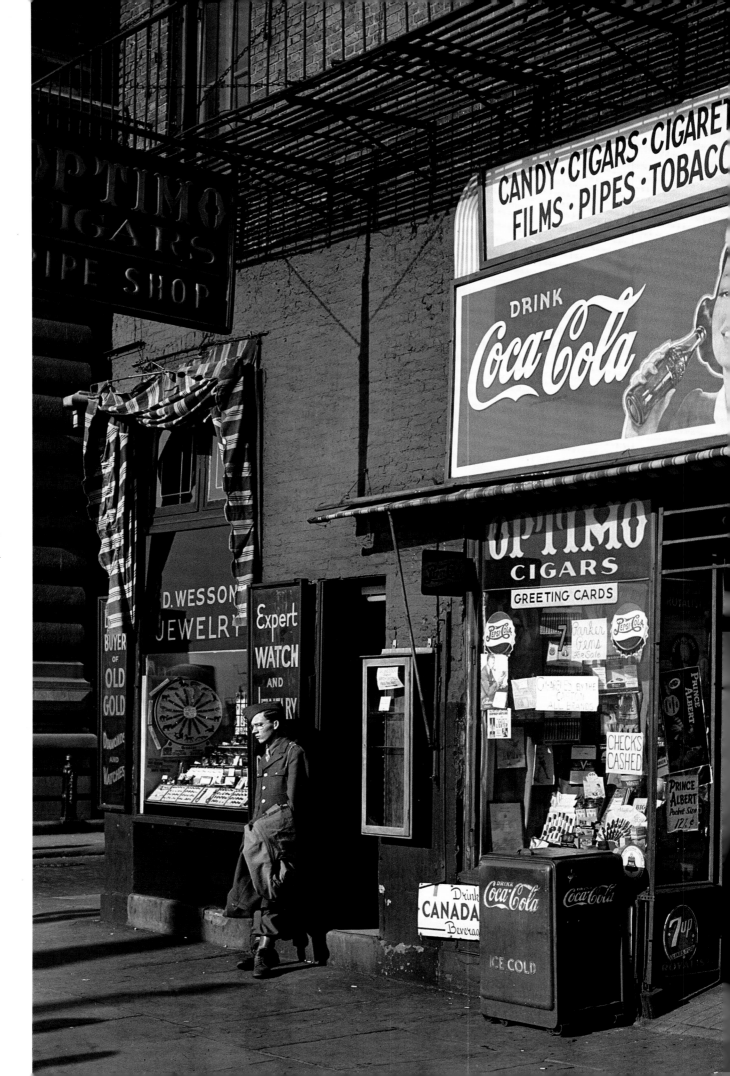

Amsterdam Avenue, 1946

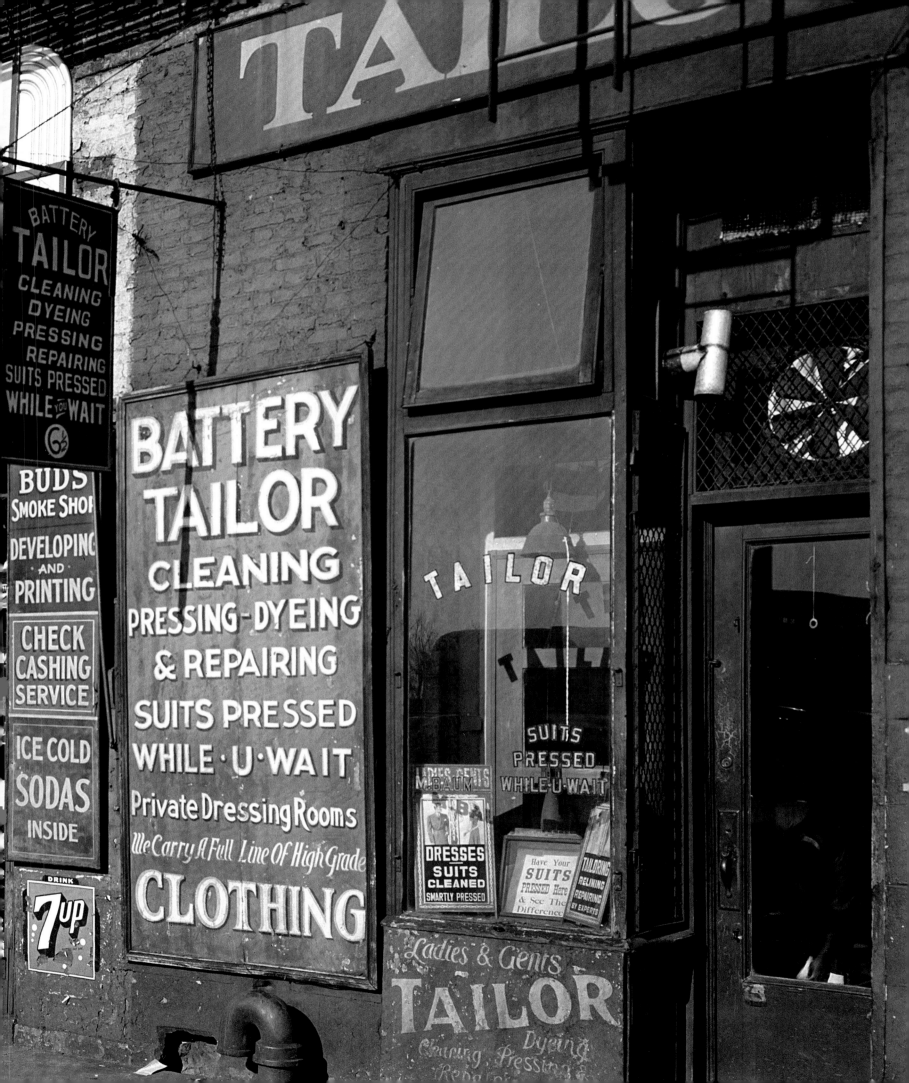

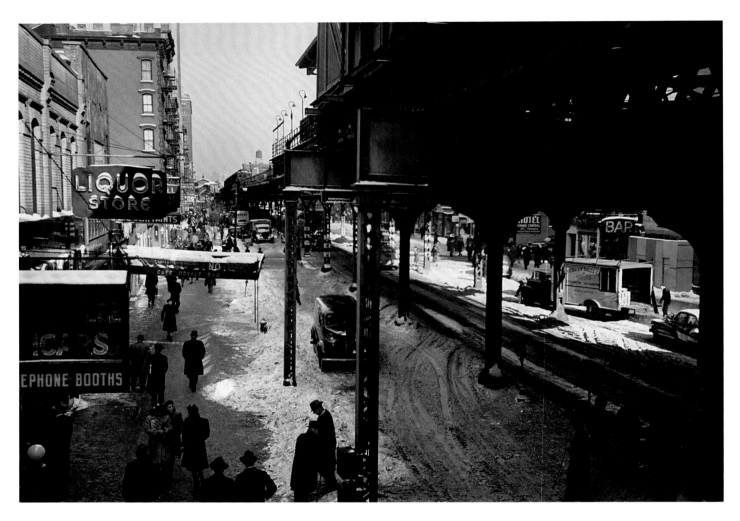

Third Avenue from the 42nd Street El Station, 1945

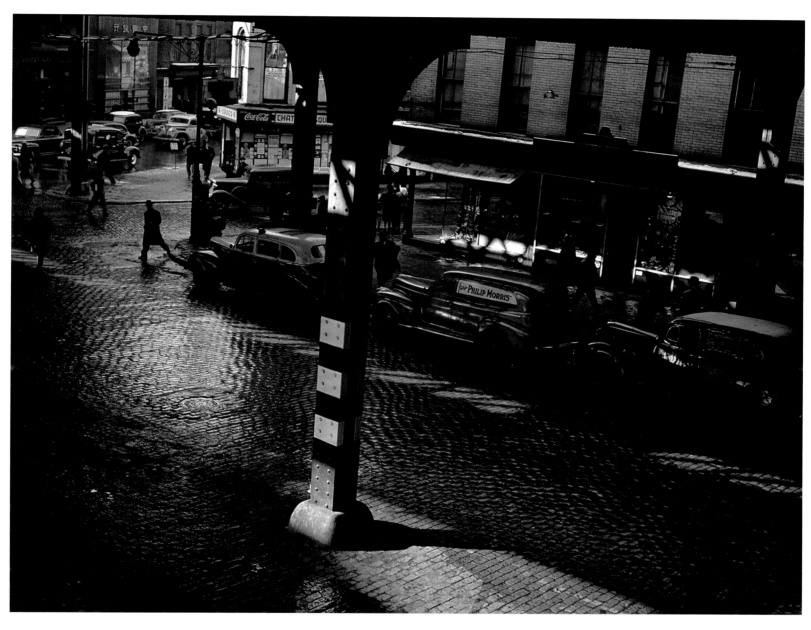

Under the El, Chatham Square, 1946

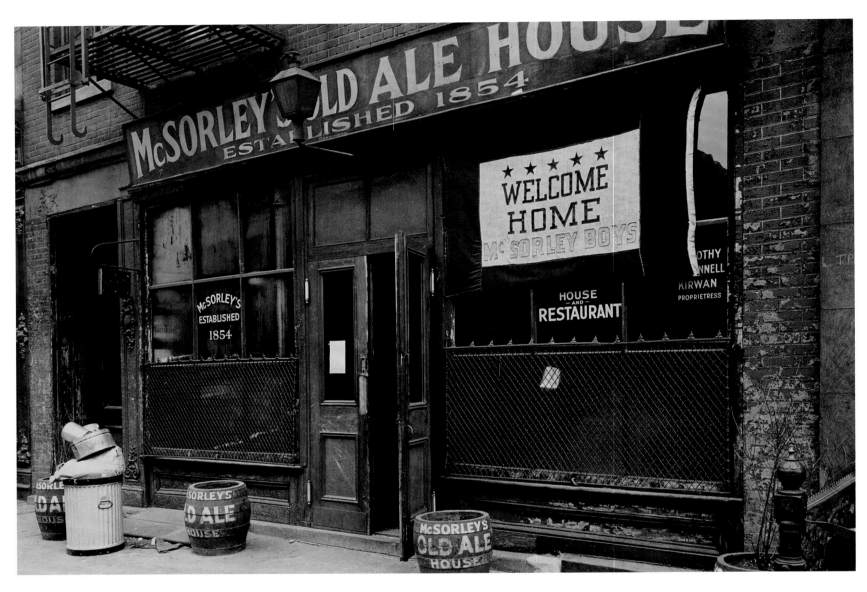

East 7th Street (Welcome Home McSorley Boys), 1946

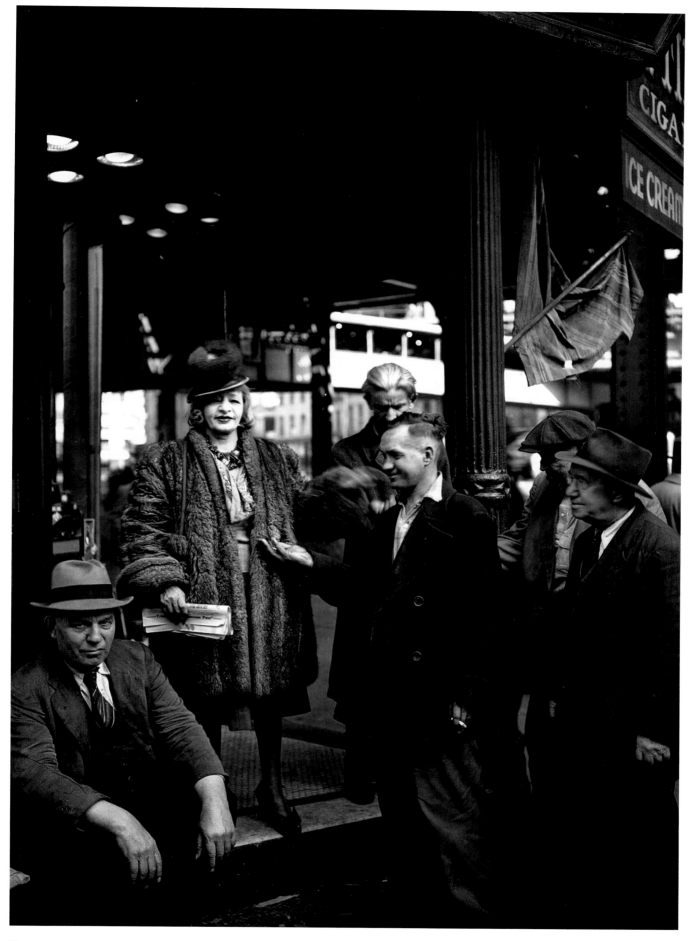

Mazie, Queen of the Bowery, 1946

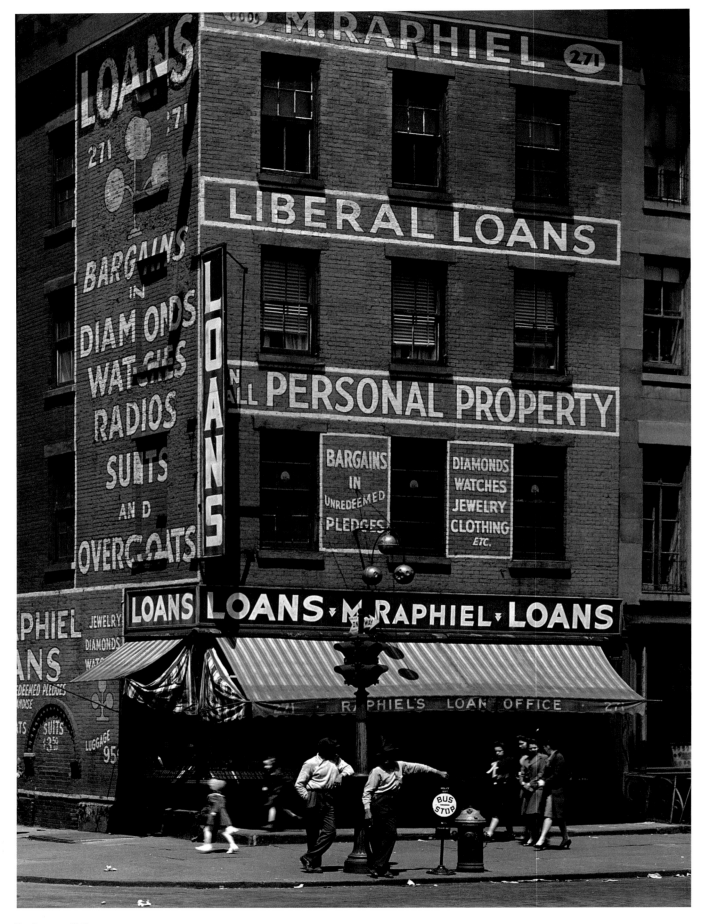

The Bowery, 1946

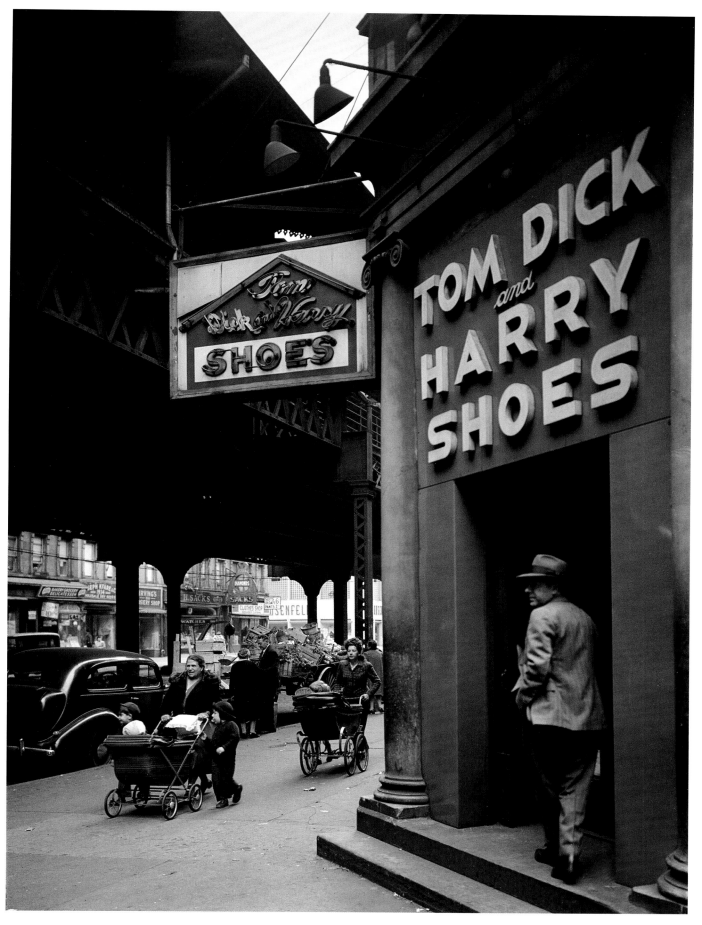

Shoe Store, Third Avenue, 1946

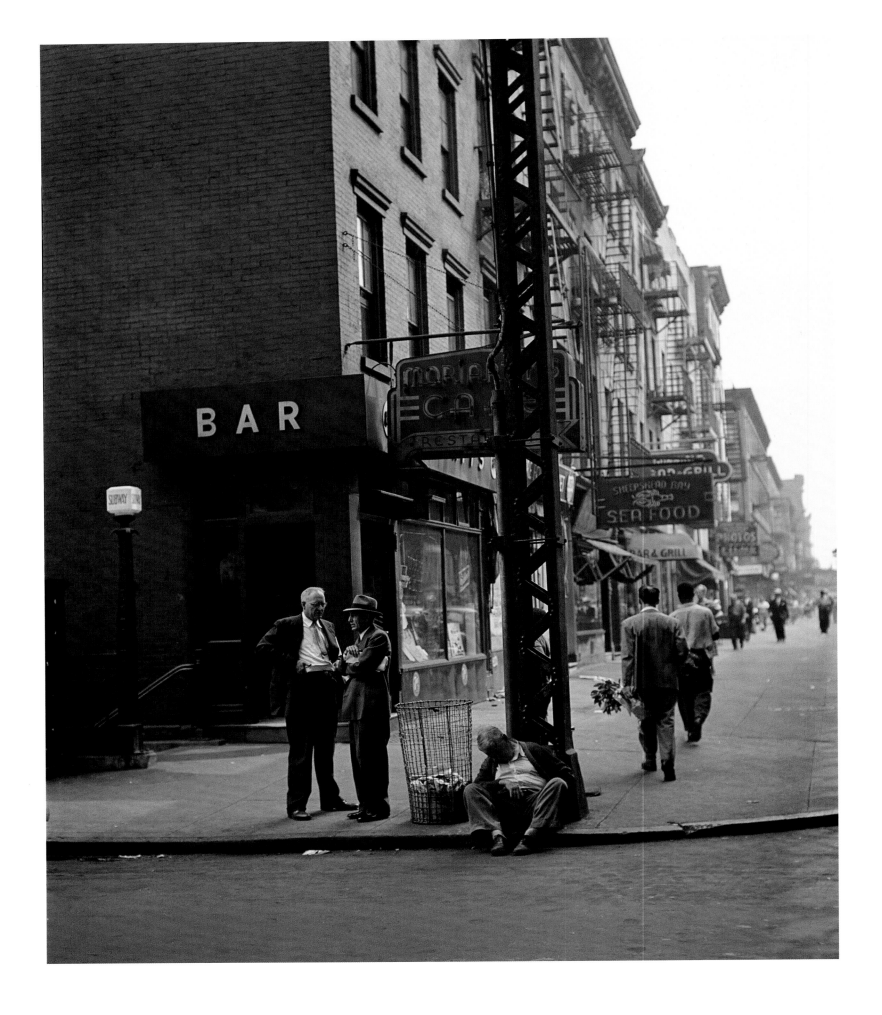

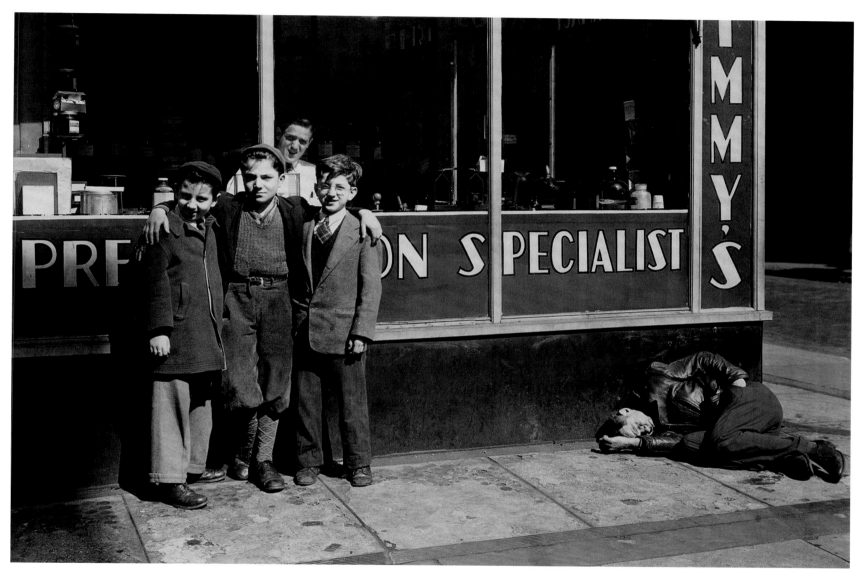

Lower East Side Boys, 1946

OPPOSITE:
Third Avenue, 1946

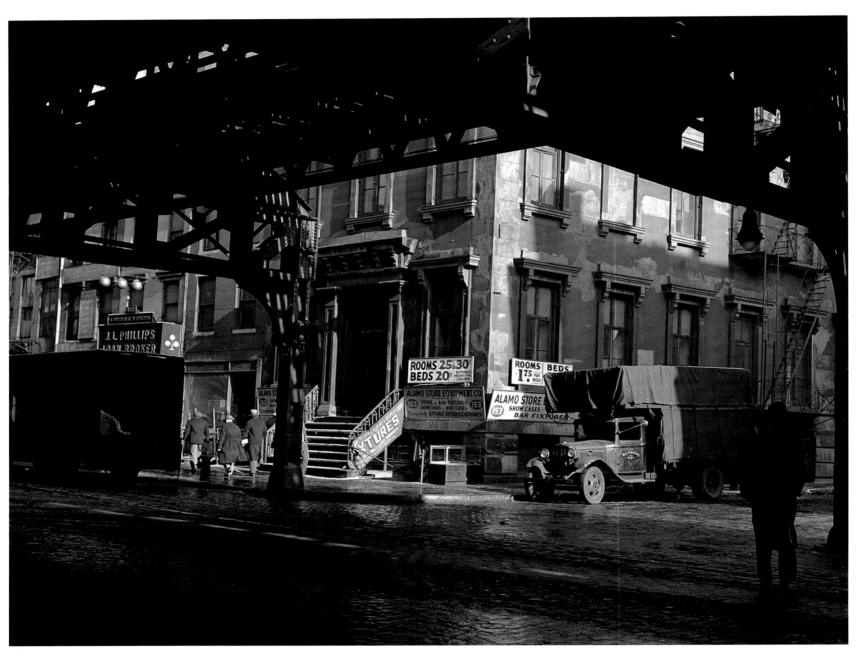

The Bowery, 1946

OPPOSITE:
Under the El, Pearl Street at
Fulton Street, 1946

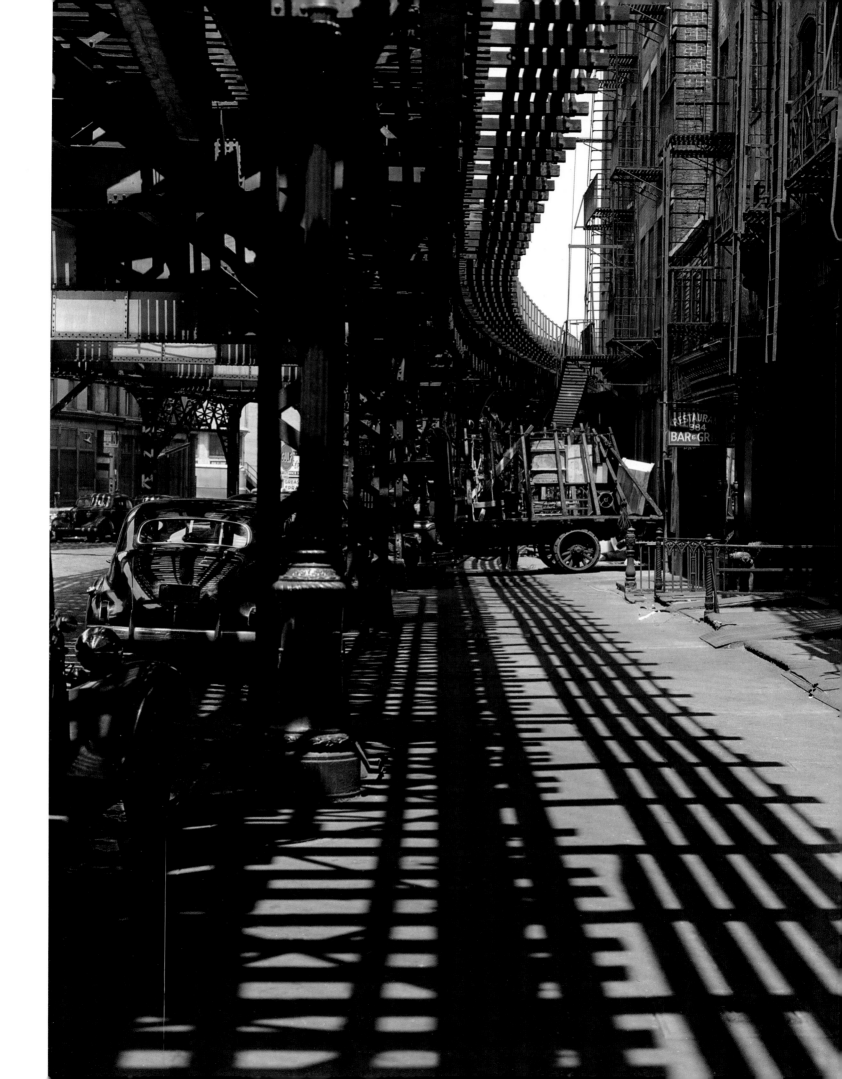

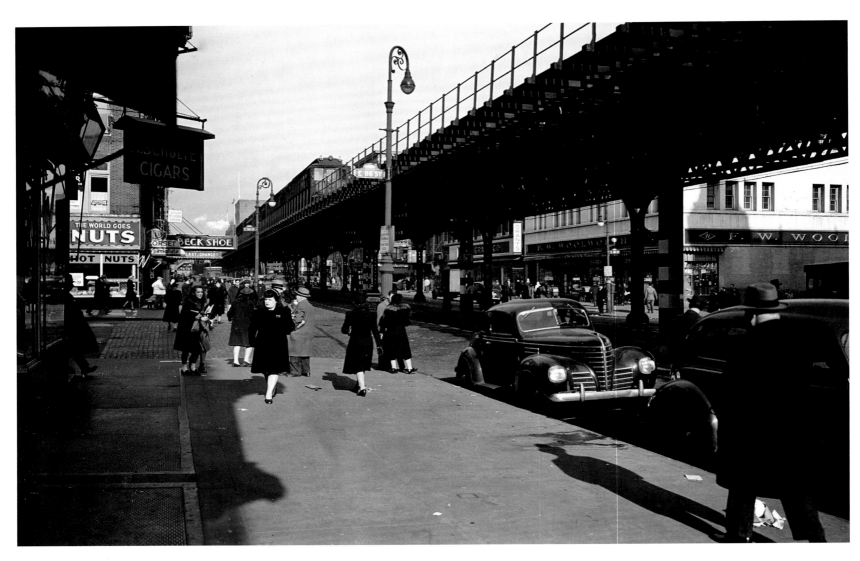

Third Avenue El, 1946

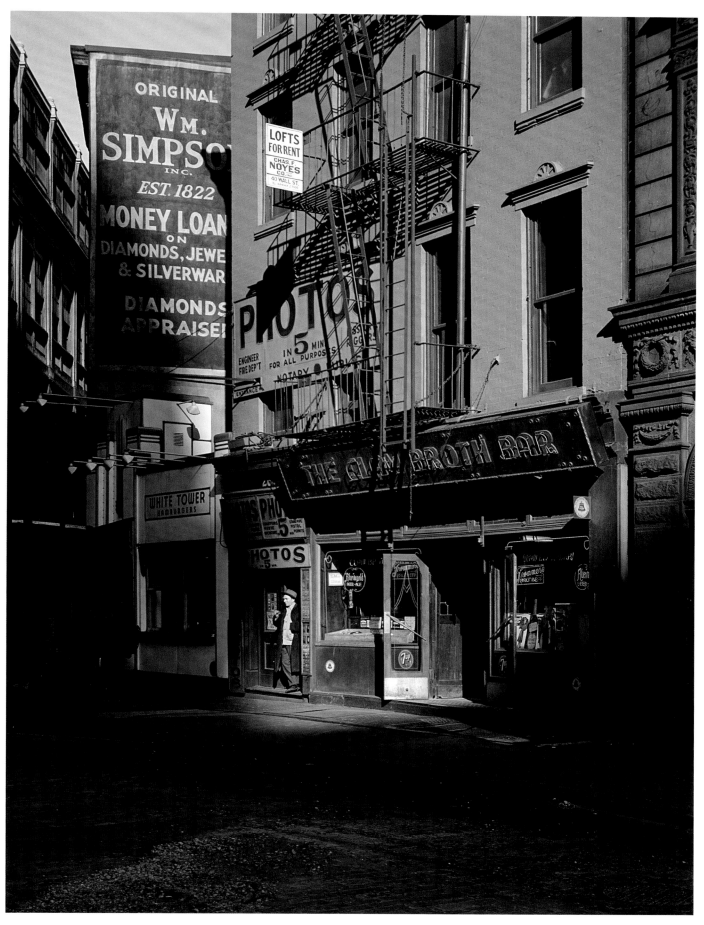

The Bowery, 1946

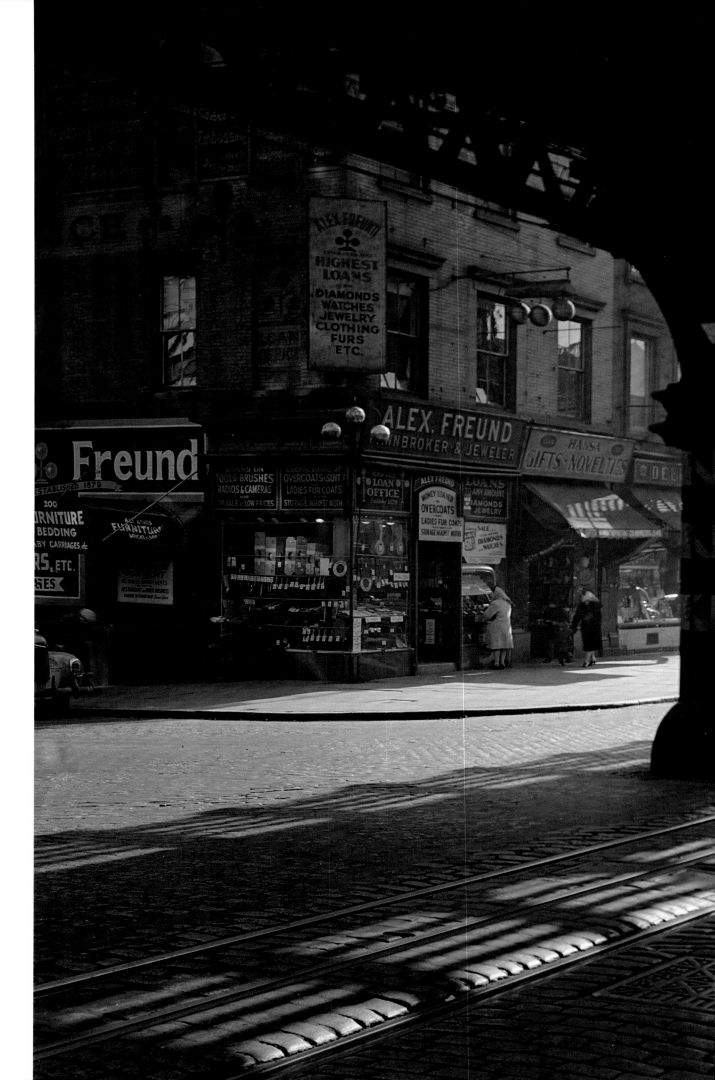

Under the El,
Third Avenue, 1946

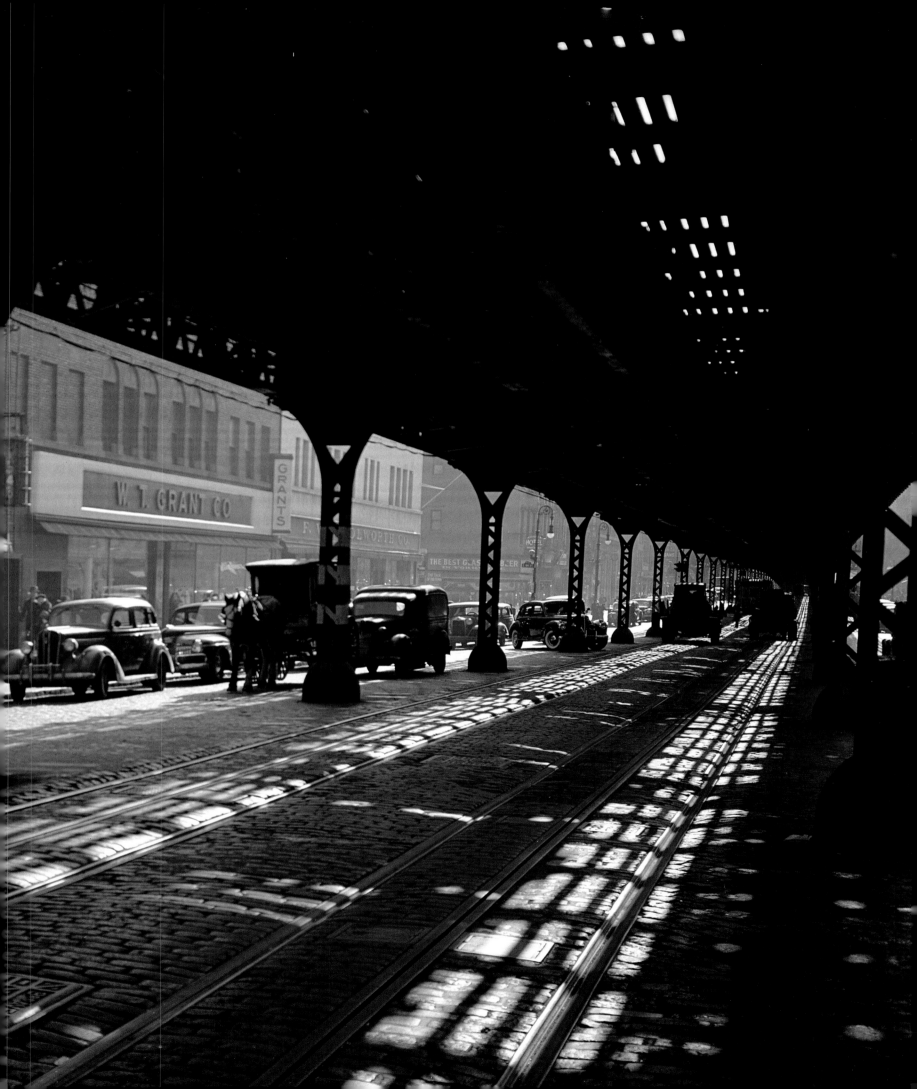

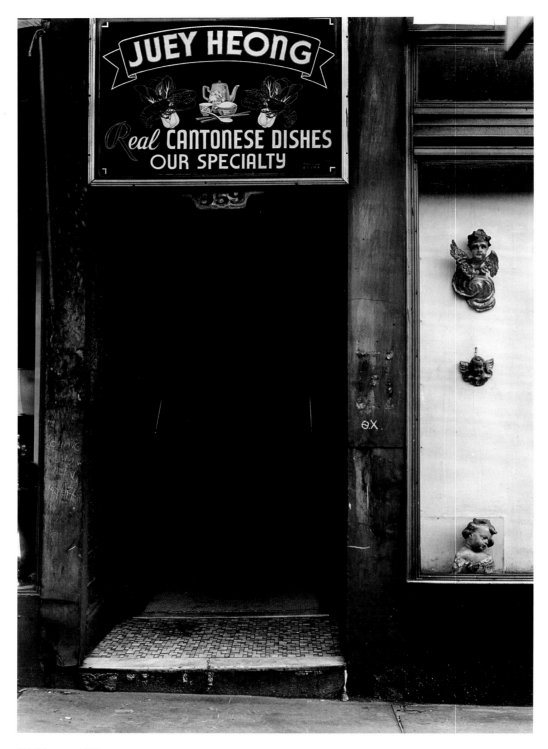

Third Avenue, 1946

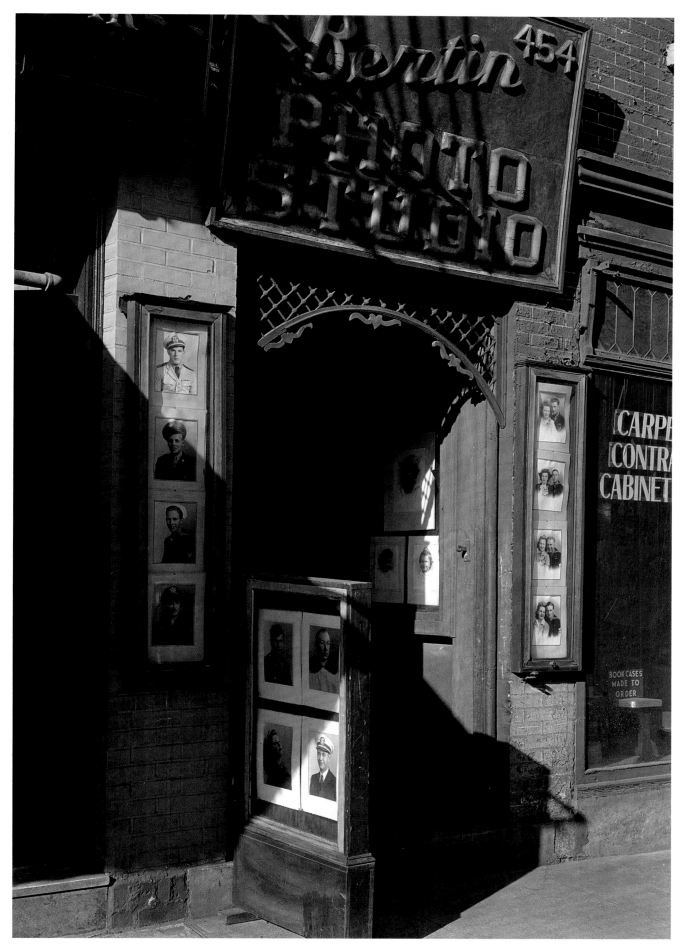

Third Avenue, 1946

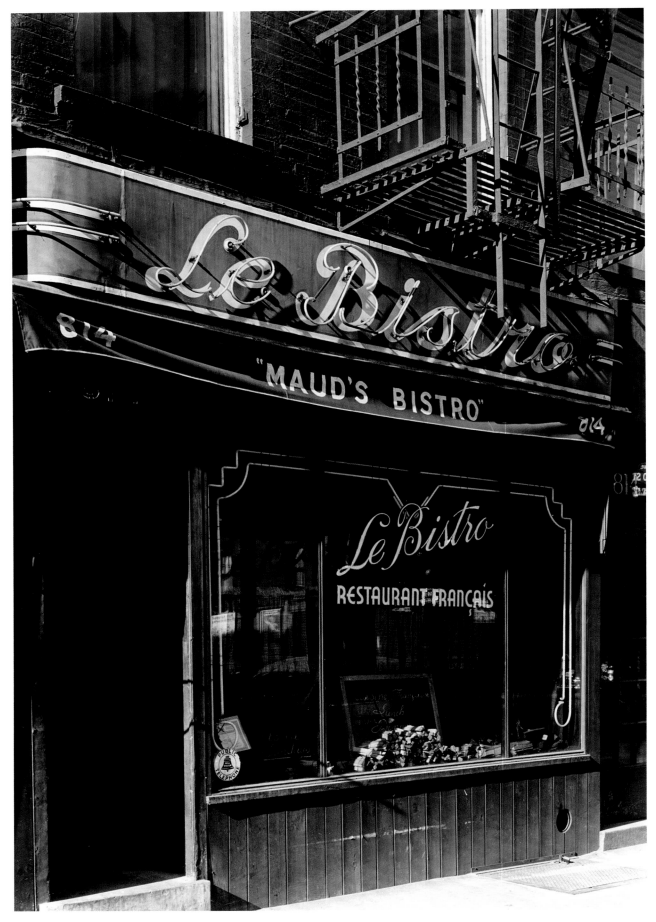

Third Avenue, 1946

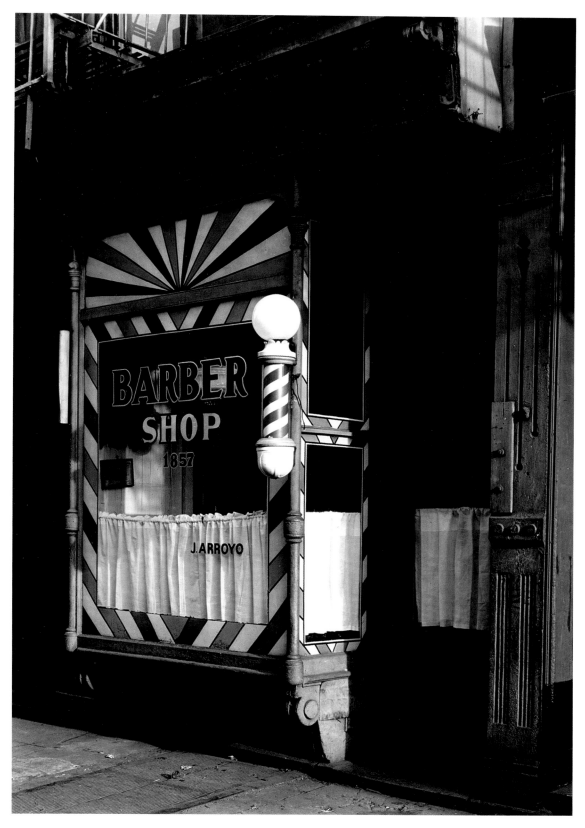

Third Avenue, 1946

From the Third Avenue El,
on the Bowery (157 Bowery at
Broome Street), 1946

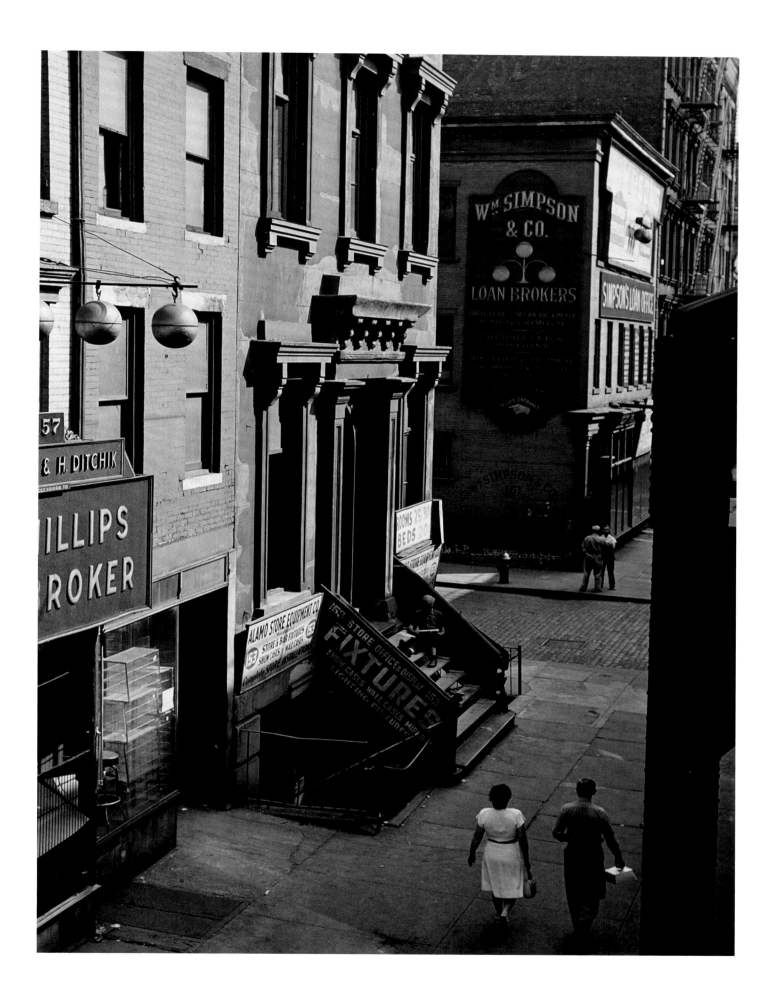

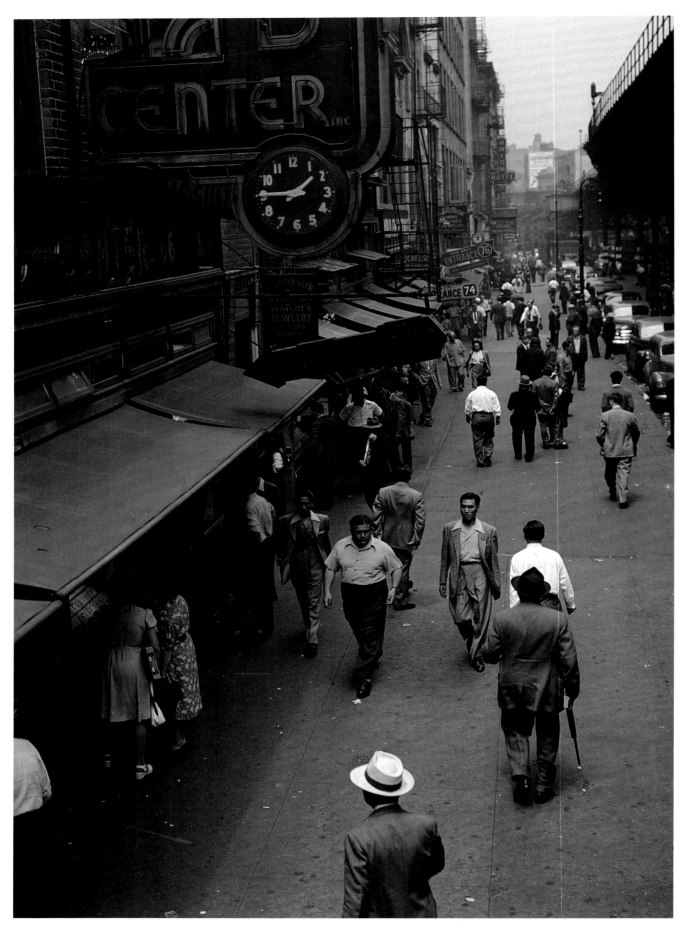

Third Avenue, 1946

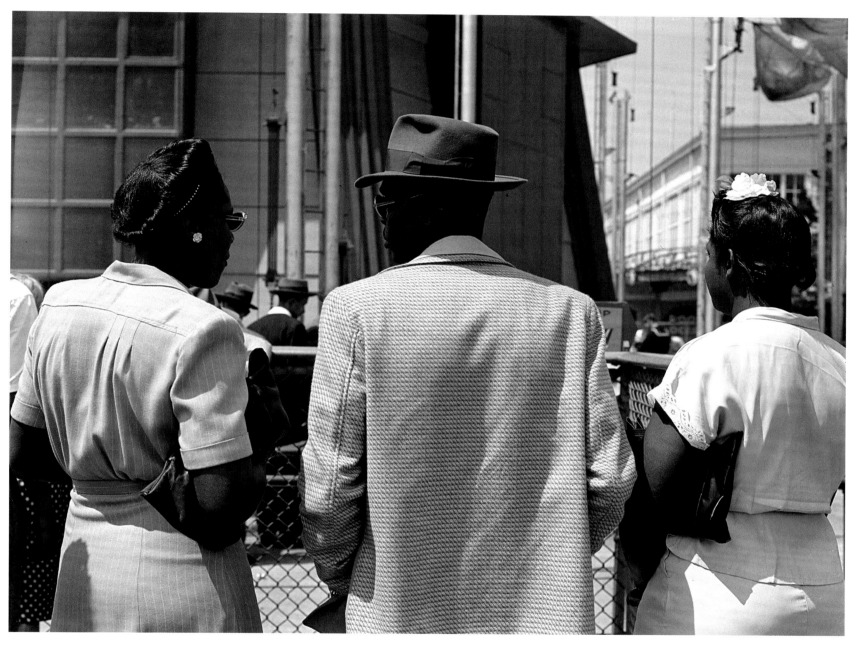

Coney Island, 1946

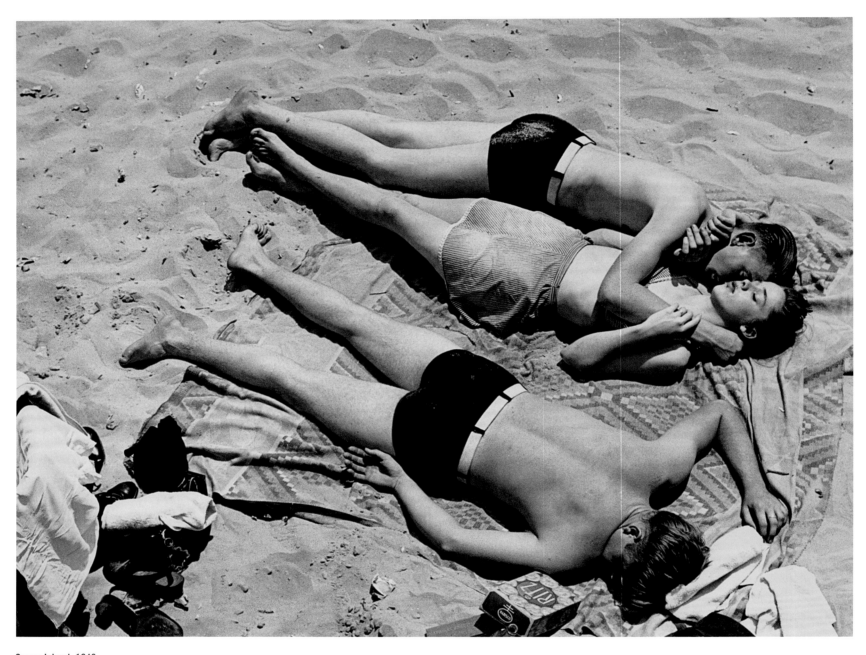

Coney Island, 1946

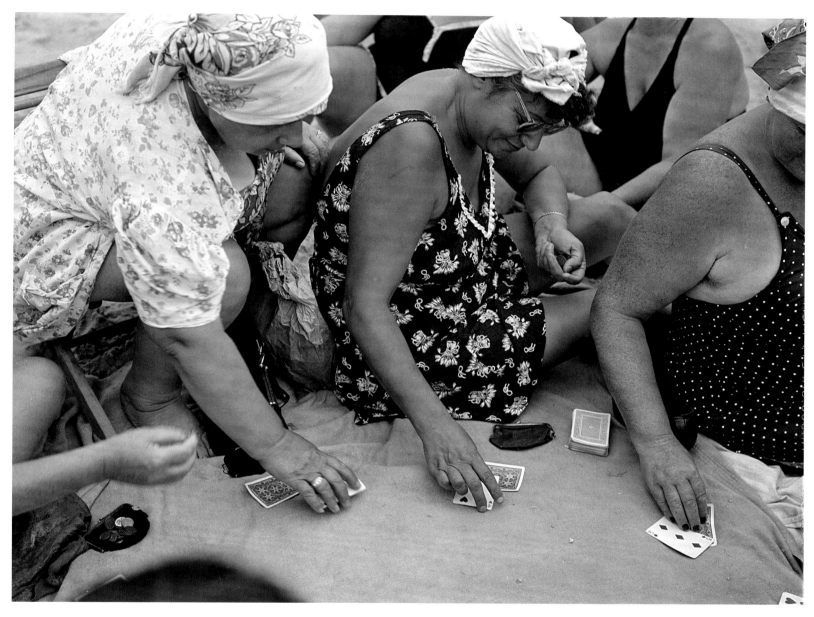

Coney Island, 1946

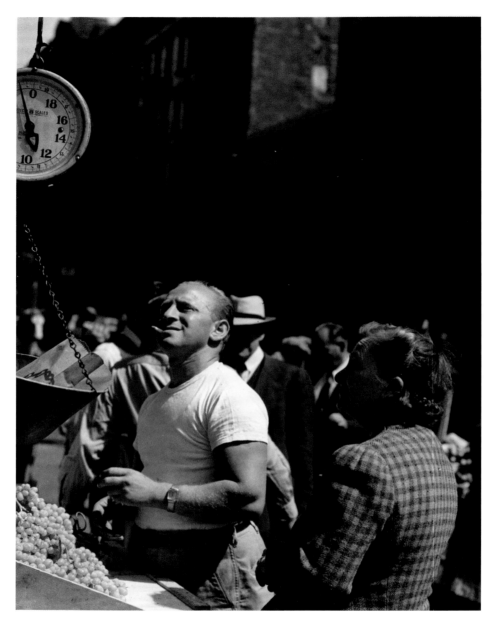

Pushcart Vendor, Suffolk Street, 1946

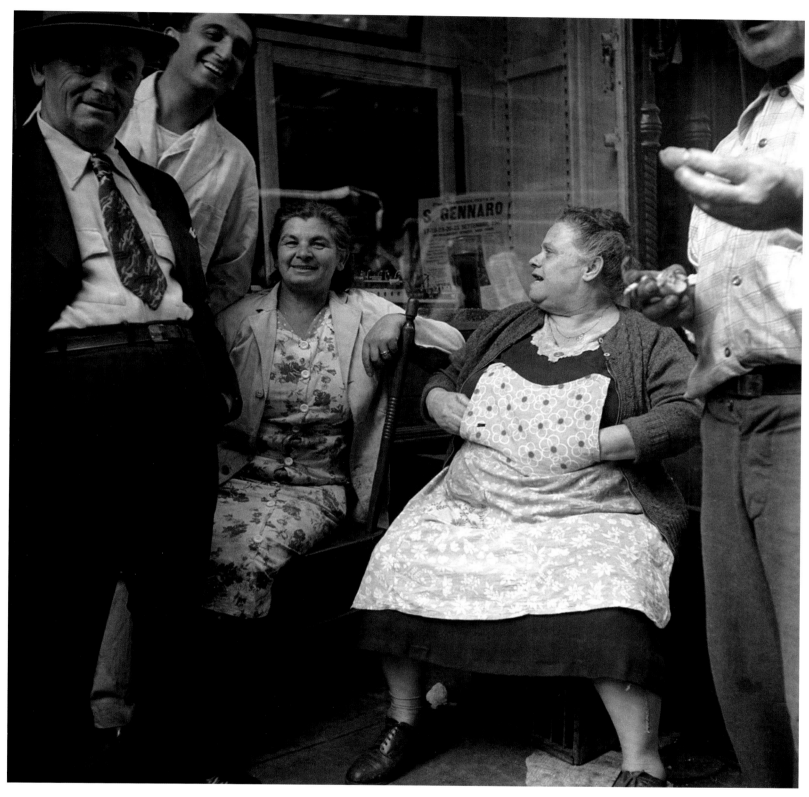

Mott Street, 1946

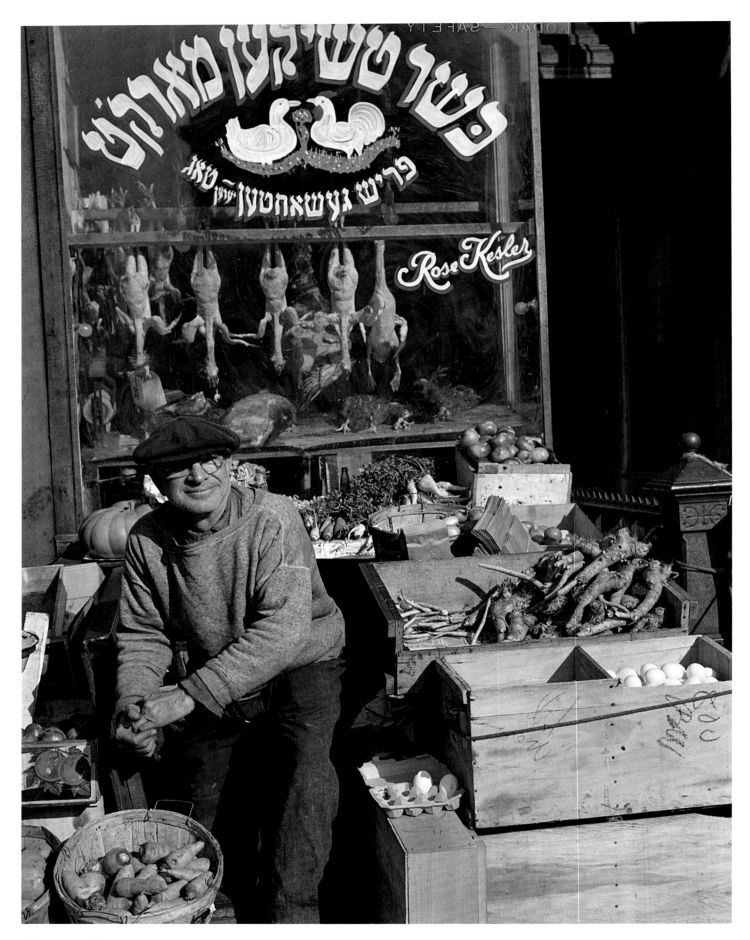

Hester Street, 1946

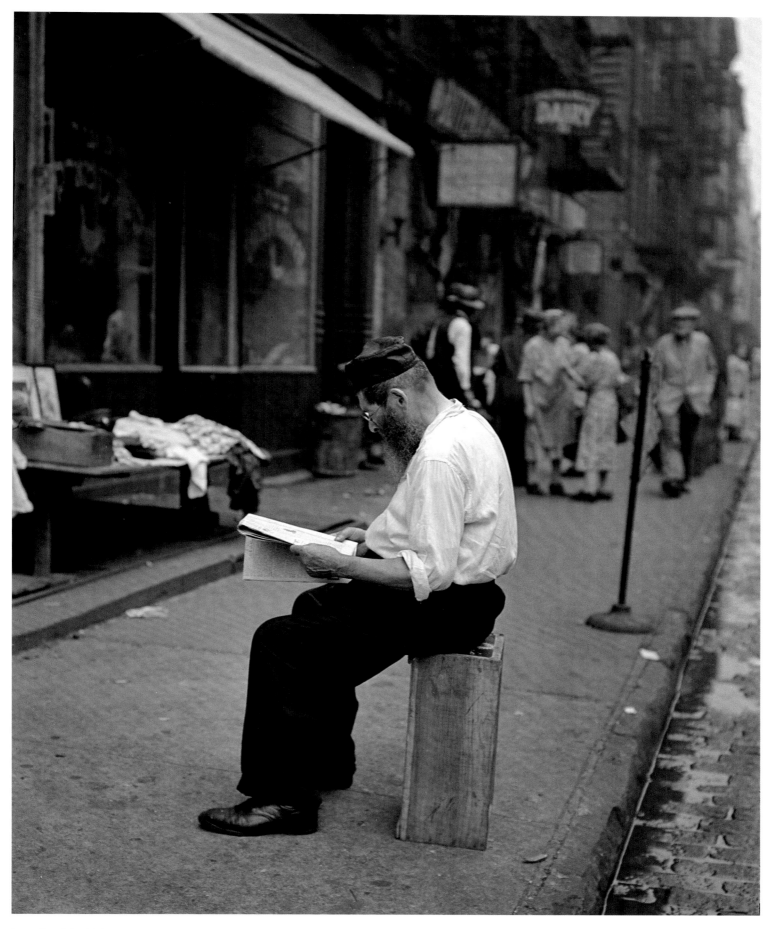

Lower East Side, 1946

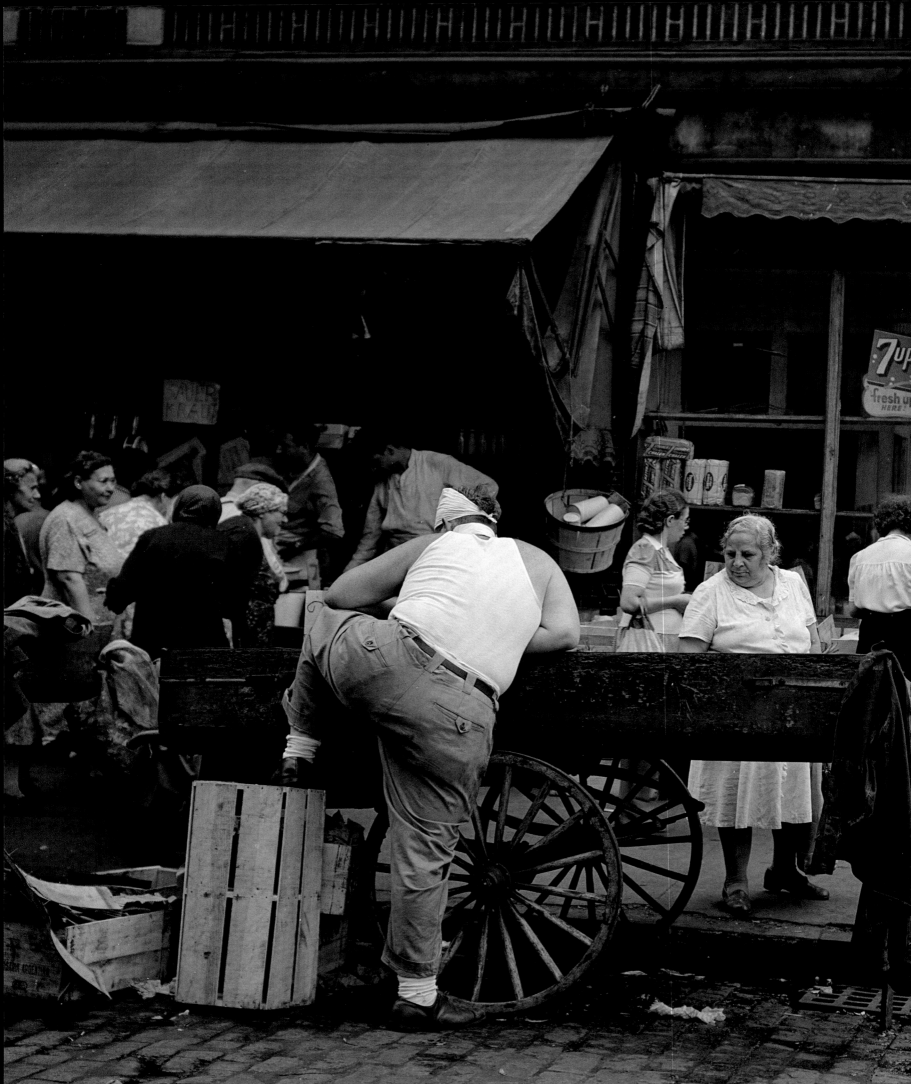

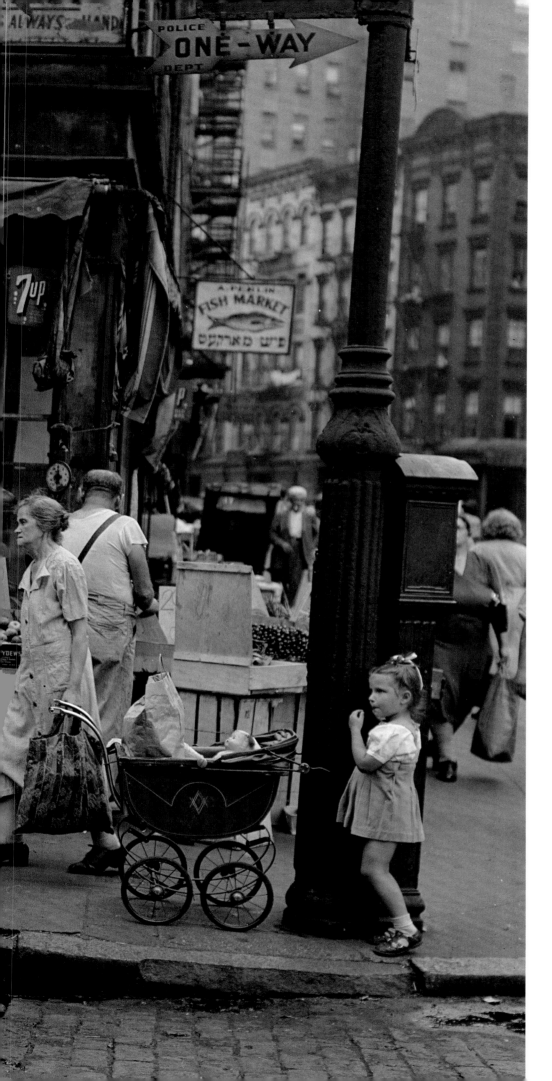

Suffolk and Hester Streets, 1946

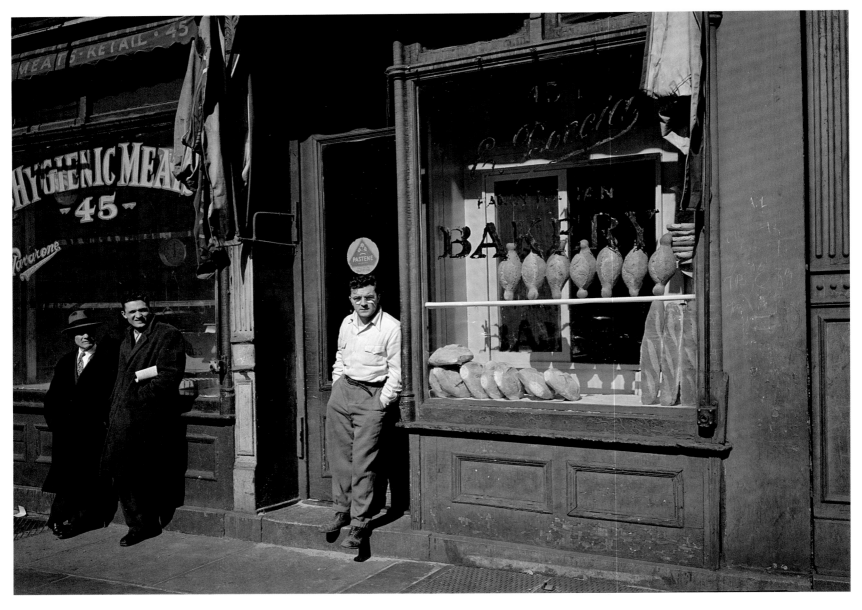

Mott Street, 1946

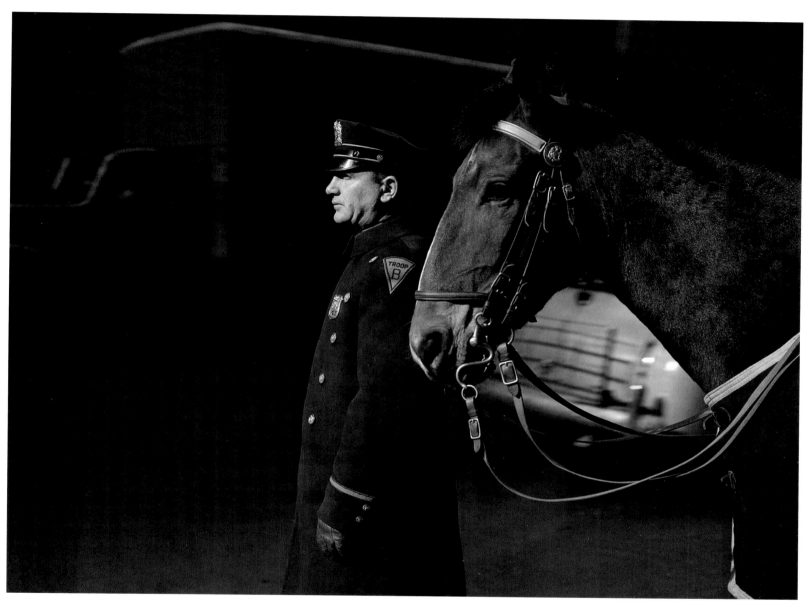

New York, 1946

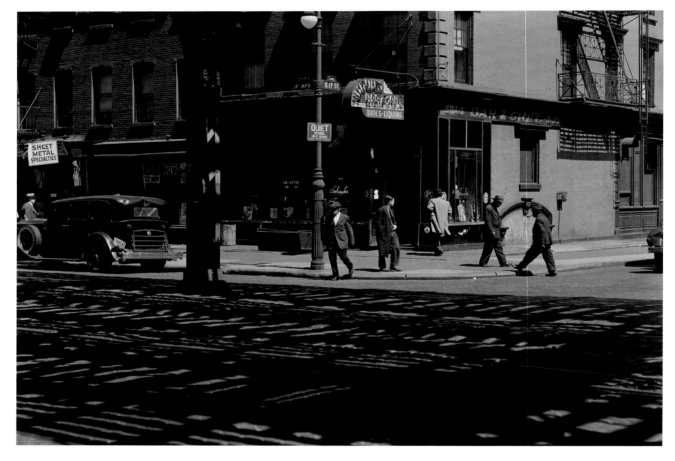

Third Avenue, 1946

OPPOSITE:
Midtown Manhattan, 1948

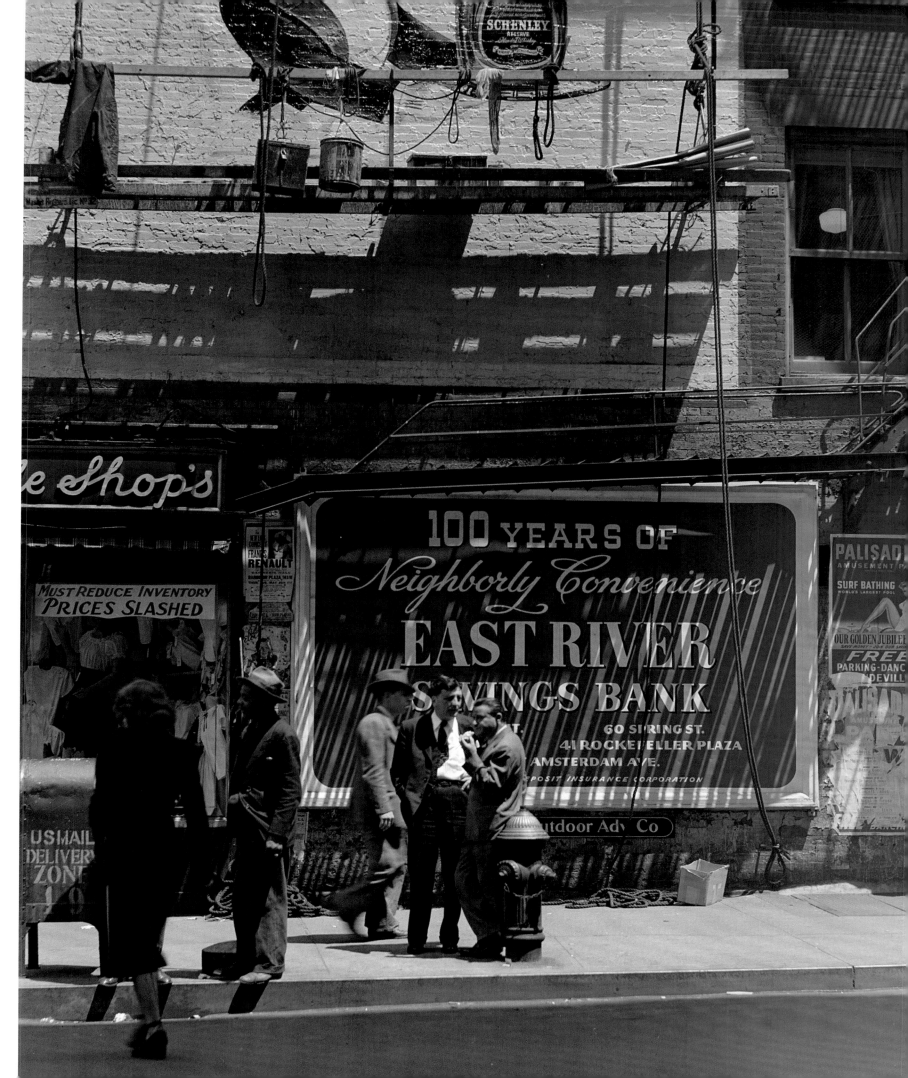

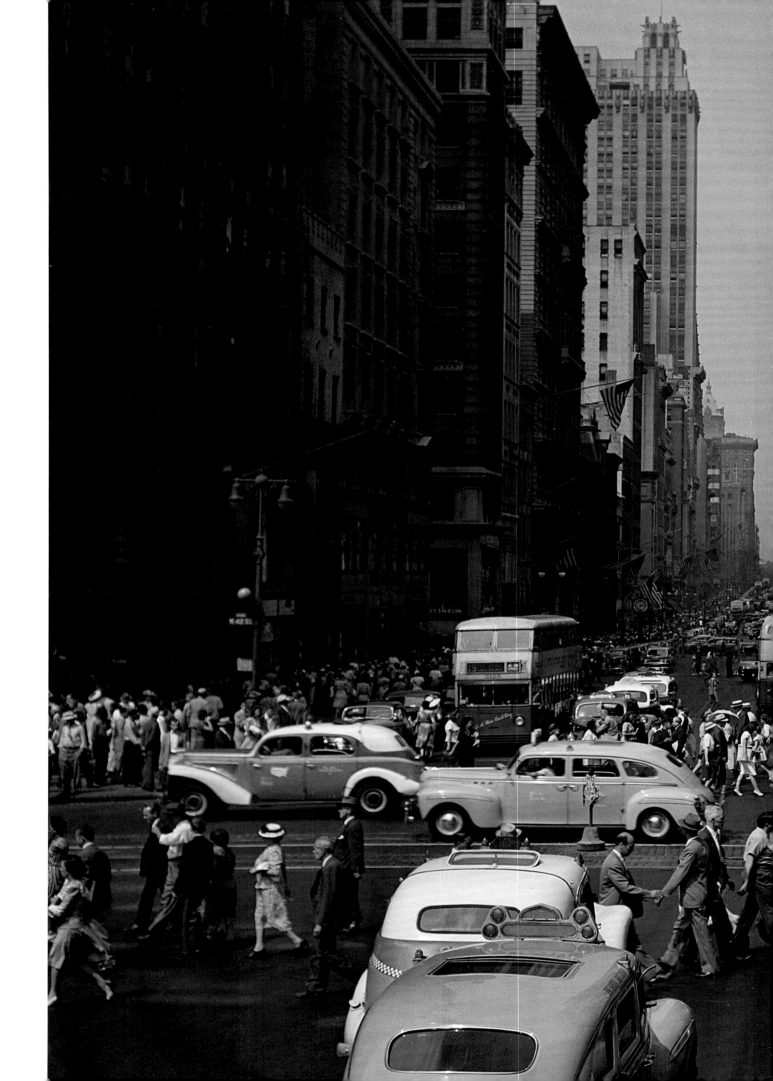

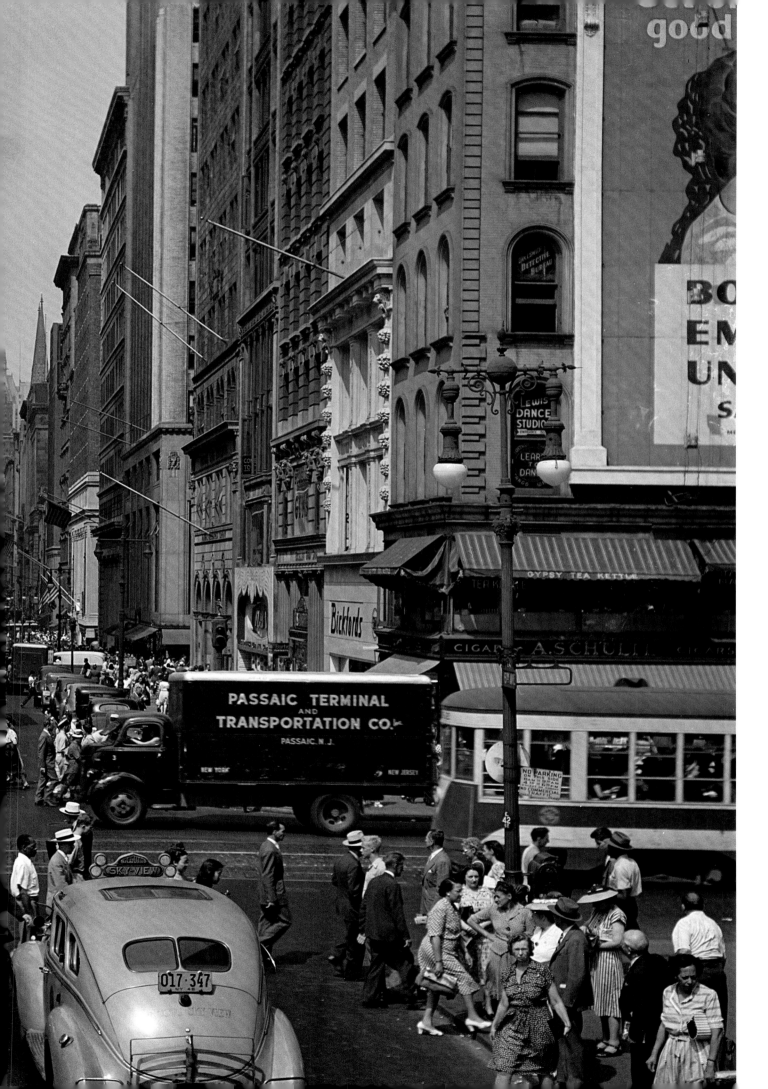

Fifth Avenue at
42nd Street, 1946

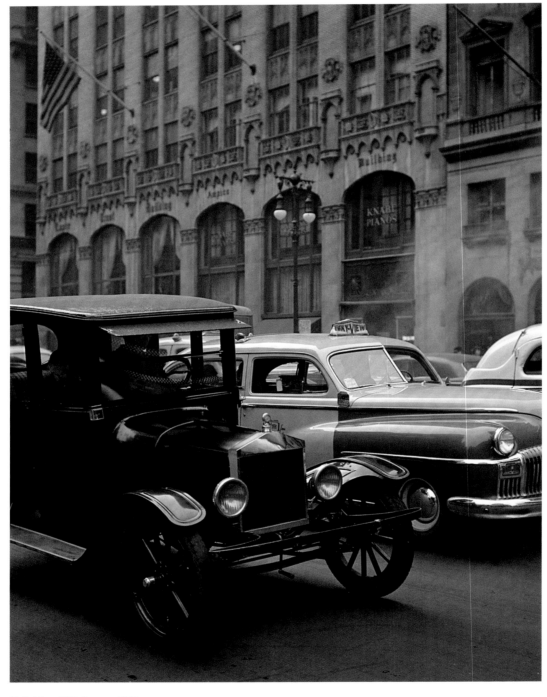

Model A on Fifth Avenue, 1946

OPPOSITE:
Sixth Avenue and
48th Street, 1946

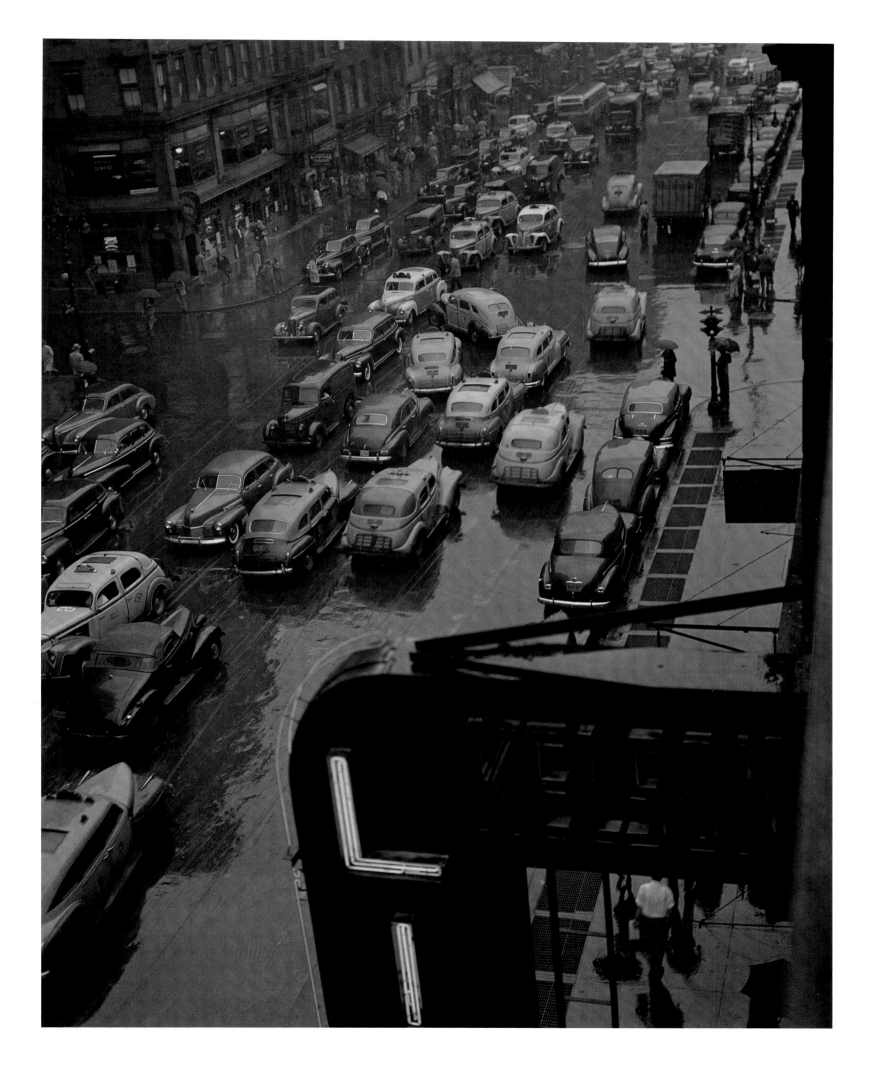

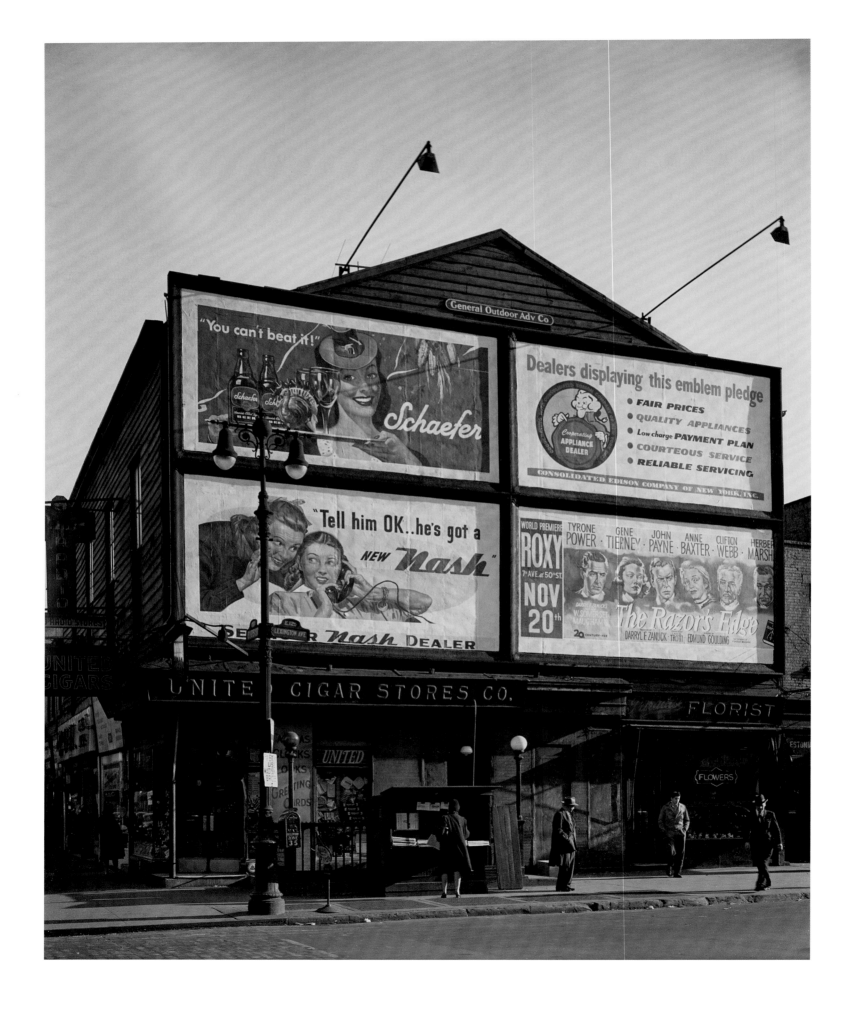

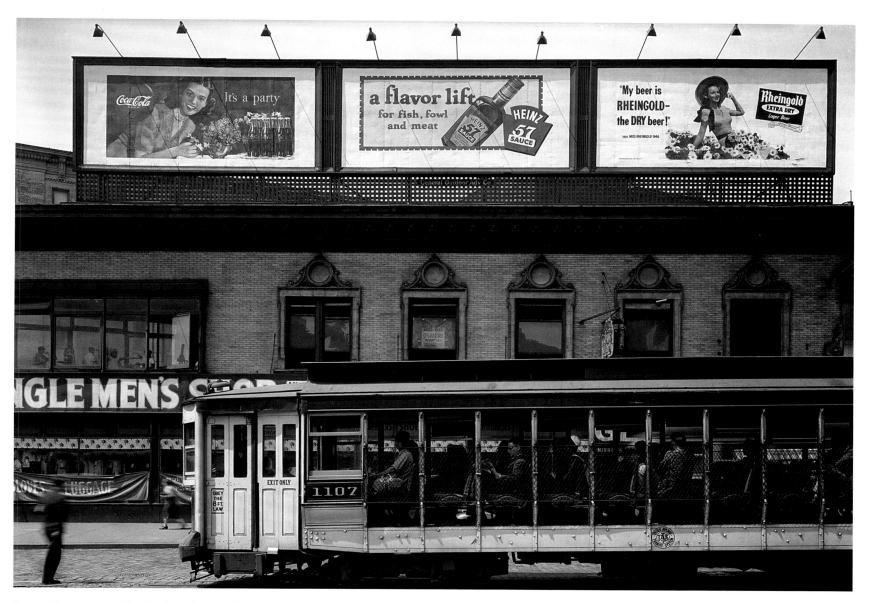

Summer Streetcar, 125th Street and Broadway, 1946

OPPOSITE:
Lexington Avenue at 125th Street, 1946

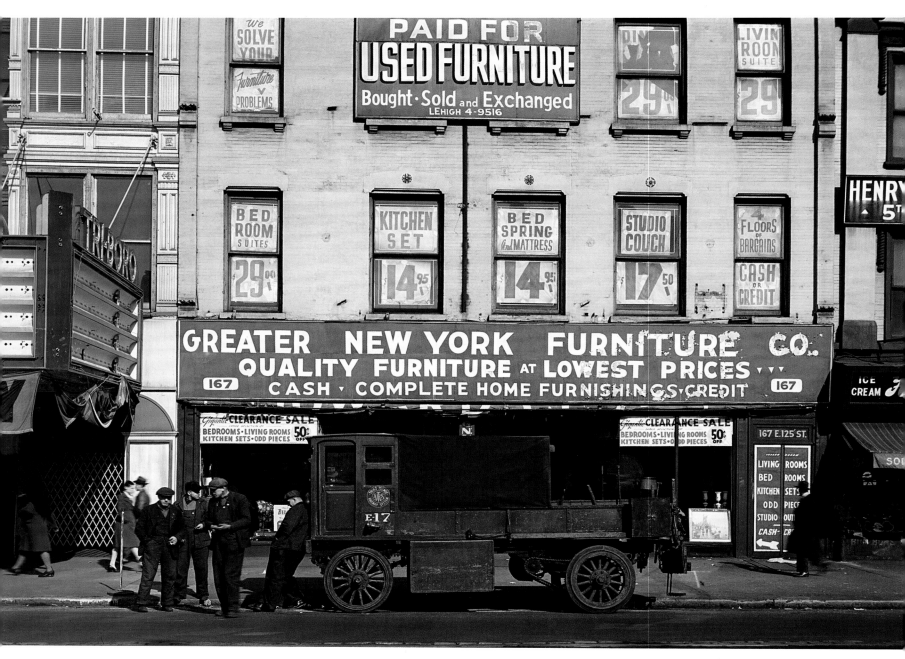

East 125th Street, Harlem, 1946

OPPOSITE:
Amsterdam Avenue,
December 1945

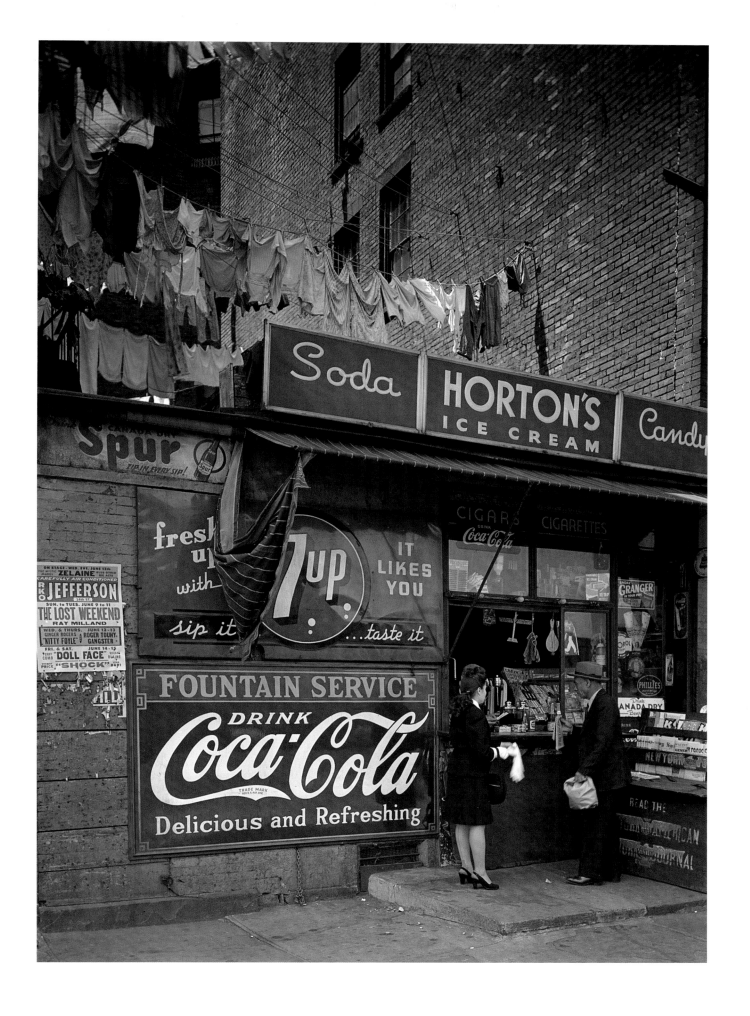

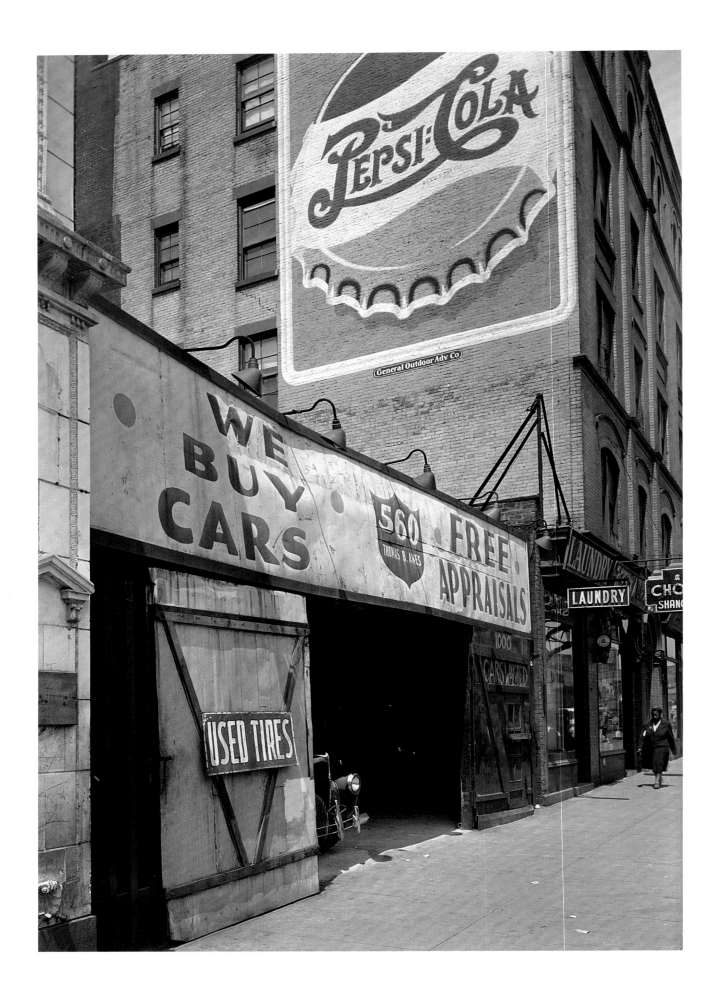

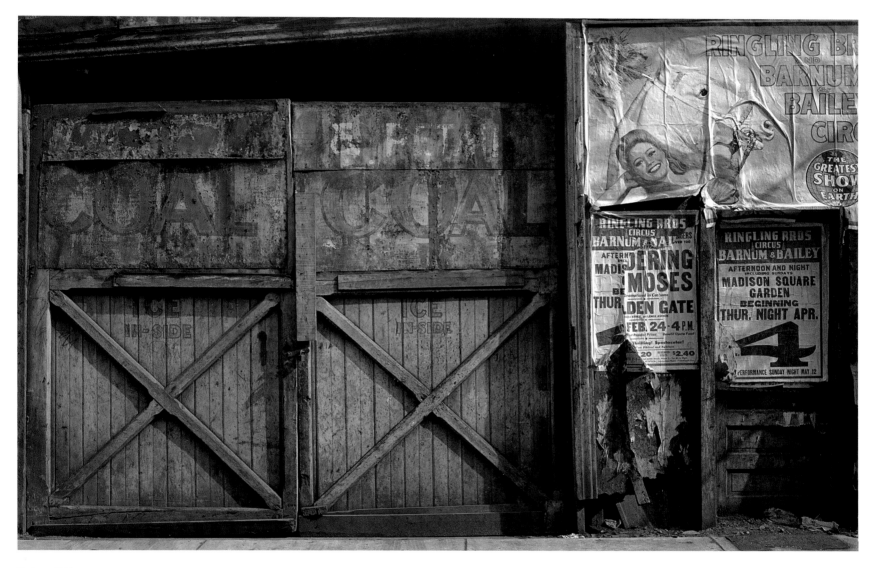

Harlem, 1946

OPPOSITE:
Harlem, 1946

St. Nicholas Avenue and
125th Street, Harlem, 1946

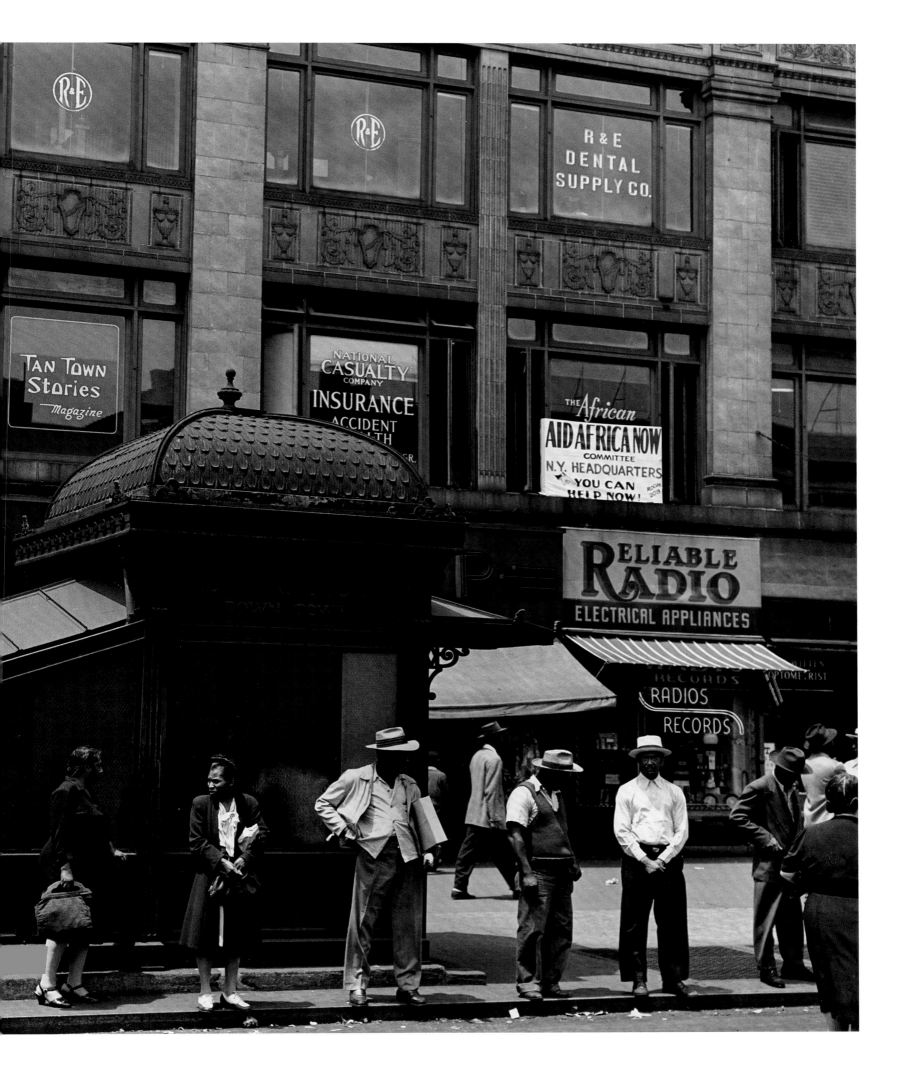

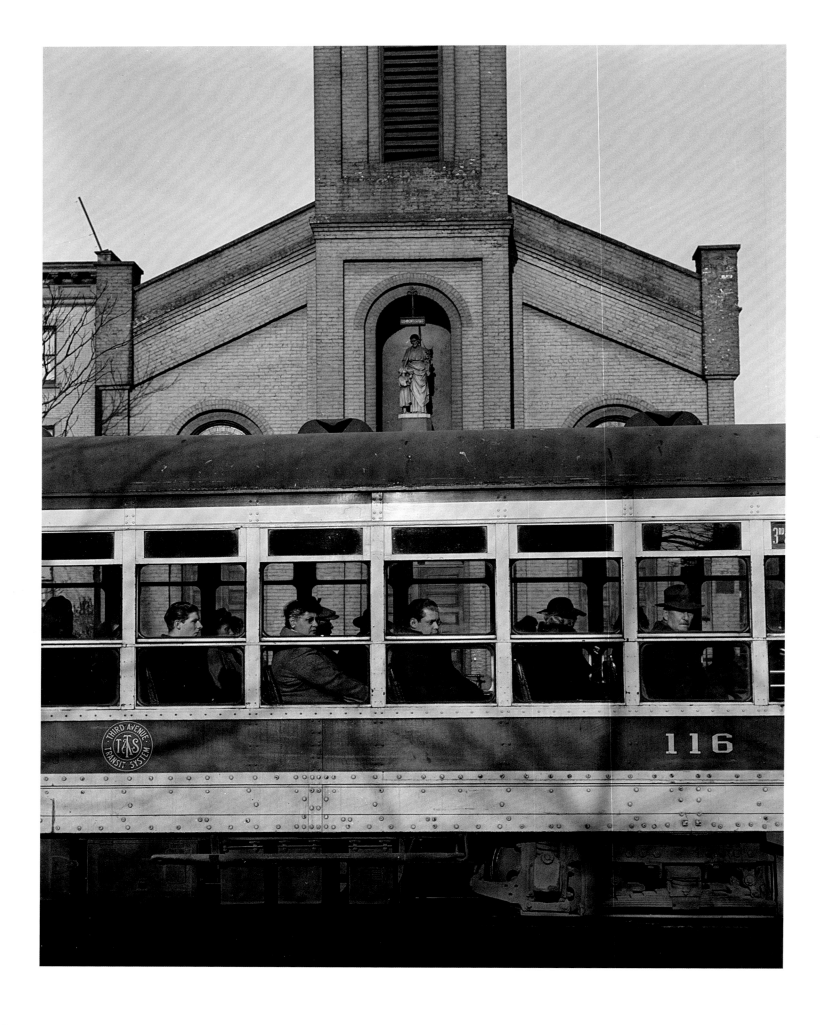

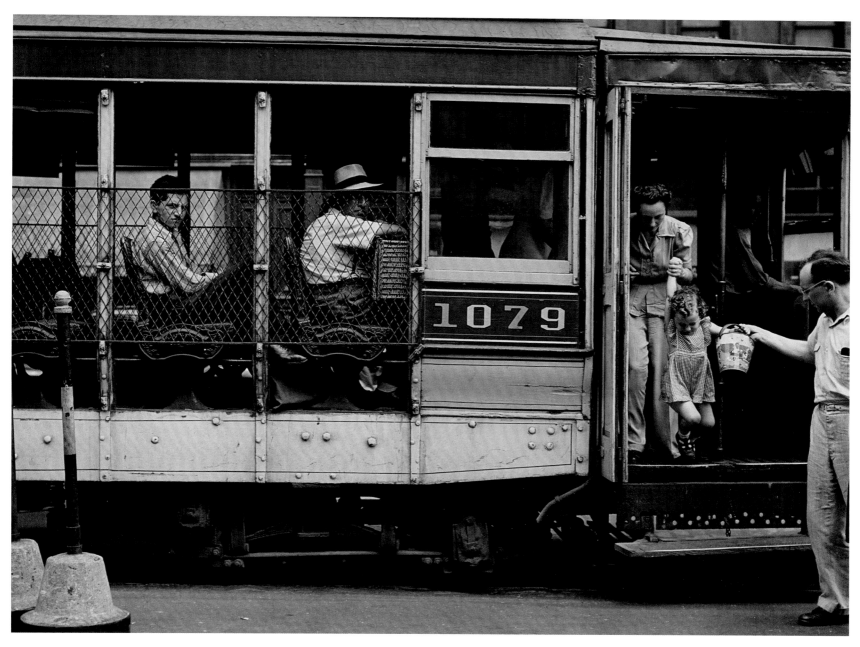

125th Street, Streetcar, 1946

OPPOSITE:
125th Street, Streetcar, 1946

East Harlem, 1946

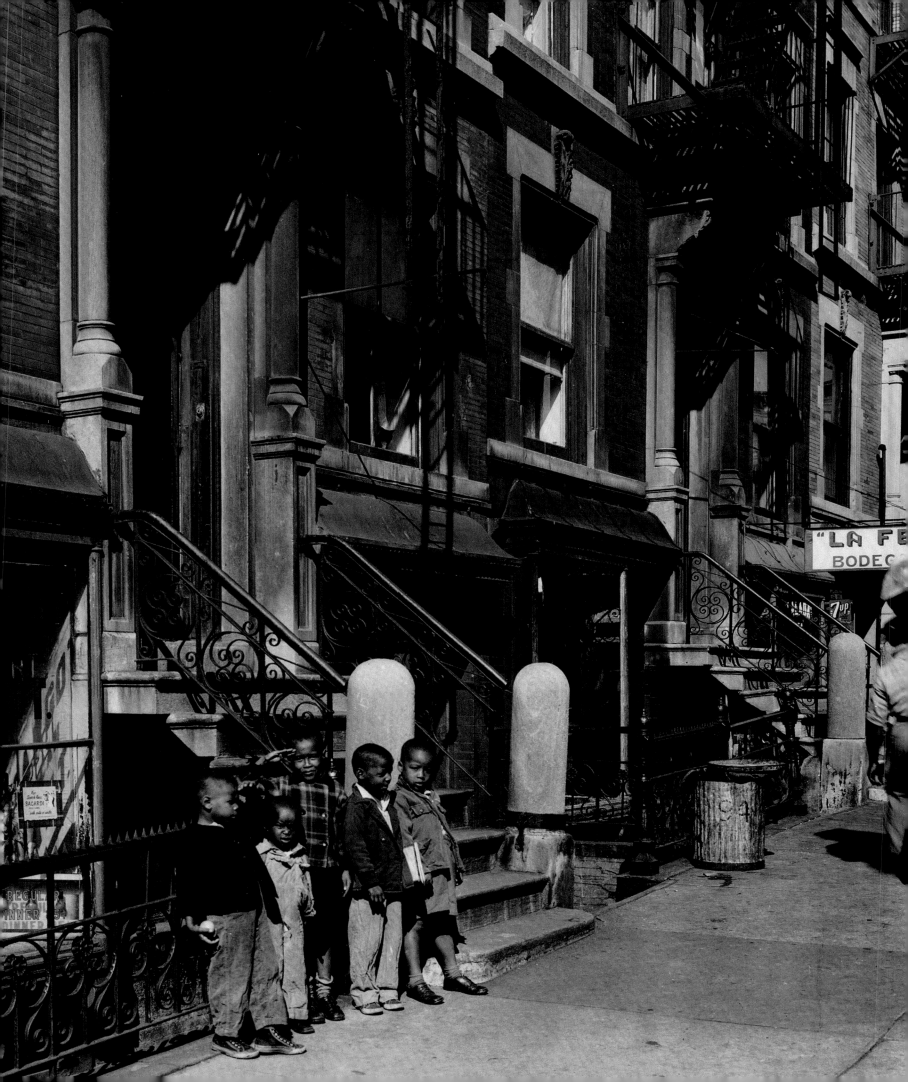

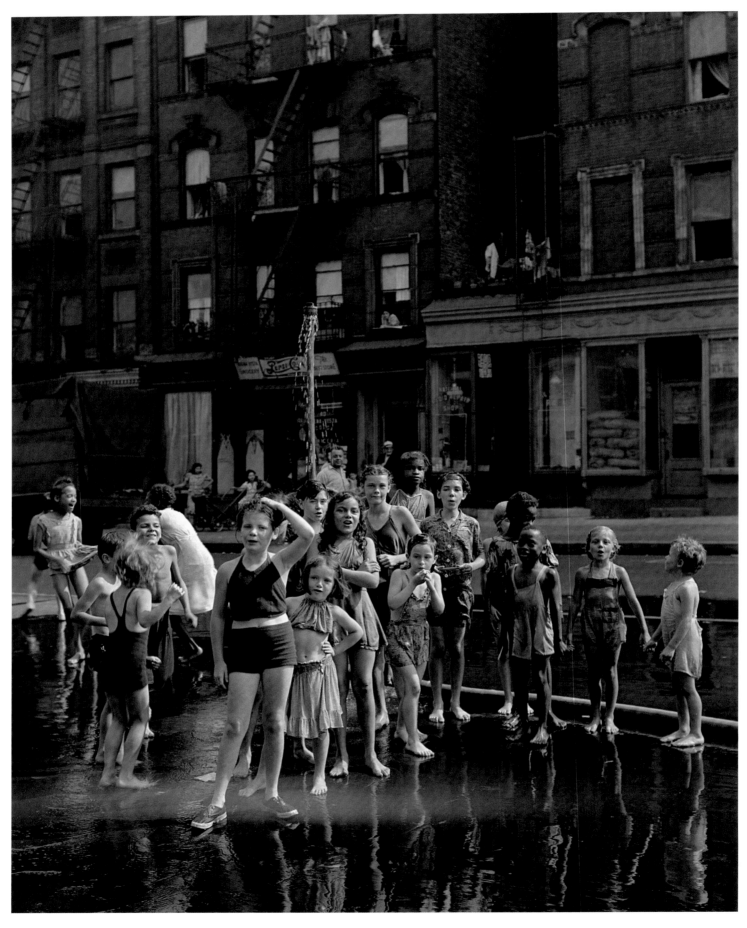

La Salle Street at Amsterdam Avenue, 1946

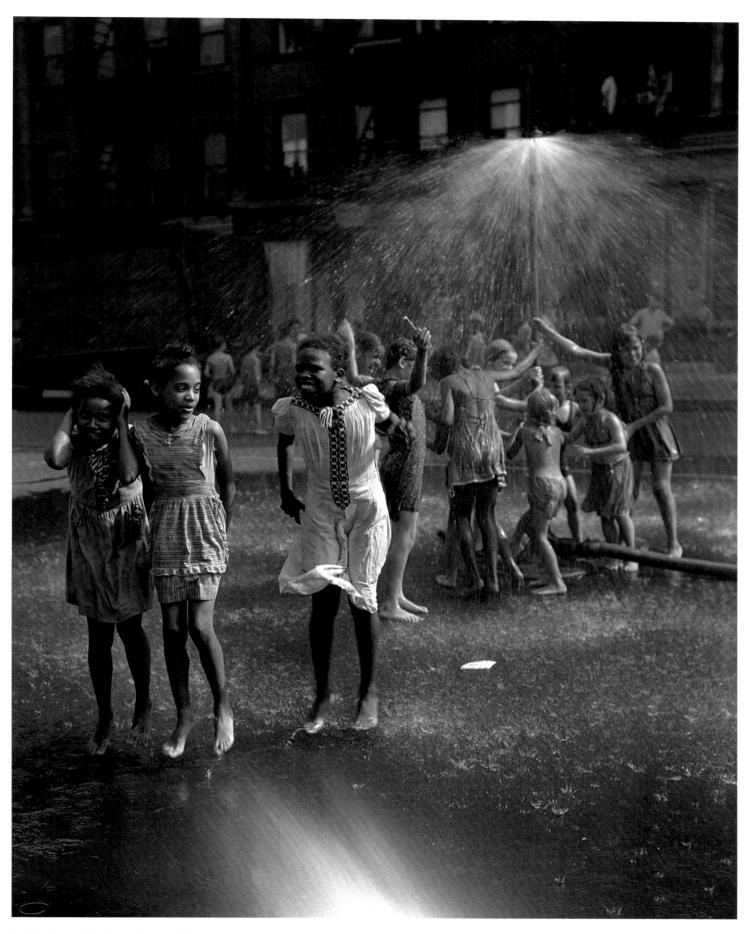

La Salle Street at Amsterdam Avenue, 1946

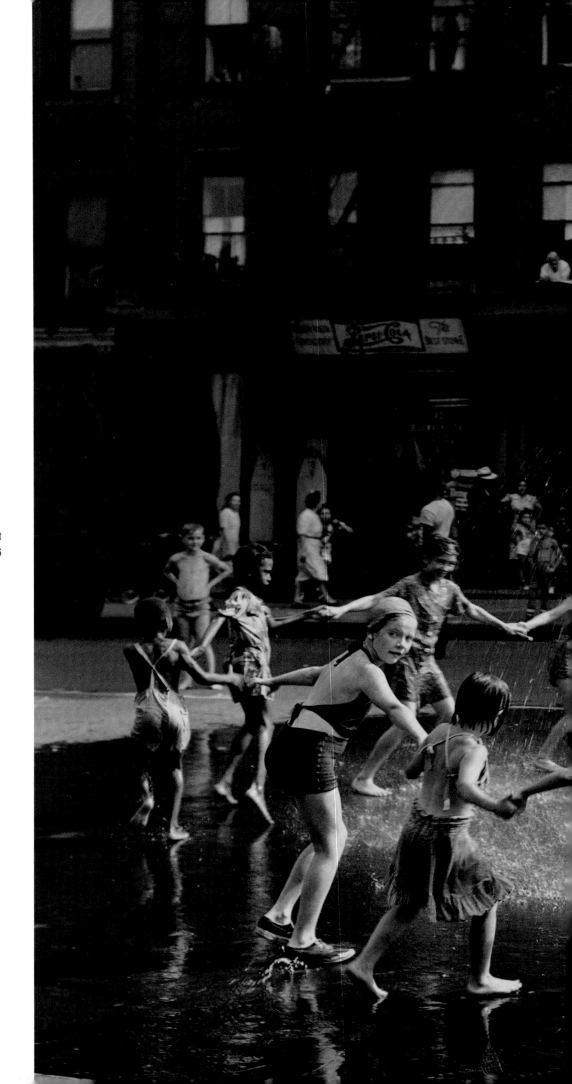

La Salle Street at
Amsterdam Avenue, 1946

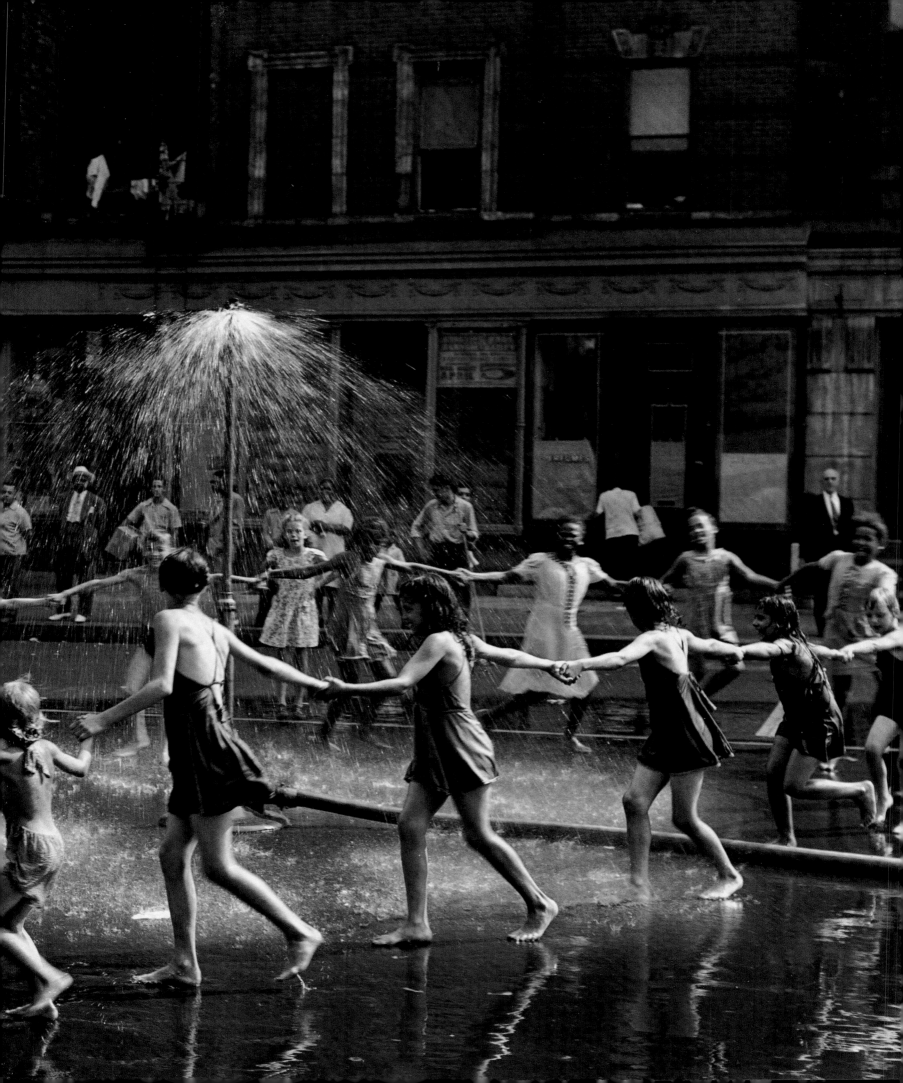

125th Street, 1946

125th Street, 1946

Harlem, 1946

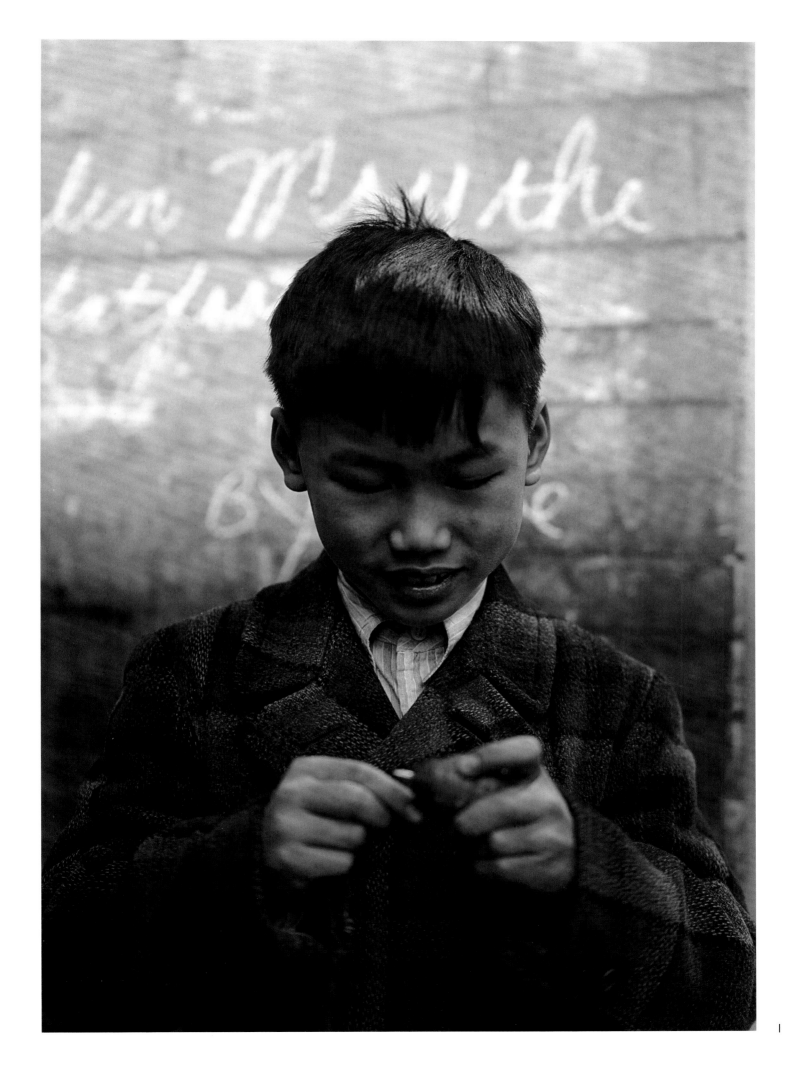

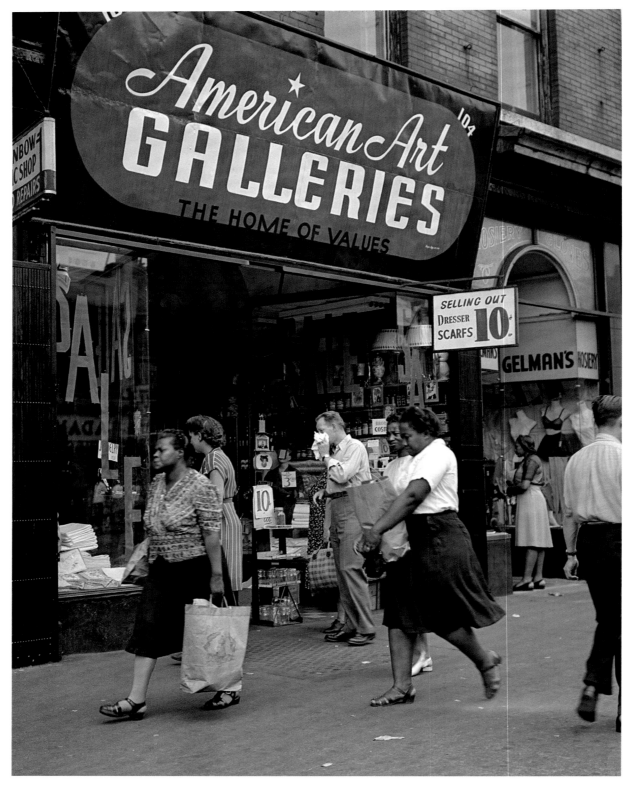

Harlem, 1946

OPPOSITE:
125th Street, Harlem, 1946

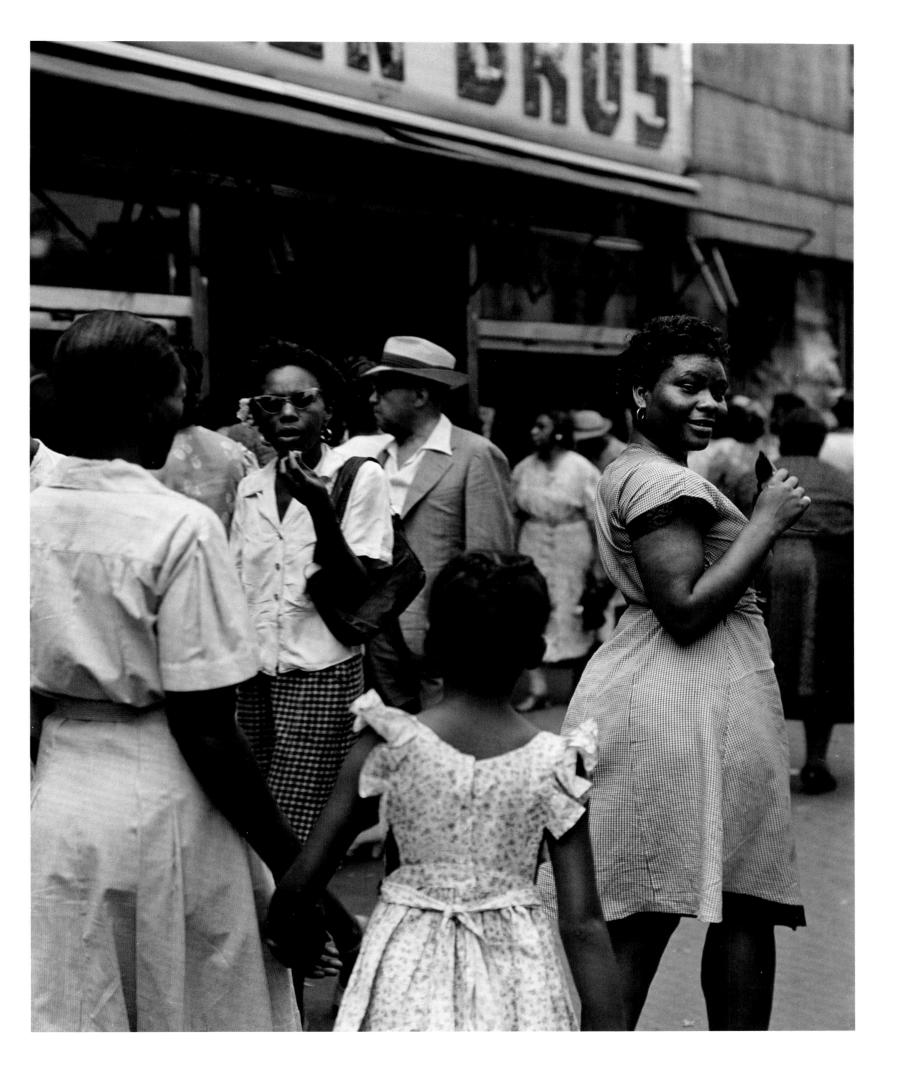

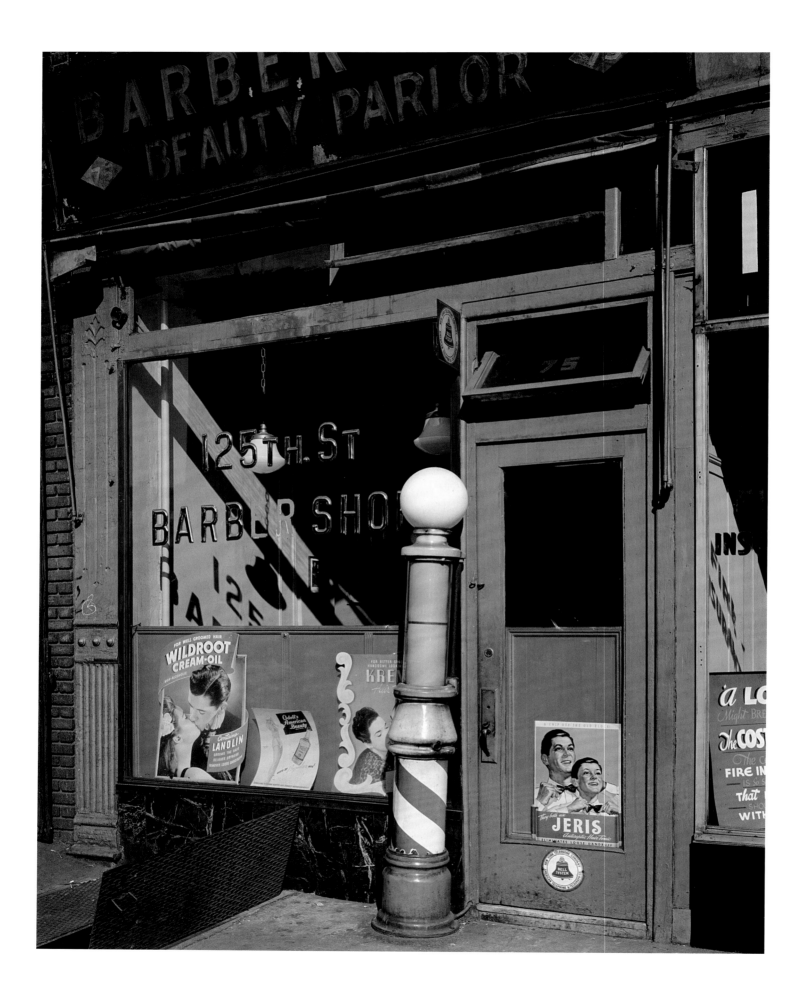

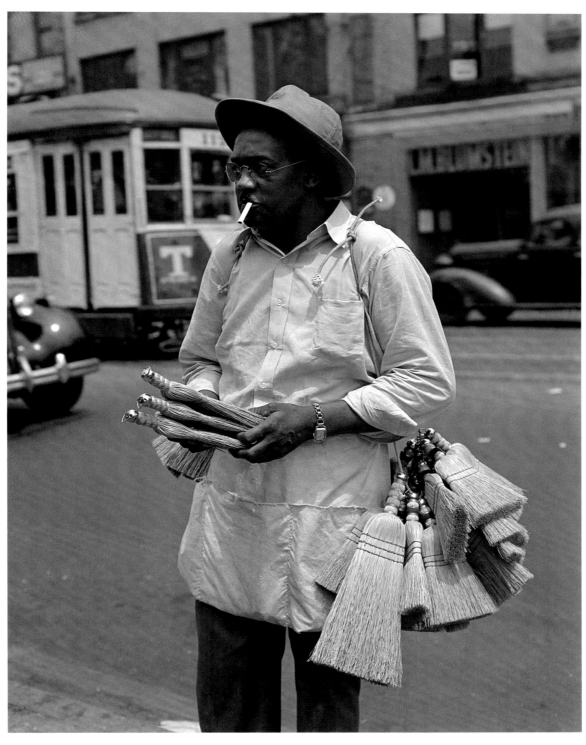

Brush Man, 125th Street, 1946

OPPOSITE:
Barbershop, 125th Street, 1946

FOLLOWING SPREAD:
Harlem, 1946

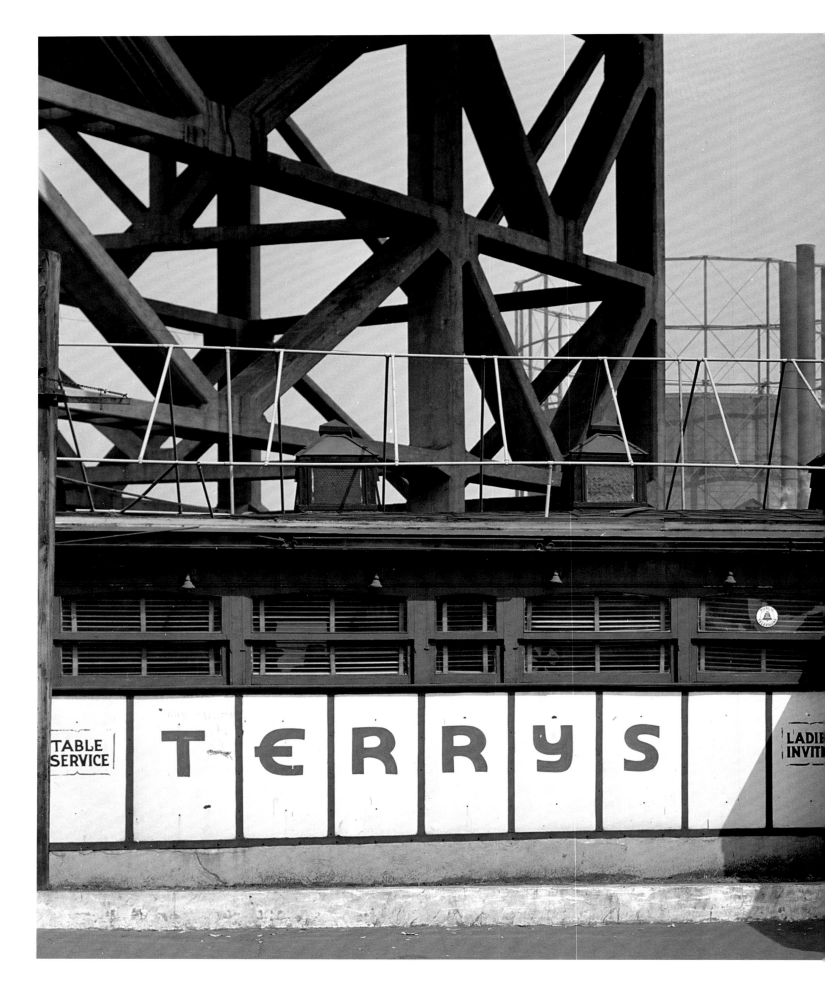

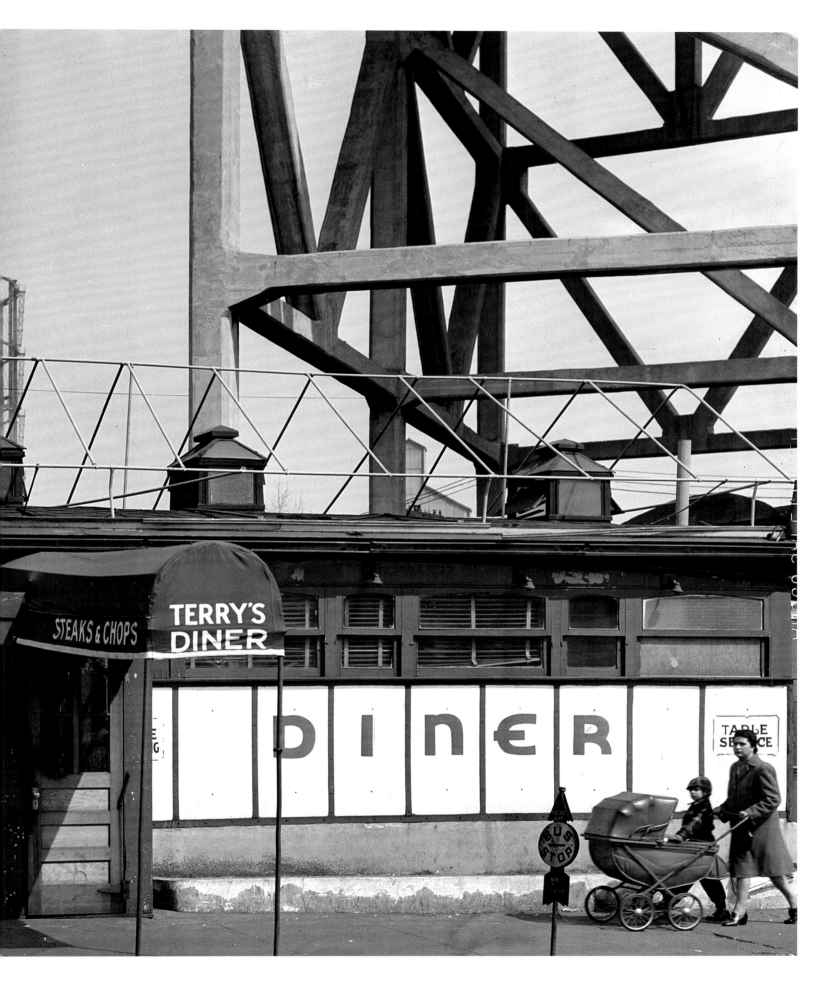

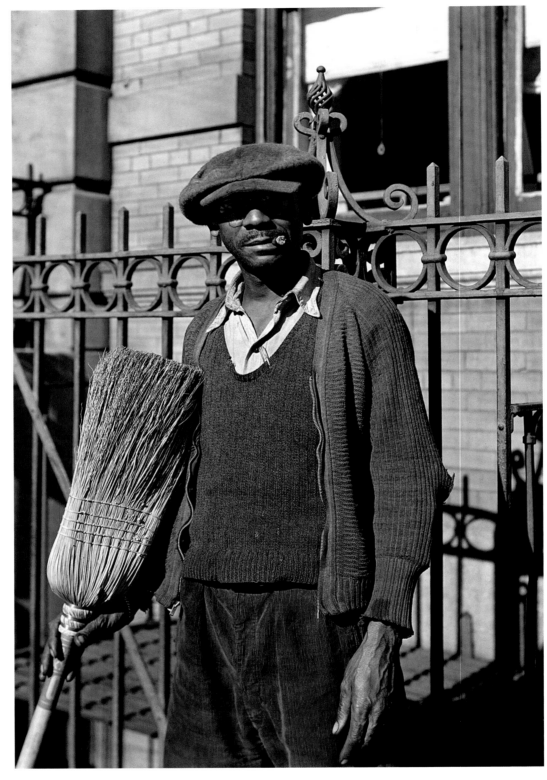

Harlem, 1946

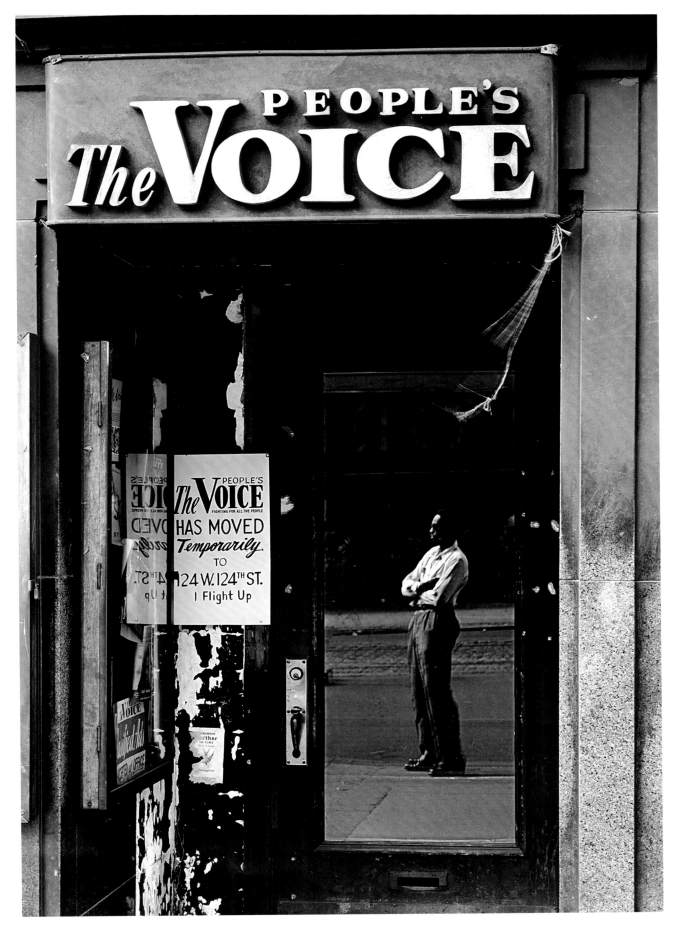

"The People's Voice," 125th Street, 1946

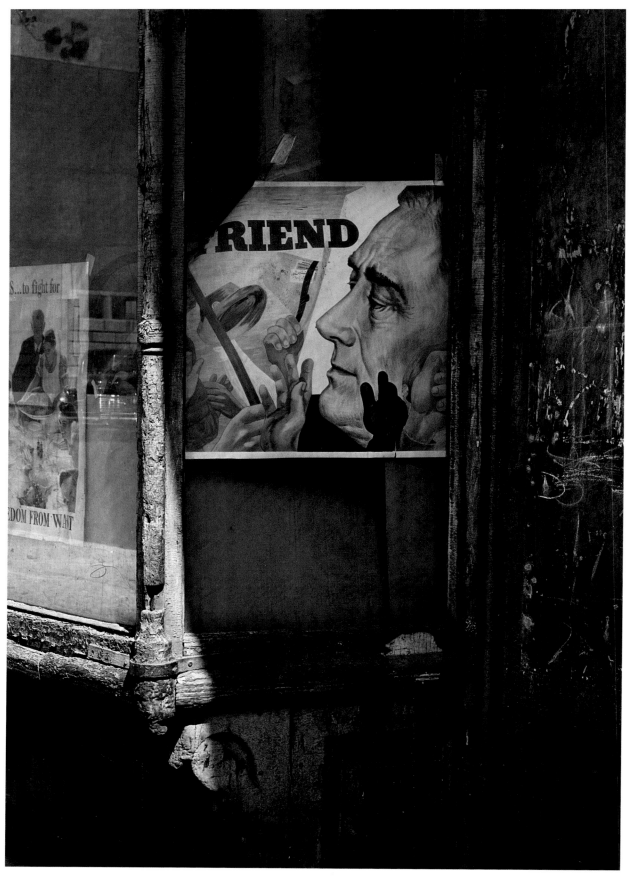

106th Street near Madison Avenue, 1946

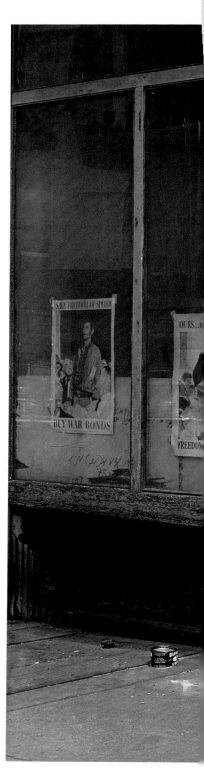

"The Four Freedoms," 106th Street
near Madison Avenue, 1946

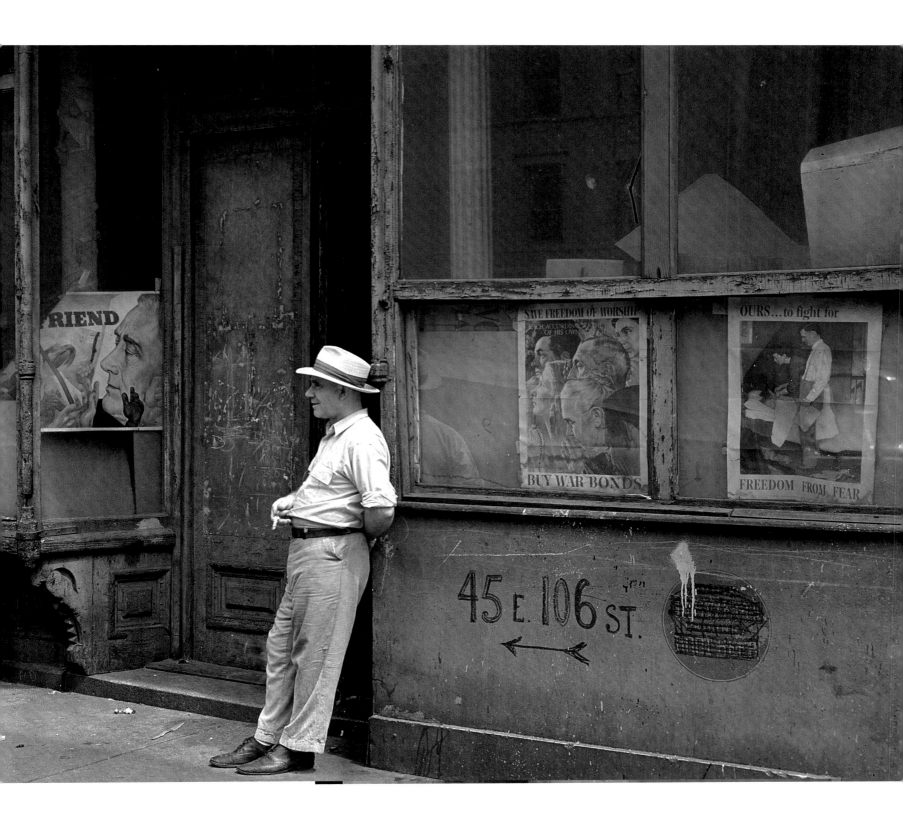

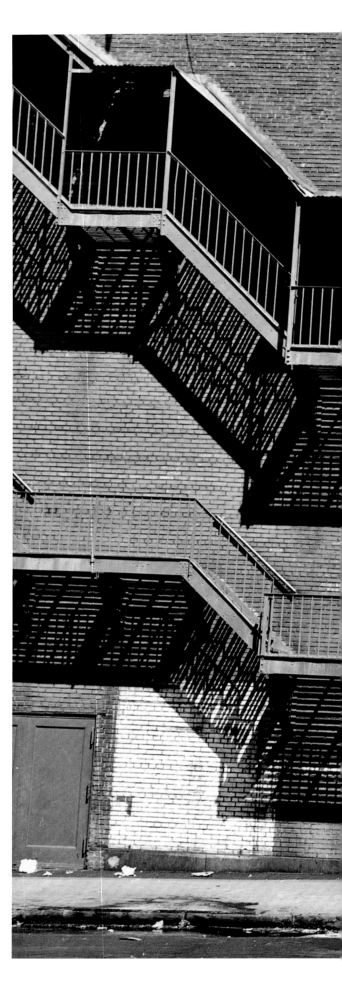

Mr. Perkins's Pierce-Arrow,
Harlem, 1946

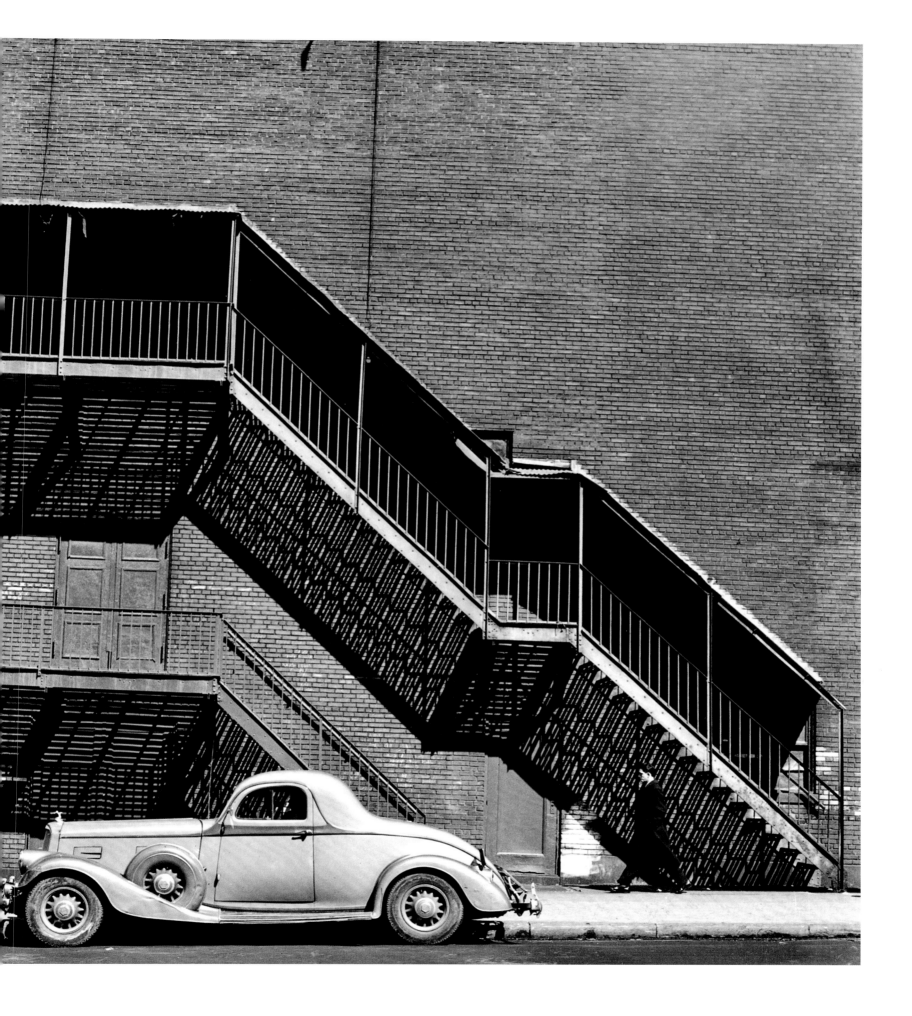

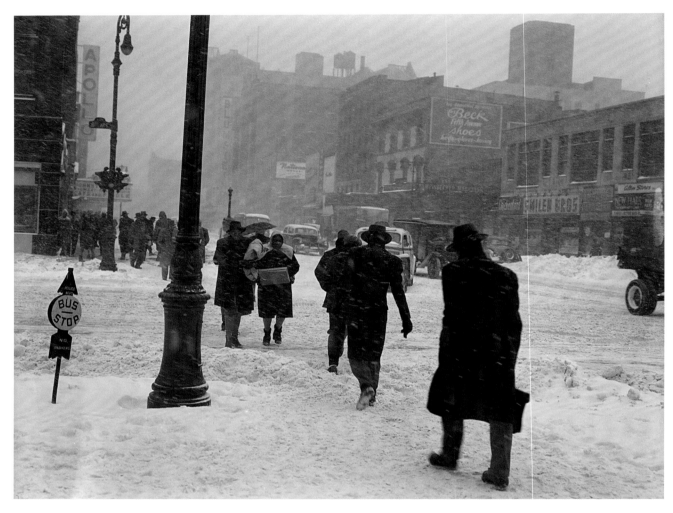

125th Street, Winter 1946

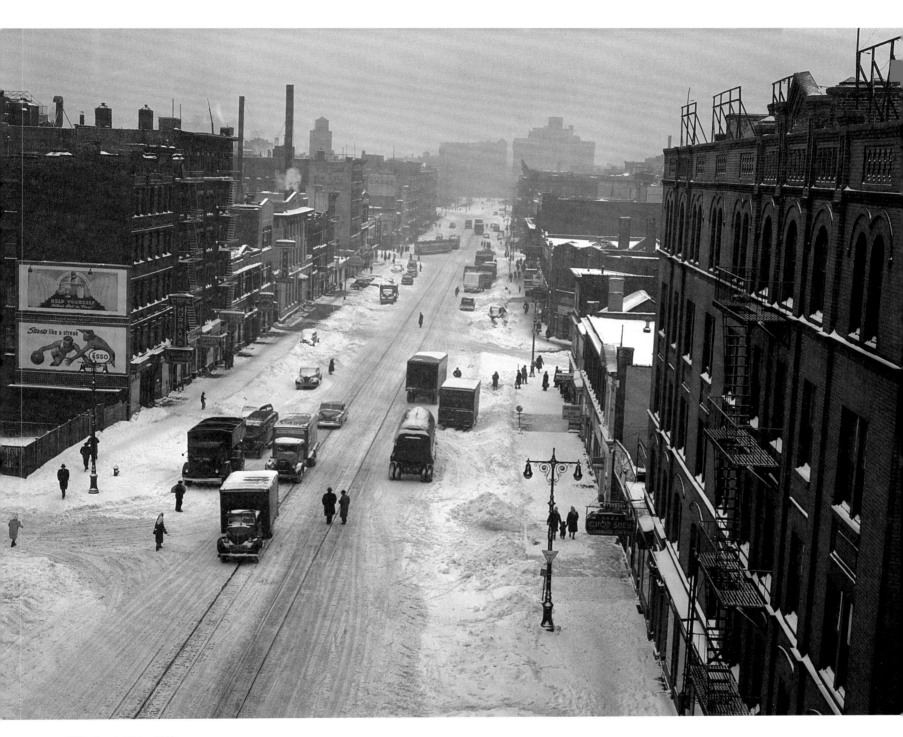

125th Street, Winter 1946

Slum Clearance, Harlem, 1946

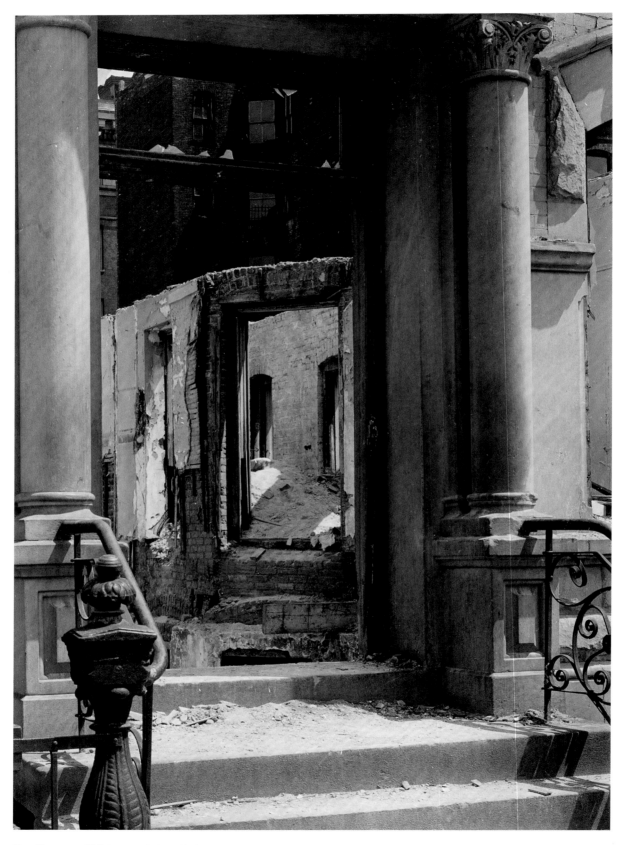

Slum Clearance, Fifth Avenue, Harlem, 1946

OPPOSITE:
Slum Clearance, Harlem, 1946

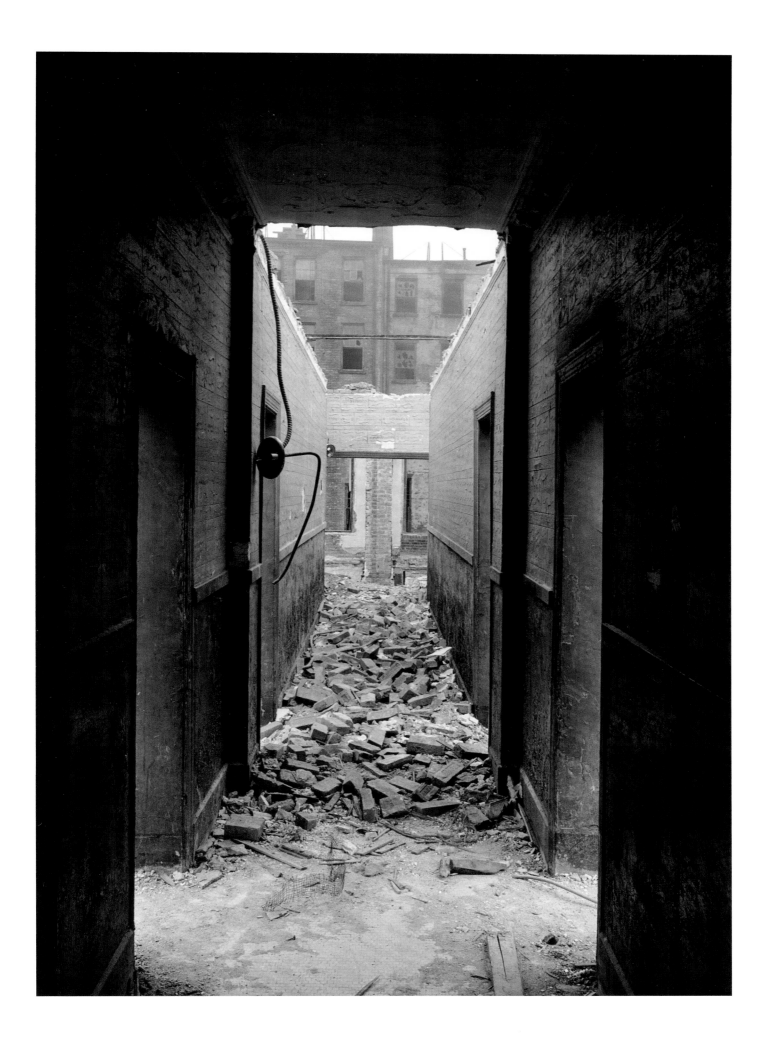

Harlem, 1946

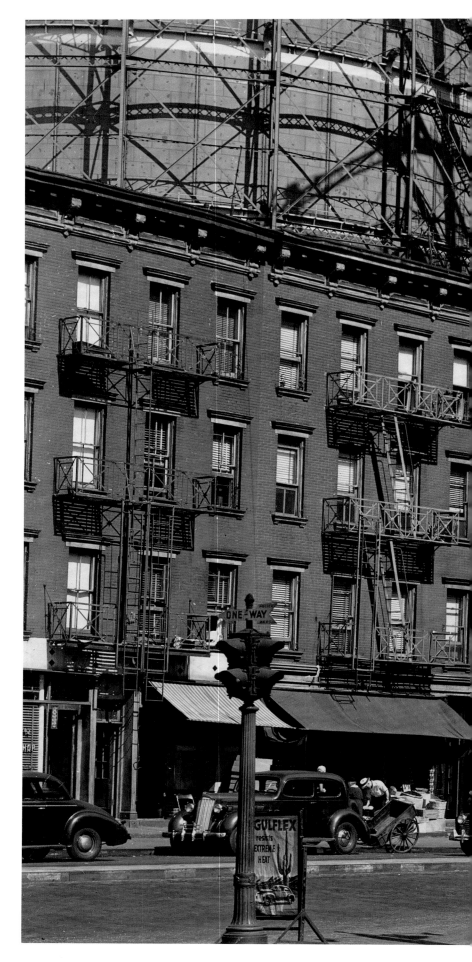

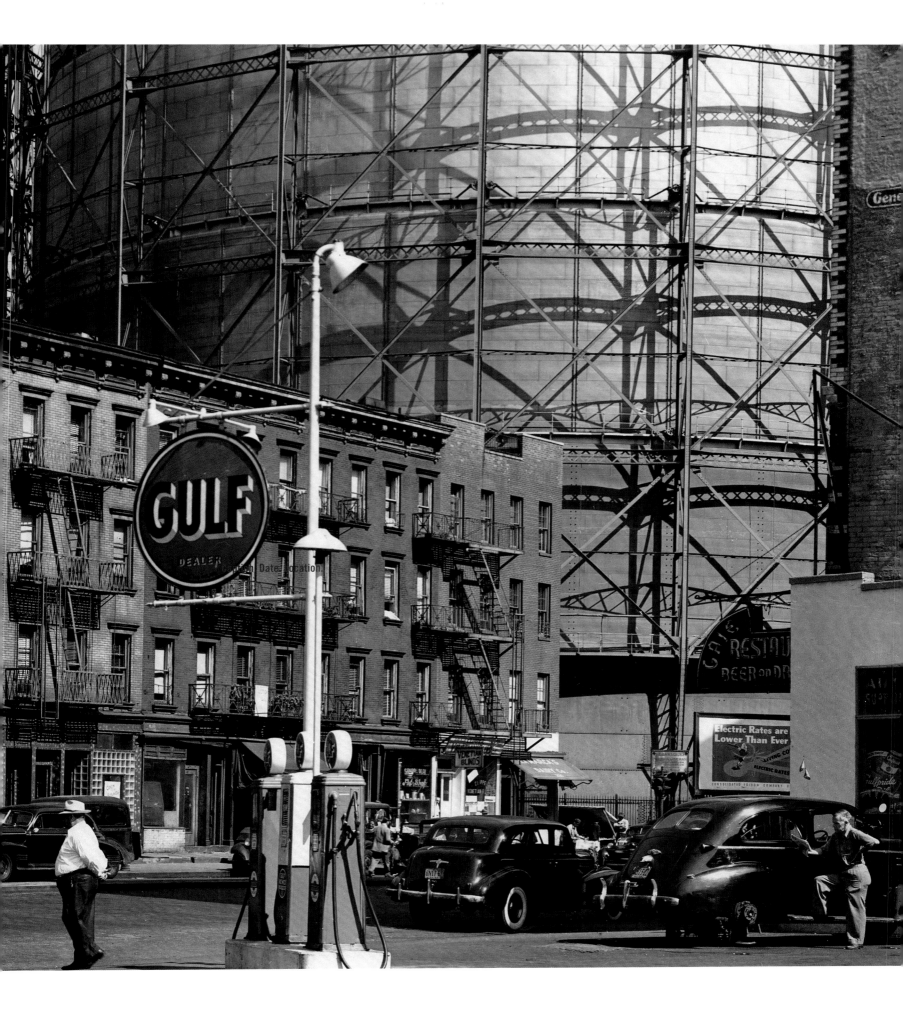

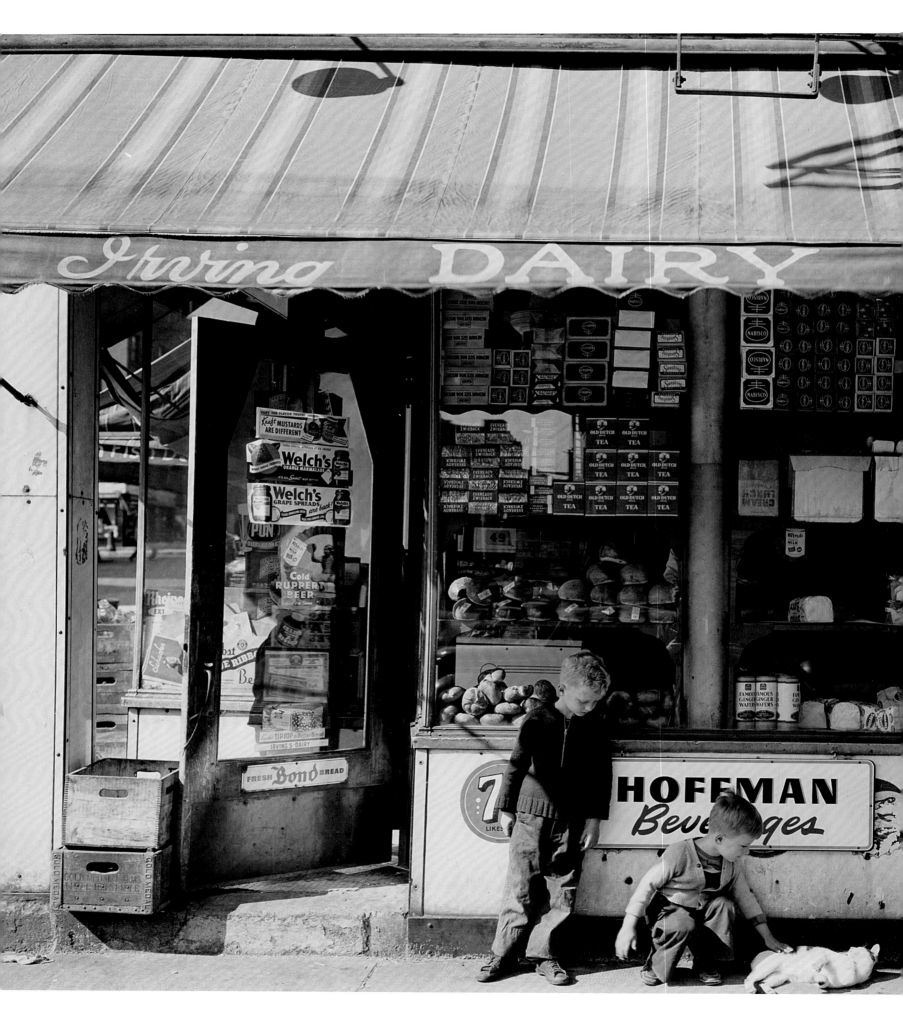

Amsterdam Avenue near 125th Street, 1946

46th Street, 1946

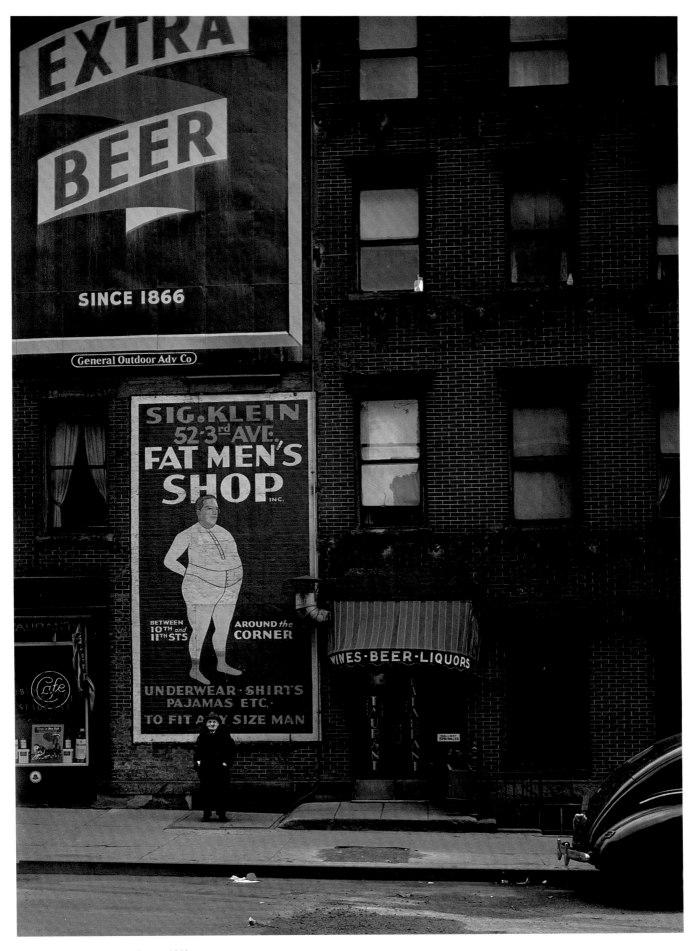

Near Third Avenue and 10th Street, 1946

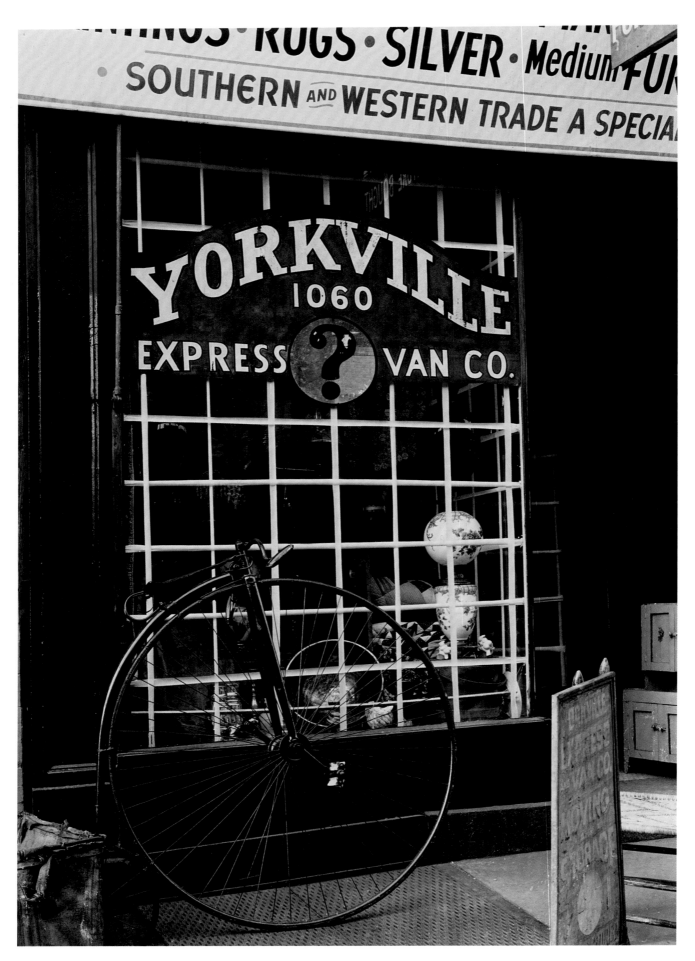

Third Avenue, Yorkville, 1946

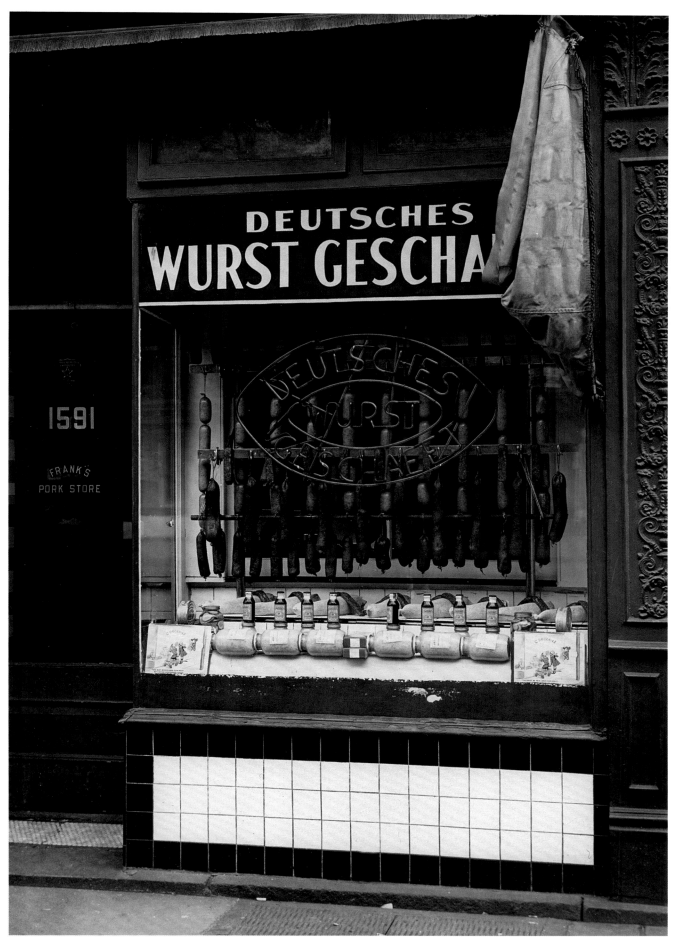

Third Avenue, Yorkville, 1946

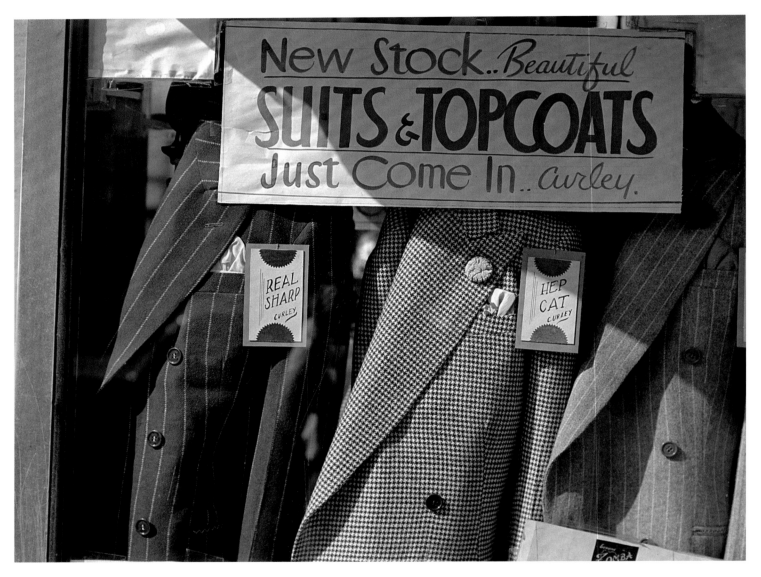

125th Street, 1946

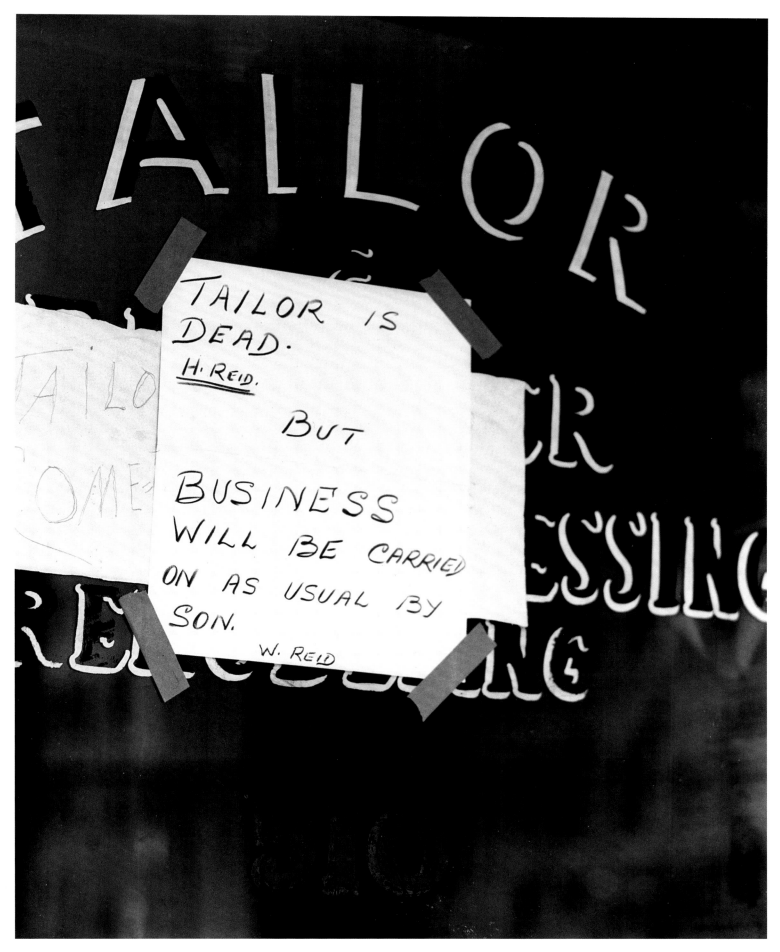

Amsterdam Avenue near 125th Street, Harlem, 1946

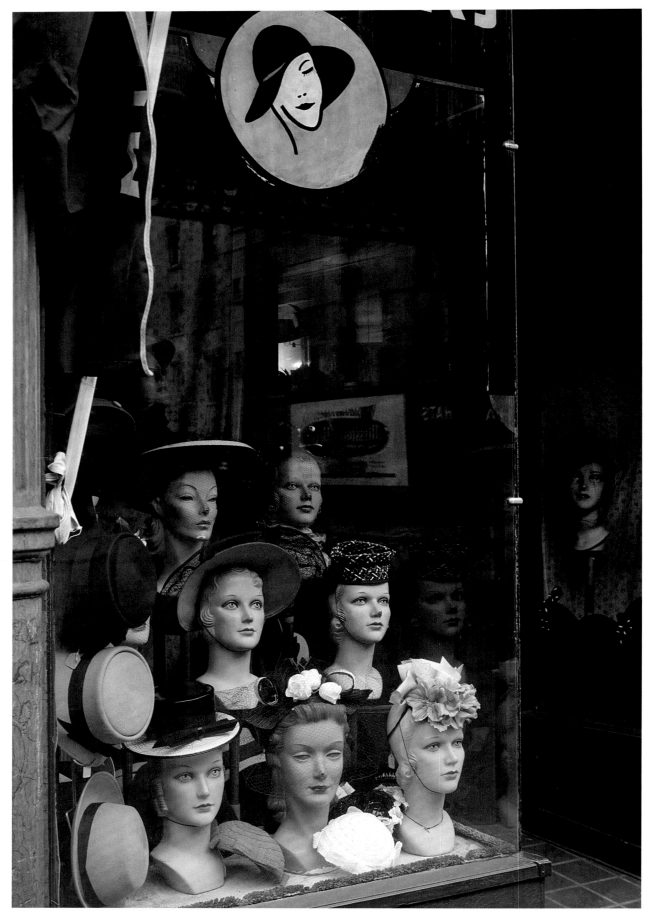

125th Street at Amsterdam Avenue, 1946

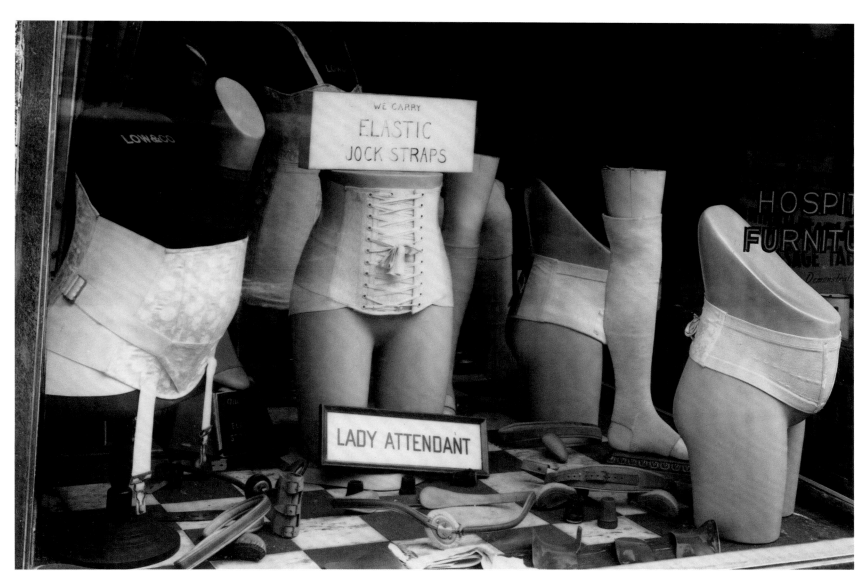

Third Avenue Corset Shop, 1946

Third Avenue Poster, 1946

OPPOSITE:
Third Avenue, 1946

Third Avenue Billboard, 1946

Harlem (I Love a Mystery), 1946

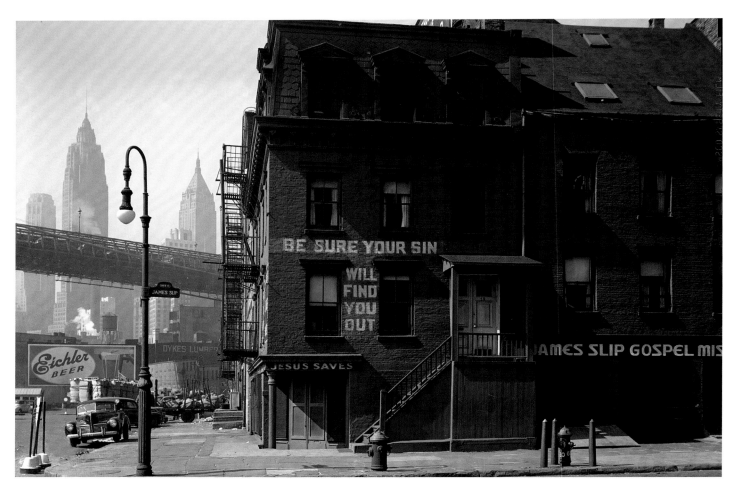

James Slip Gospel Mission at South Street, 1946

OPPOSITE:
125th Street, 1946

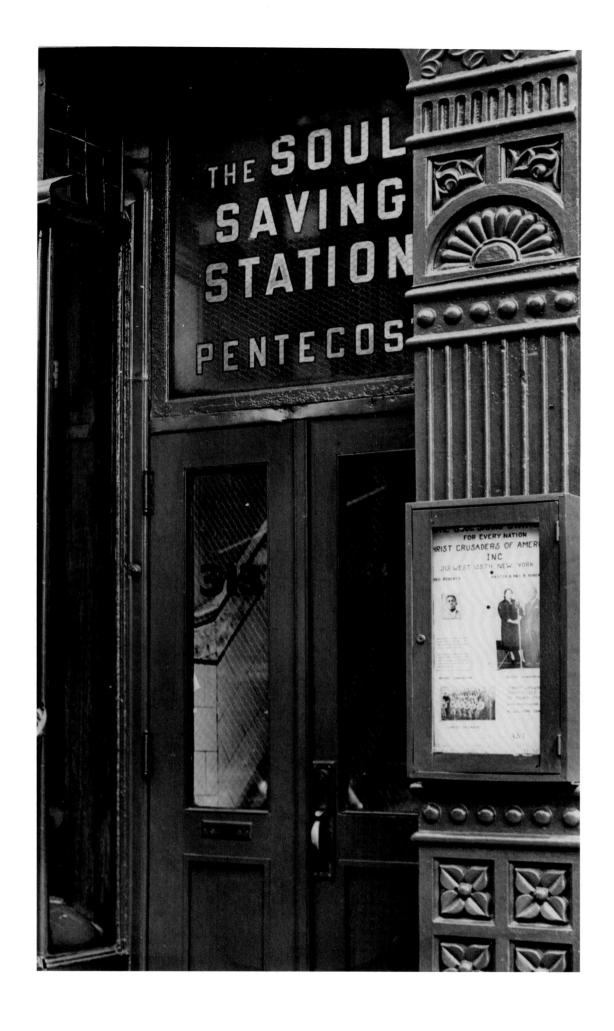

Times Square, 1946

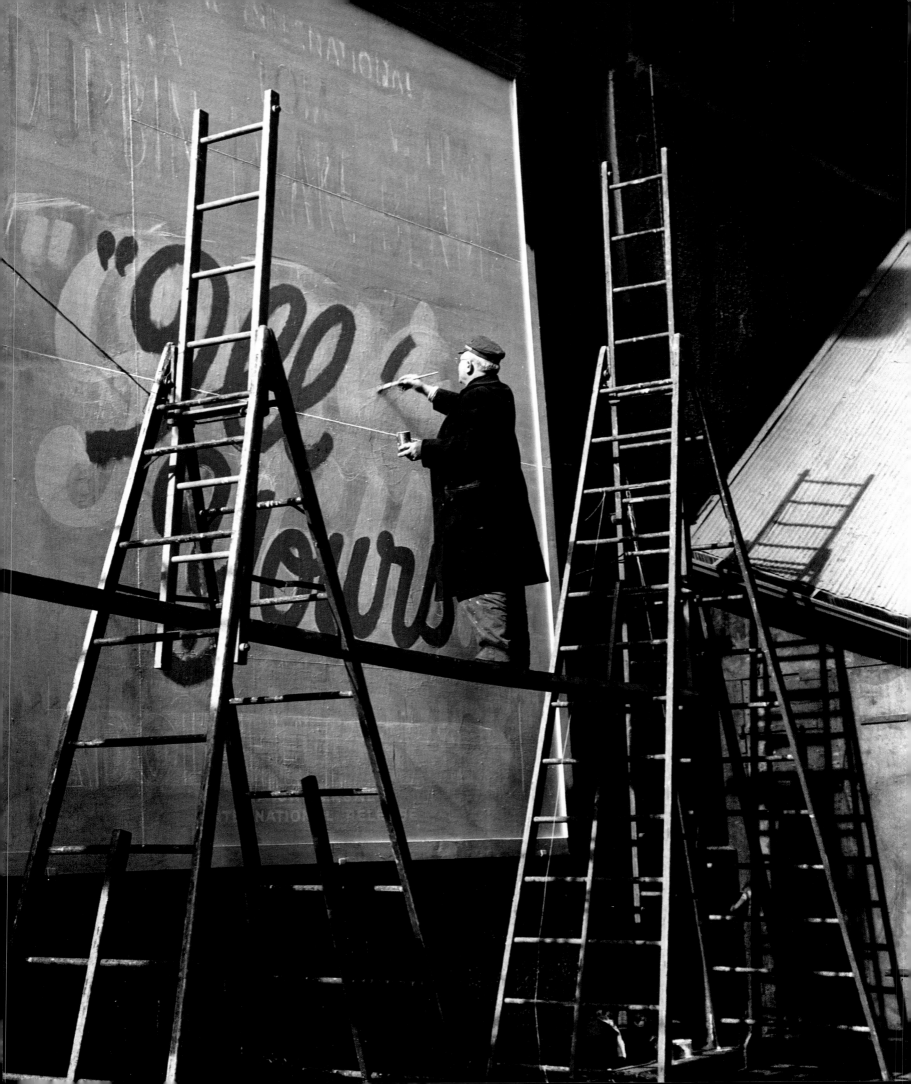

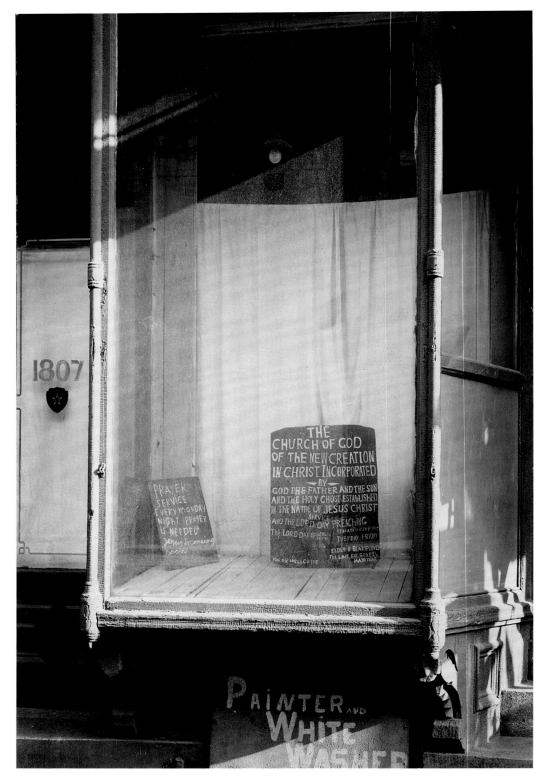

Church in Store, Third Avenue, 1945

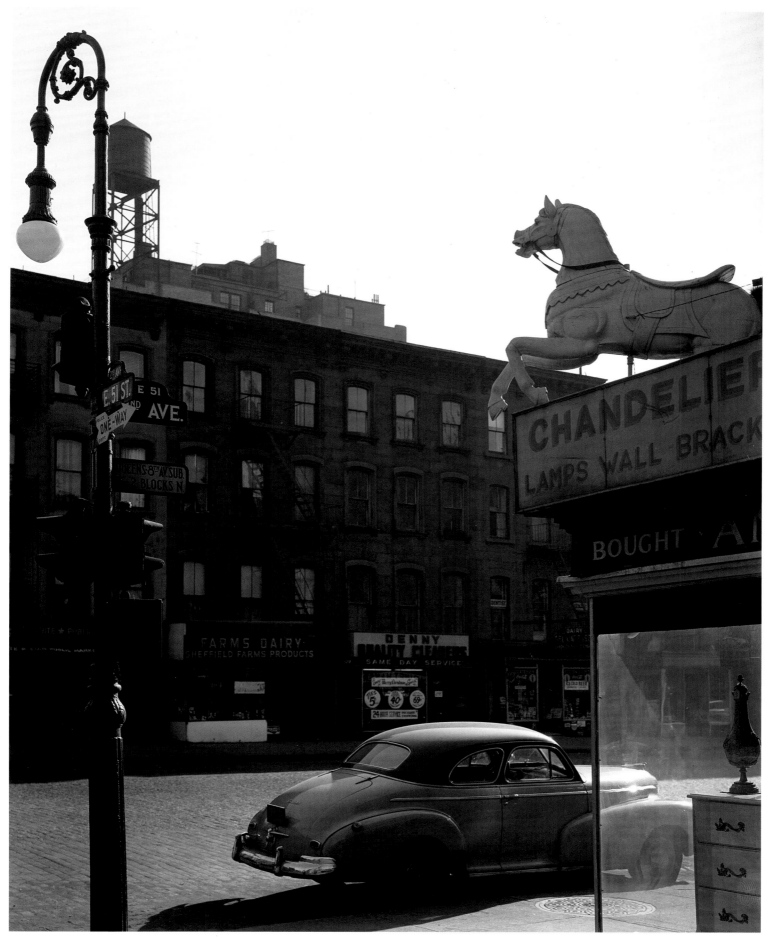

Second Avenue at 51st Street, 1946

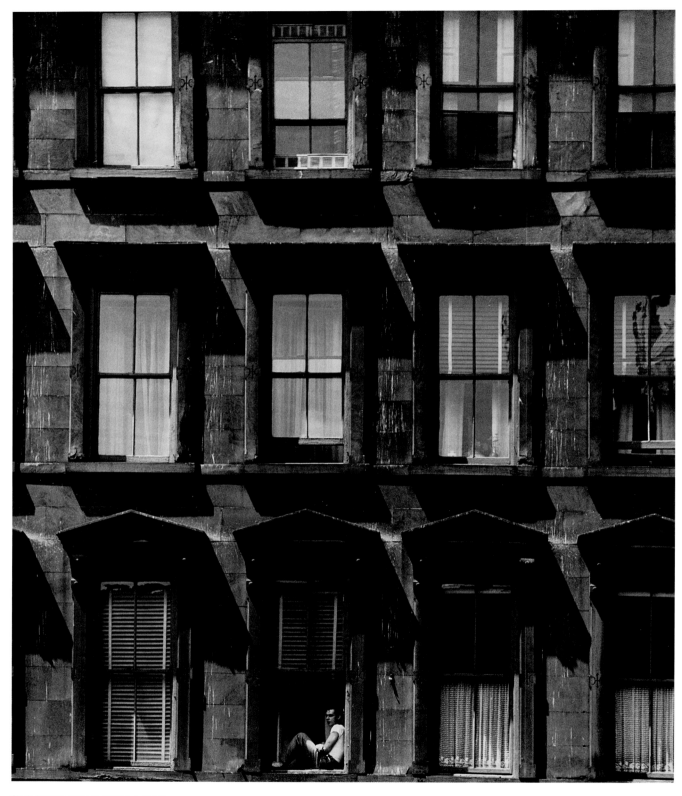

Sixth Avenue (Man in Window), 1946

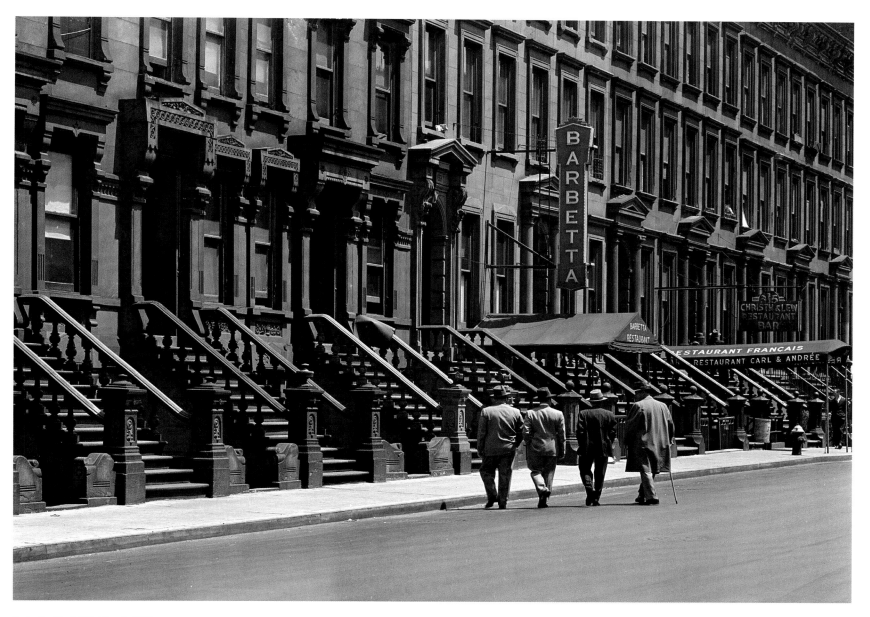

Barbetta, West 46th Street, 1946

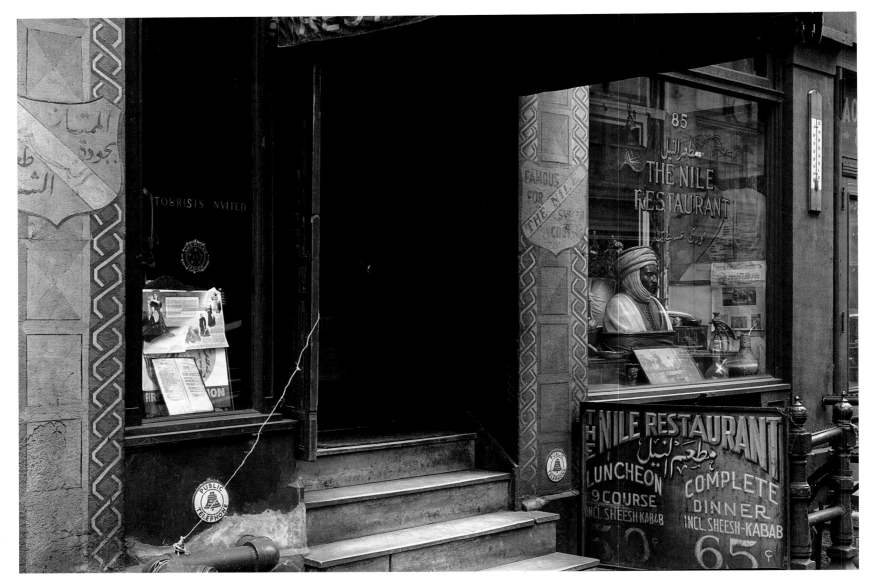

Varick Street, 1946

OPPOSITE:
Caffe Reggio, Greenwich Village, 1946

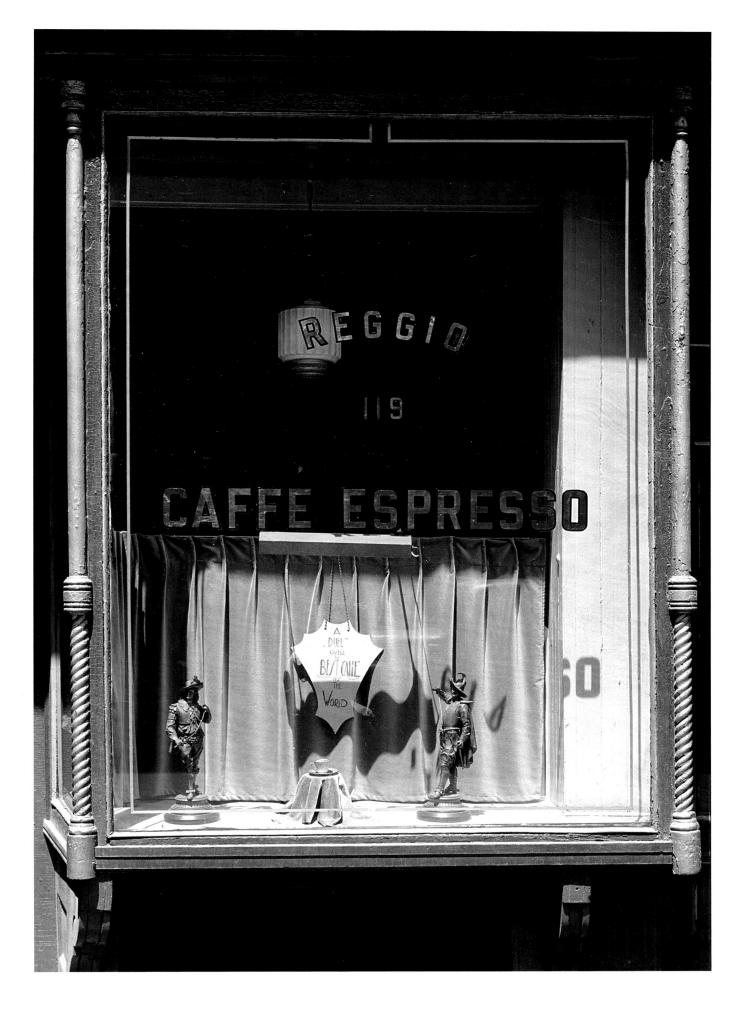

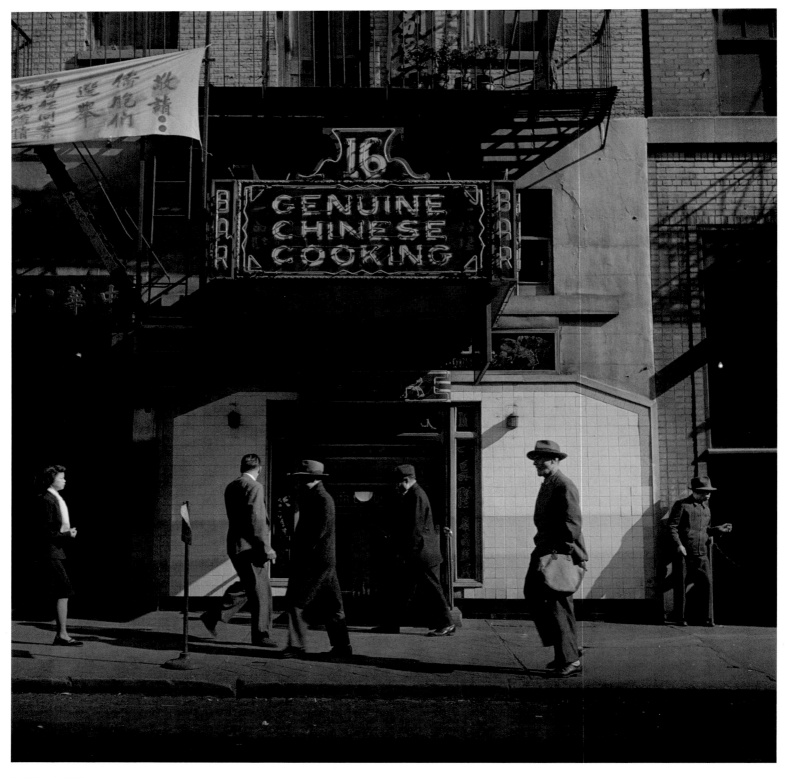

Mott Street, 1946

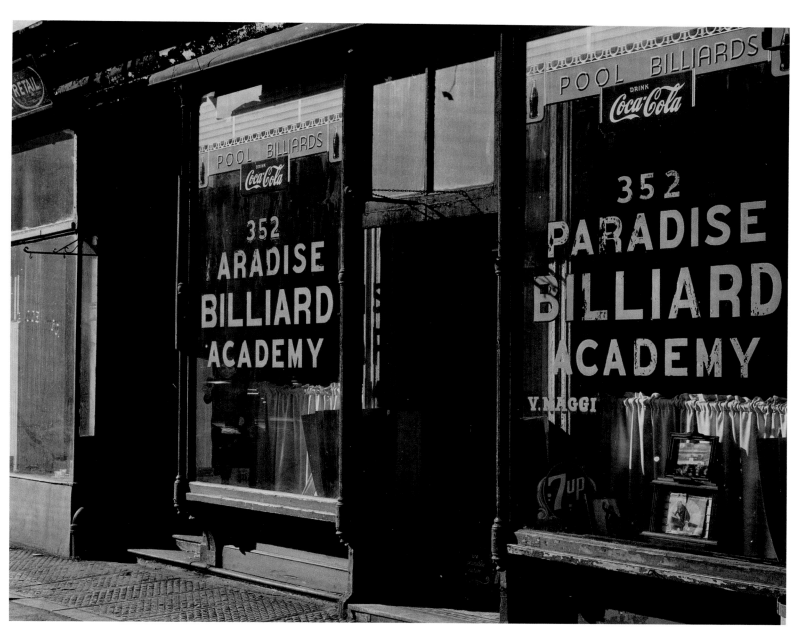

Third Avenue (Paradise Billiard Academy), 1946

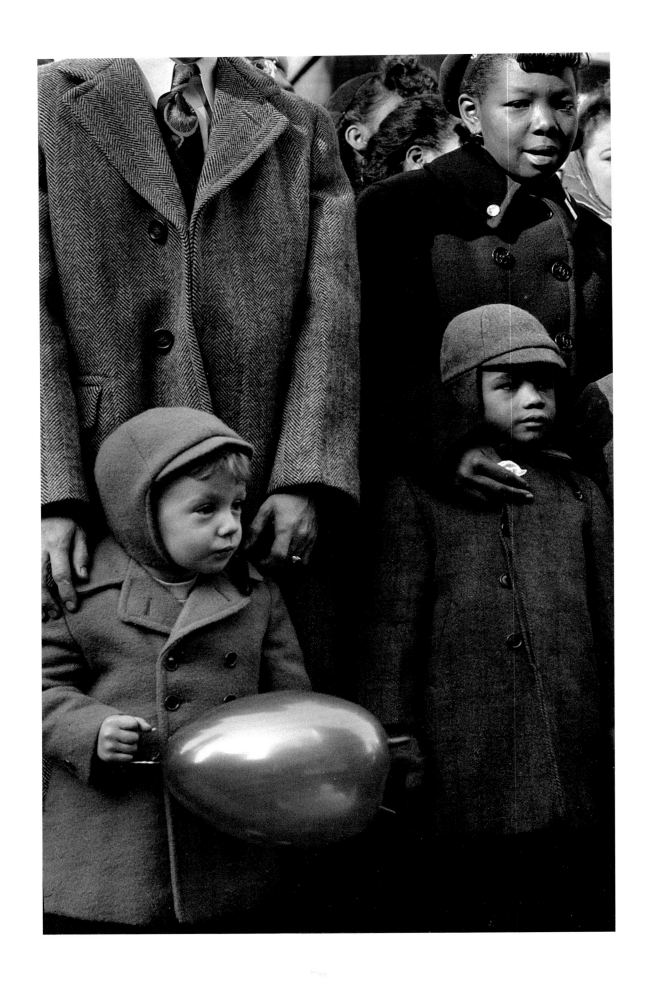

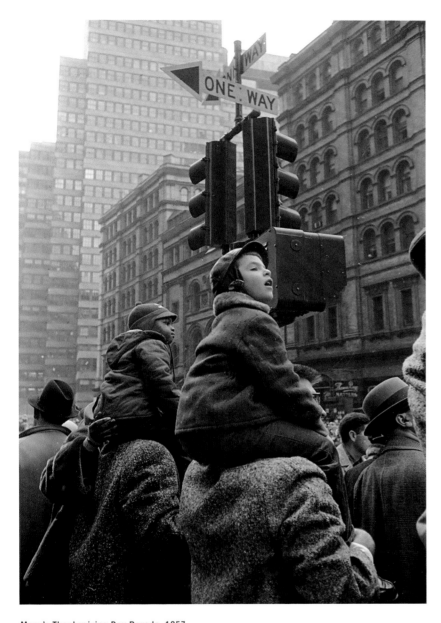

Macy's Thanksgiving Day Parade, 1957

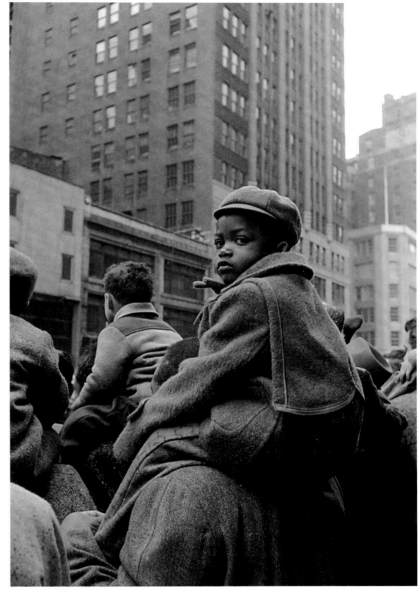

OPPOSITE:
Macy's Thanksgiving Day Parade, 1946

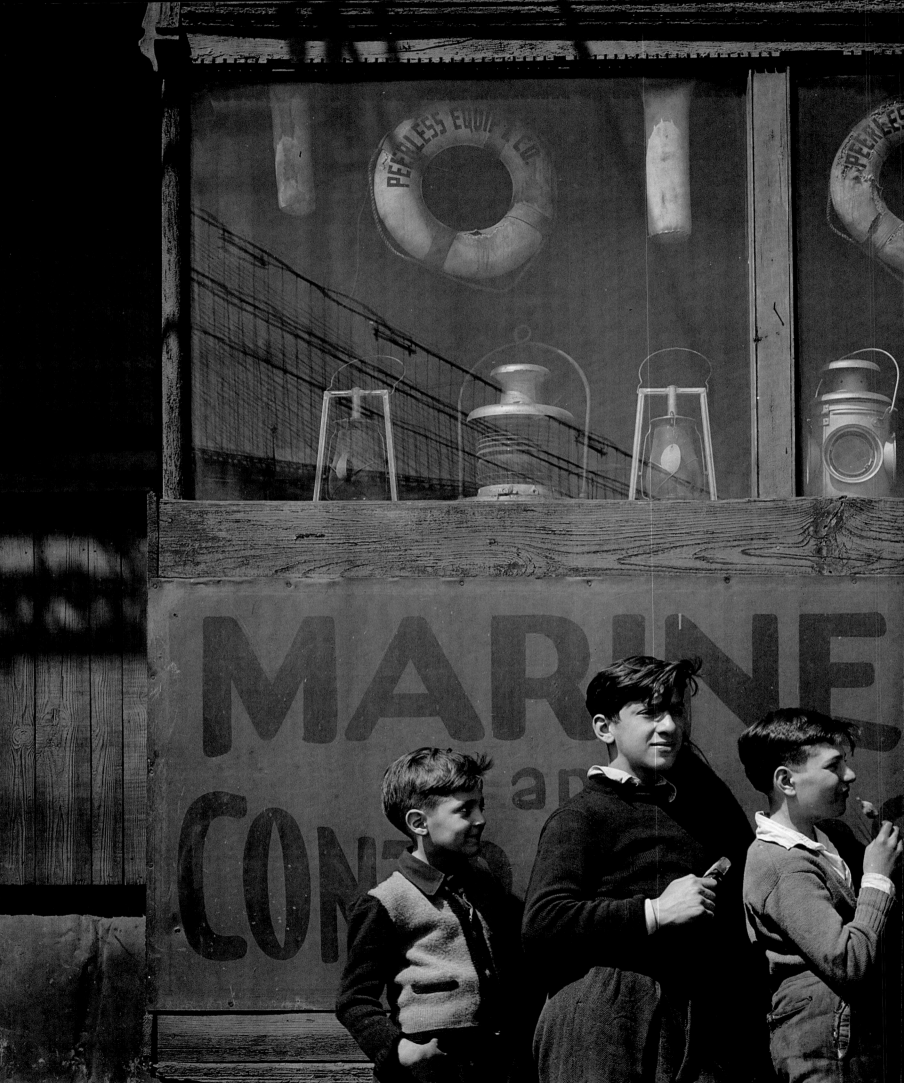

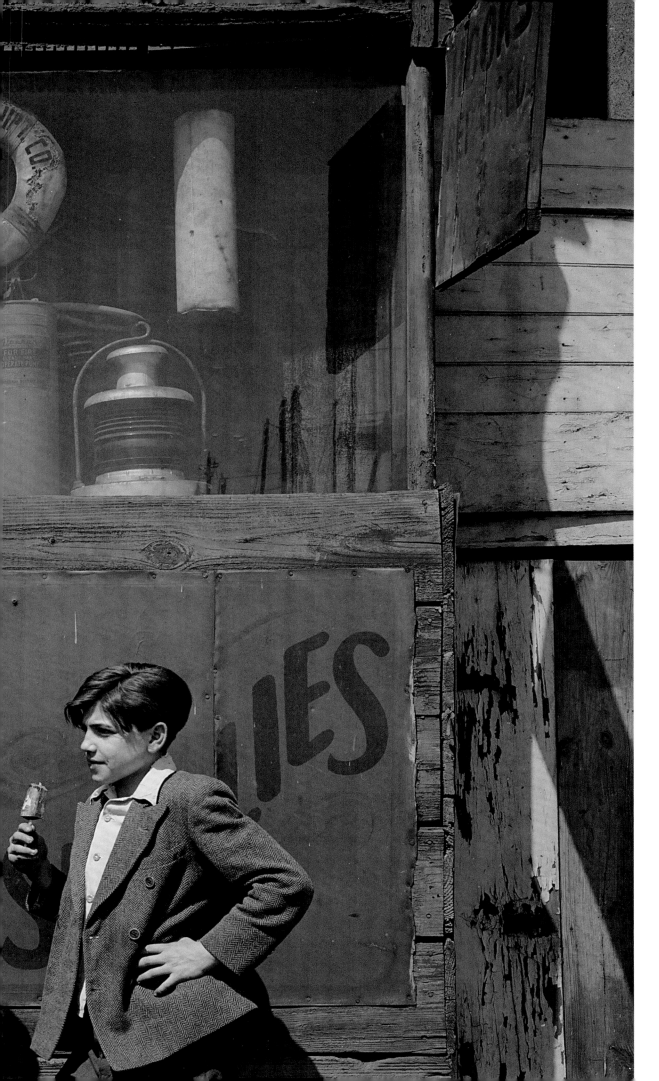

Near Fulton Fish Market, 1946

Times Square, 1946

Times Square, 1957

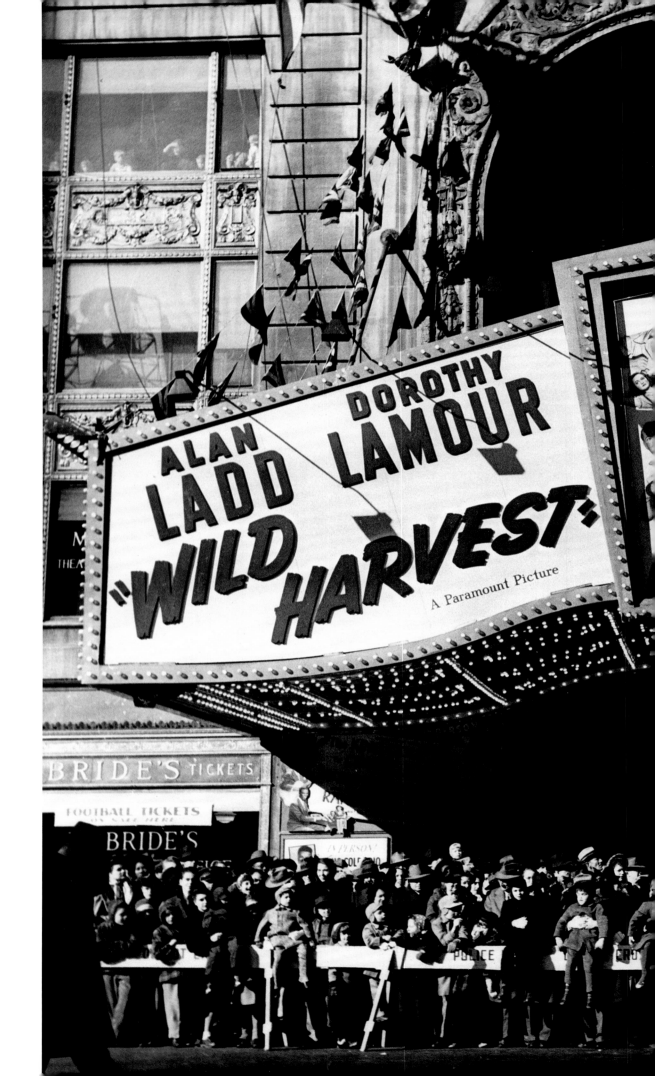

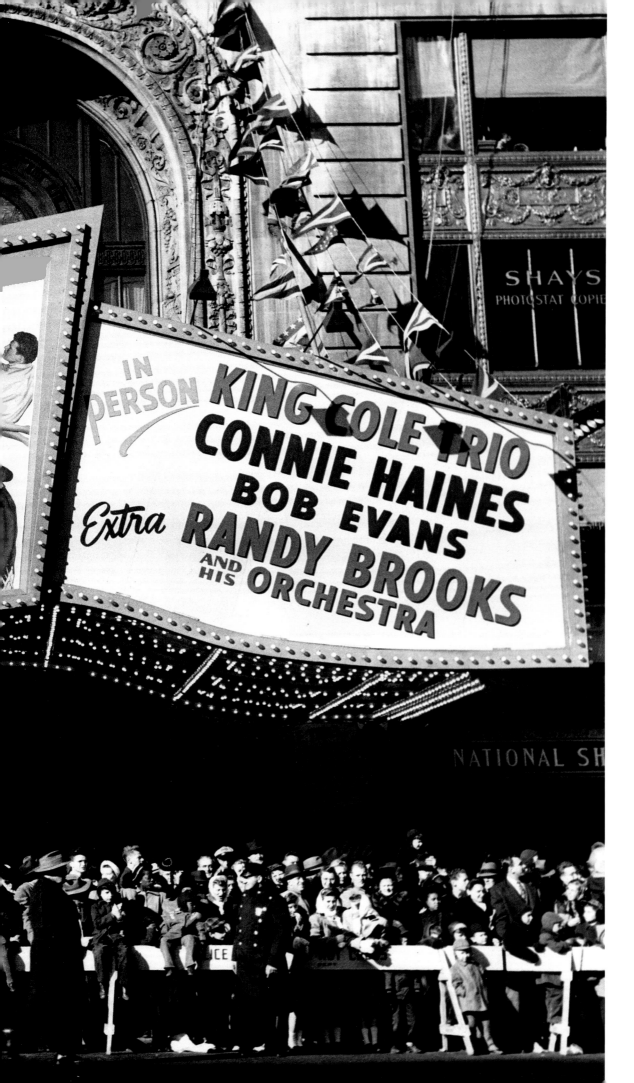

Waiting for the Macy's Thanksgiving Day Parade,
Times Square (Paramount Theatre), 1947

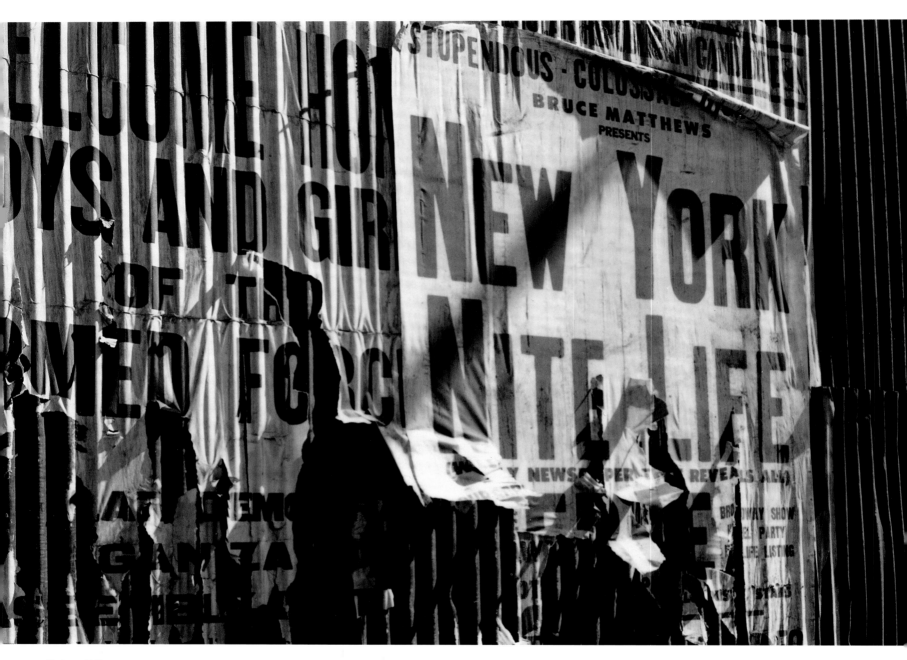

Harlem, 1946

Downtown, 1957

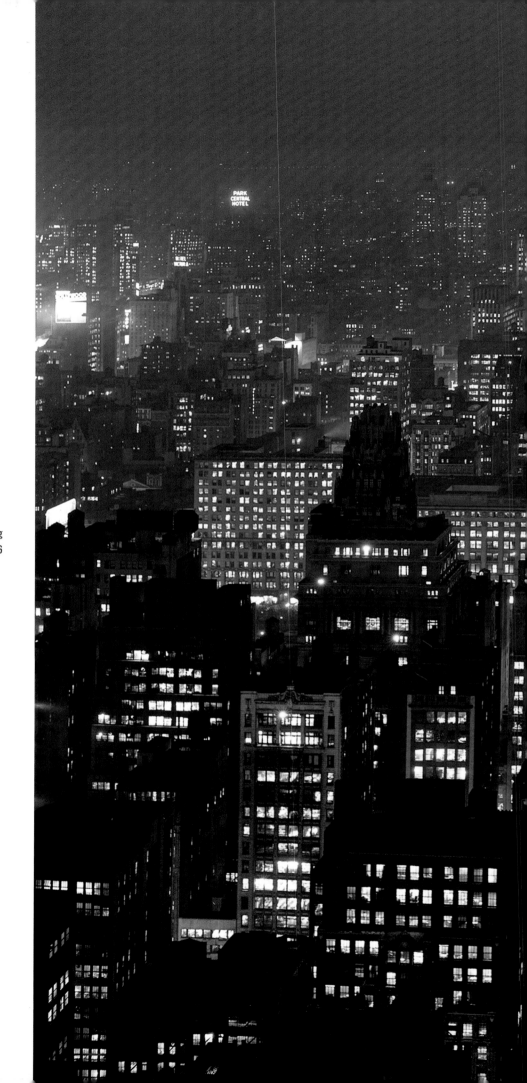

From the Empire State Building
Looking South, 1946

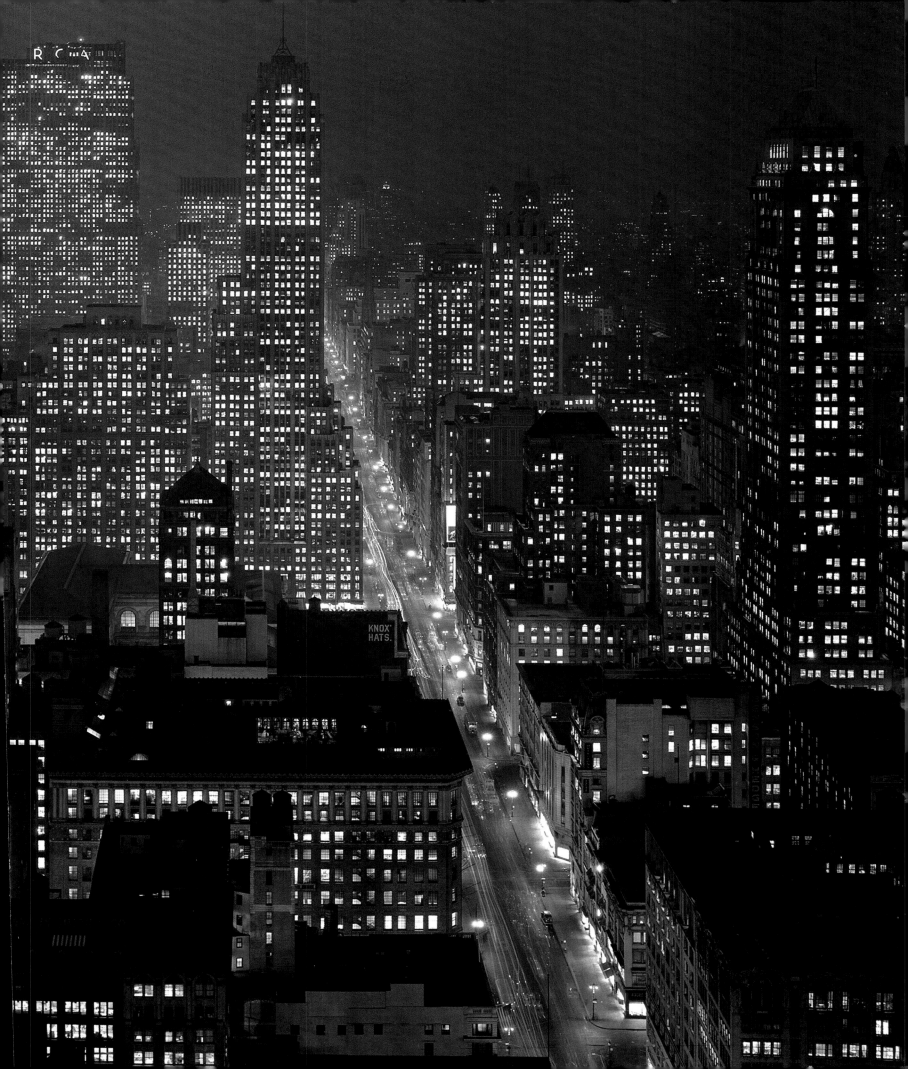

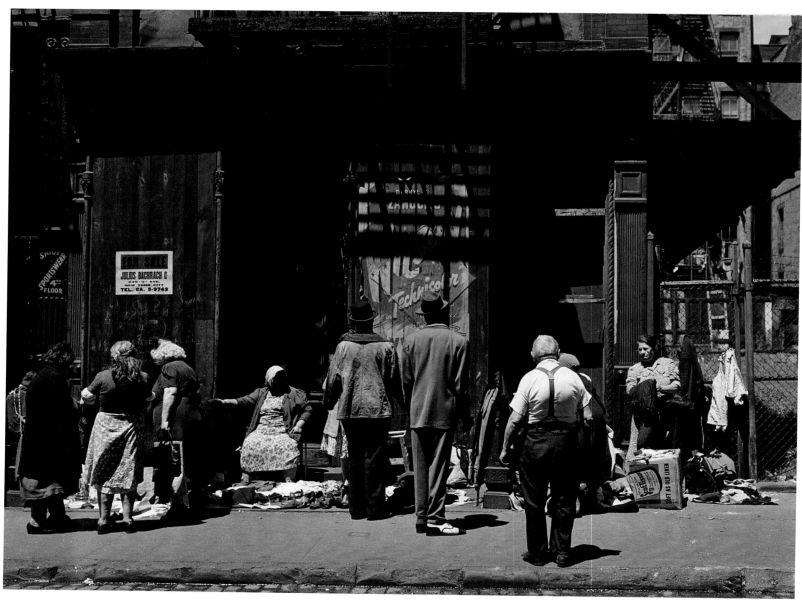

Old Clothes Market, Suffolk Street, 1946

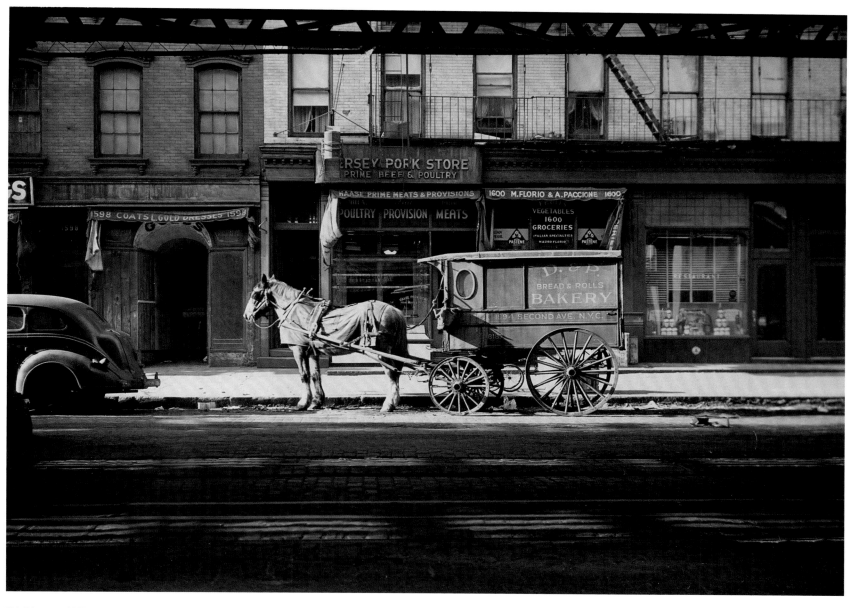

Third Avenue, 1945

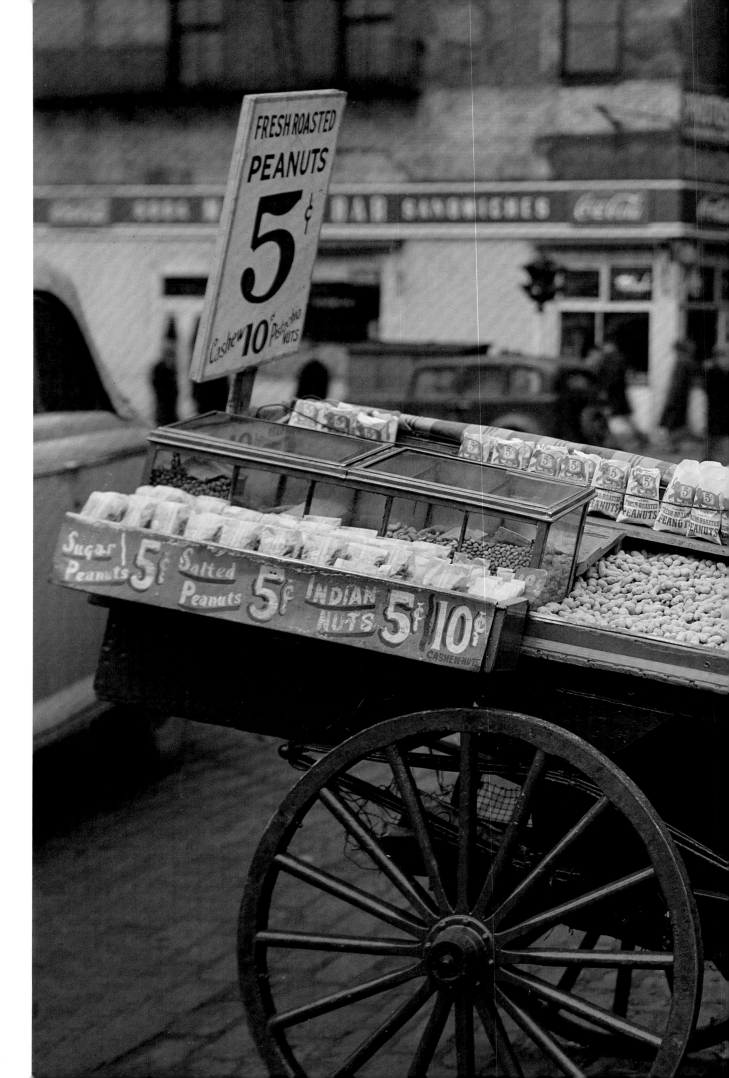

The Battery, 1945

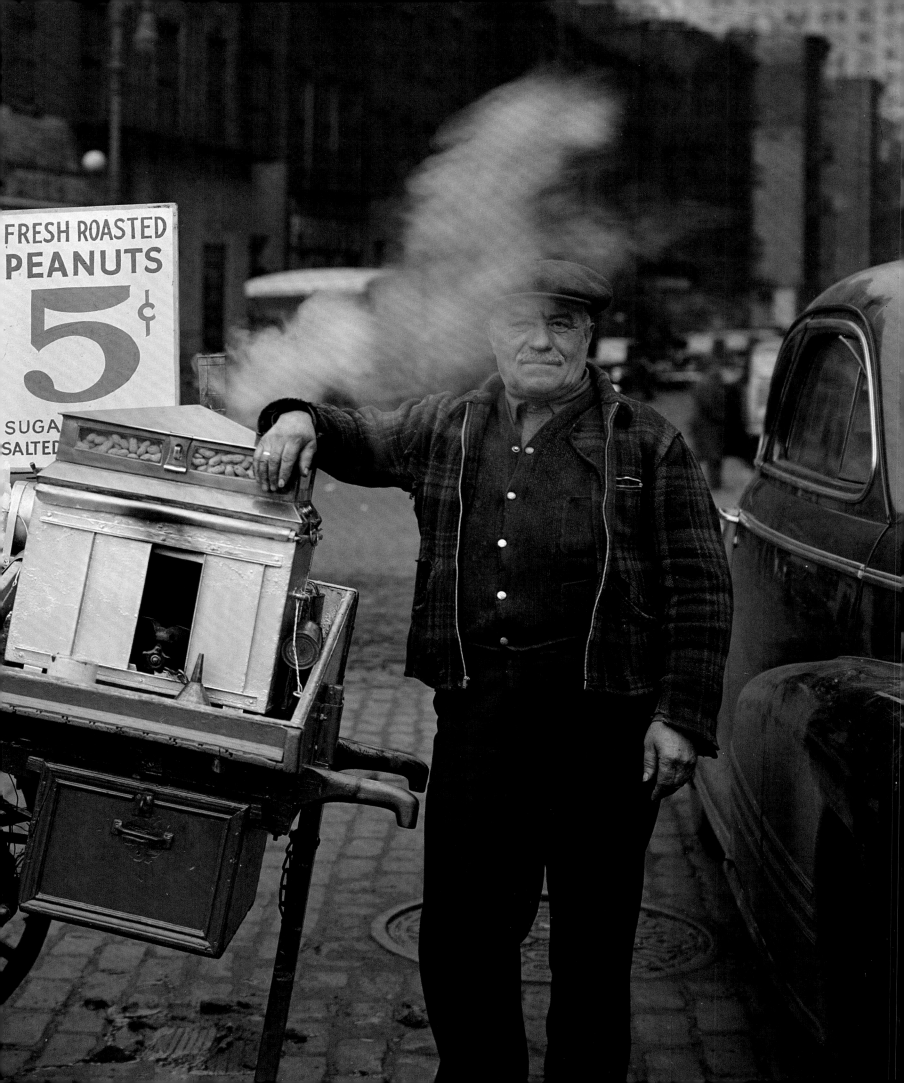

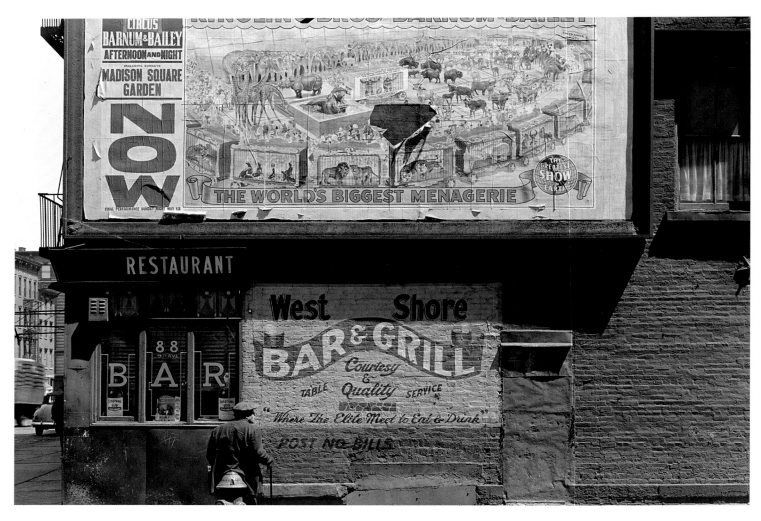

New York, 1946

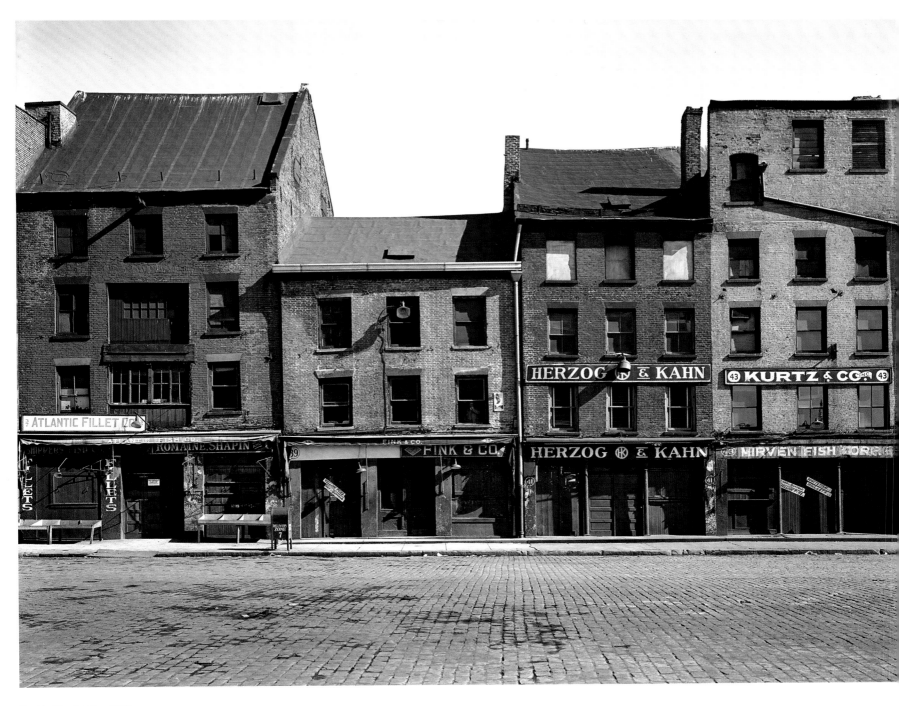

Peck's Slip, October 1946

Sixth Avenue South, August 1946

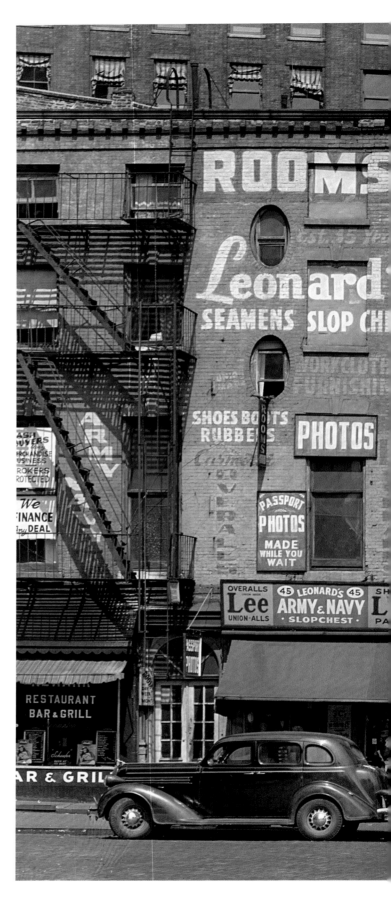

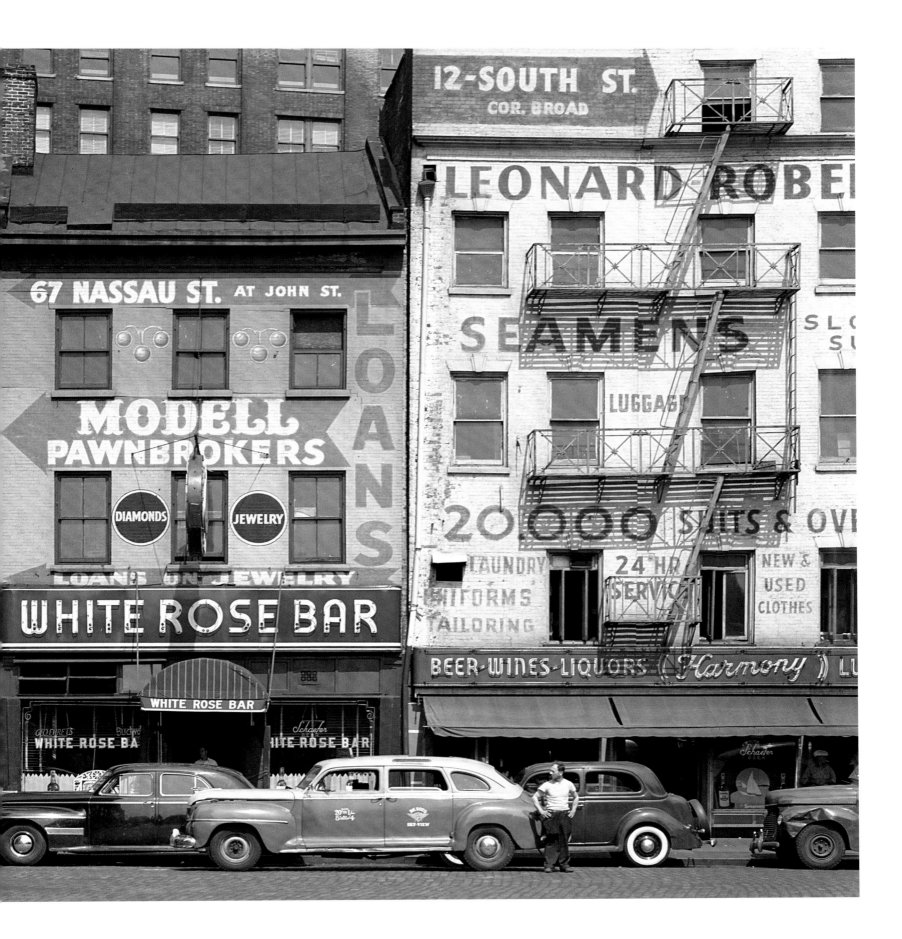

Centre Street at Leonard Street, 1948

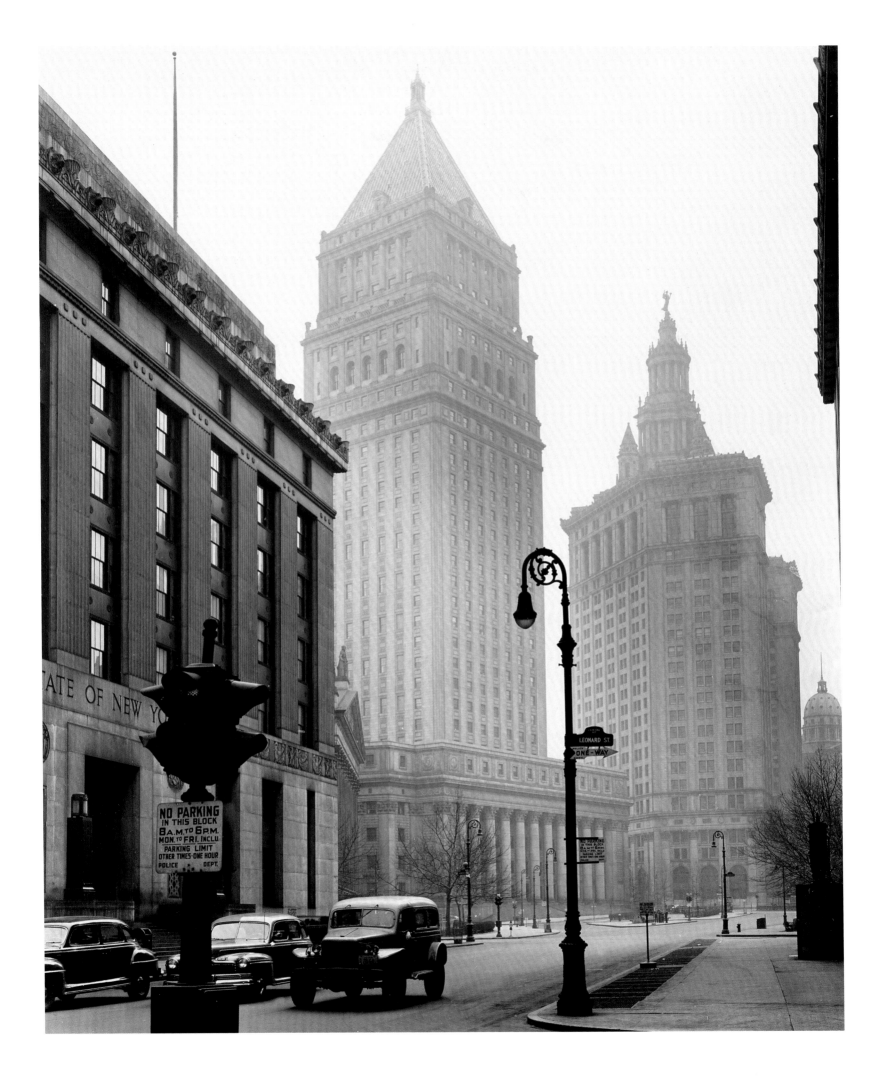

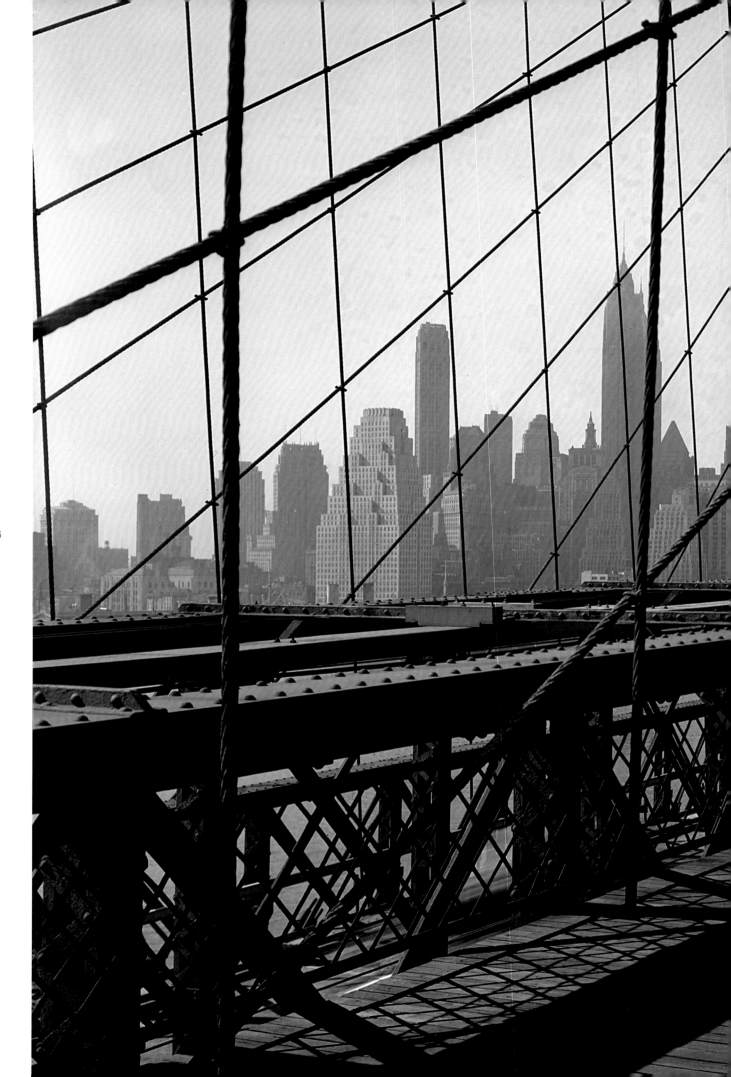

Brooklyn Bridge, 1946

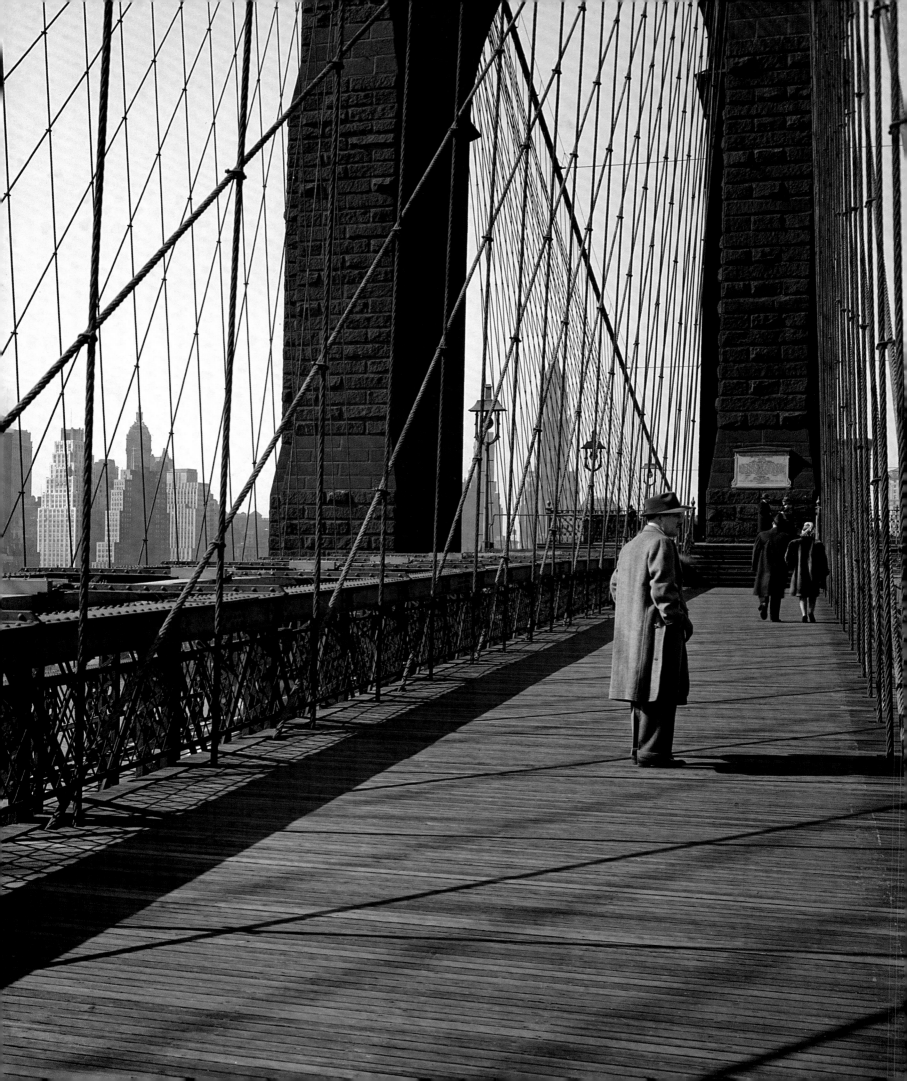

From the Brooklyn Bridge Ramp, 1946

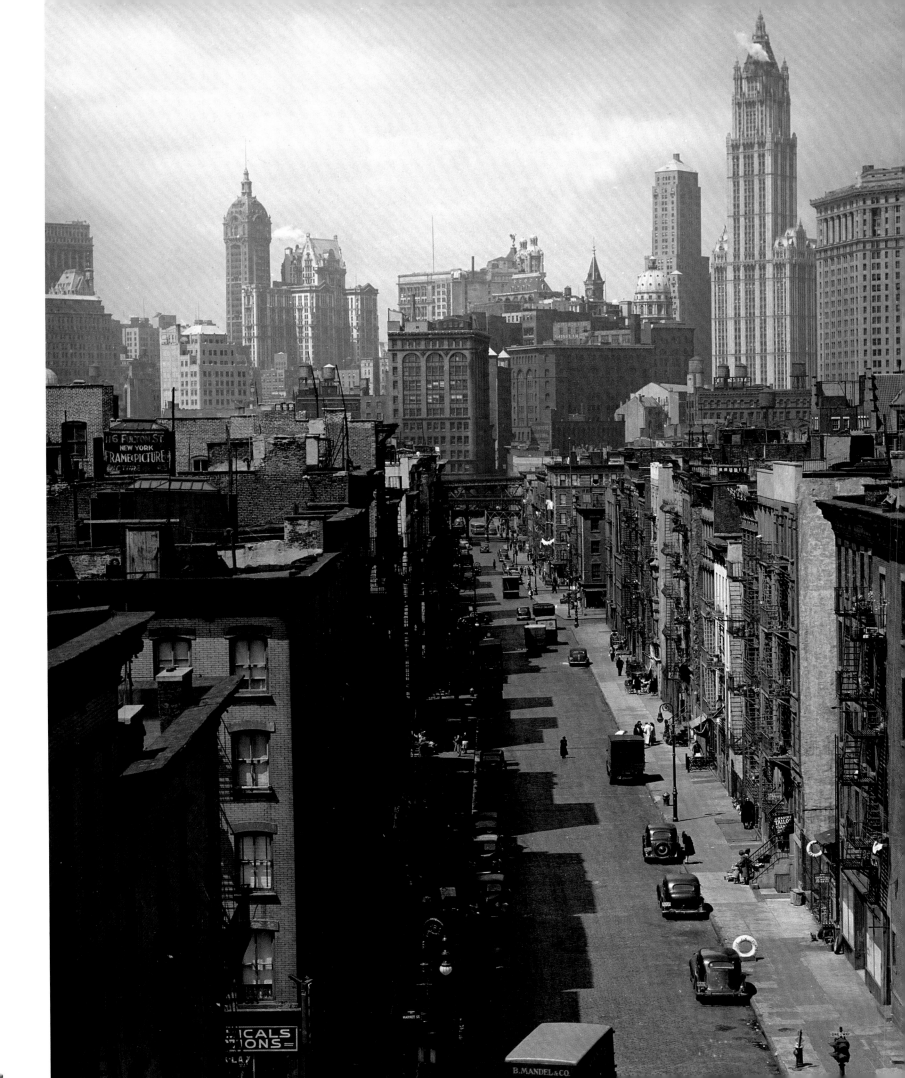

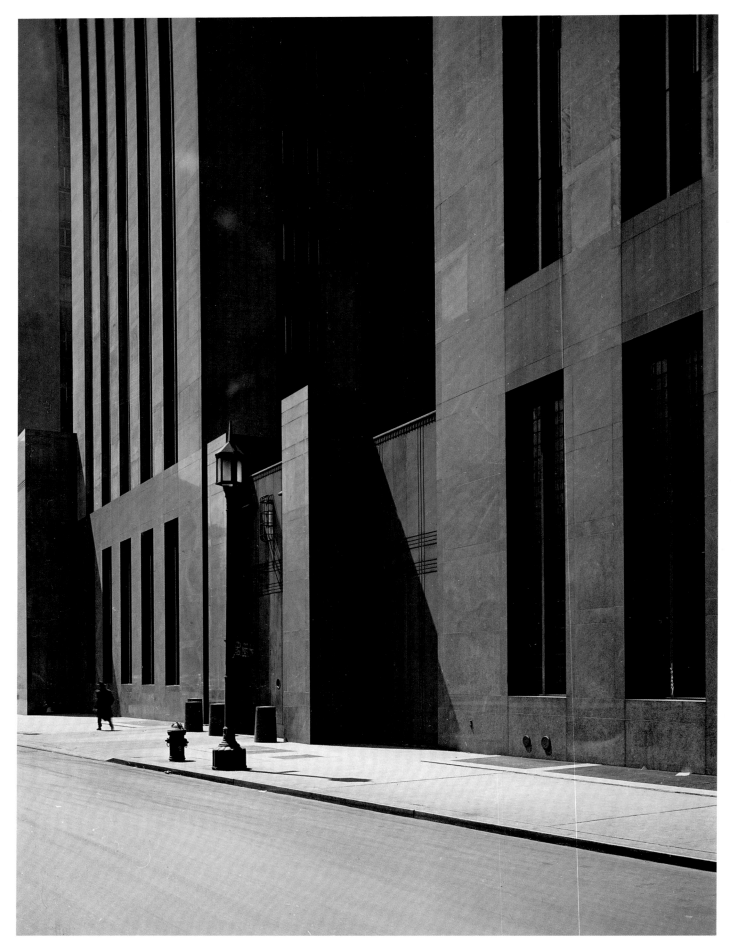

The New Tombs (100 Centre Street), 1946

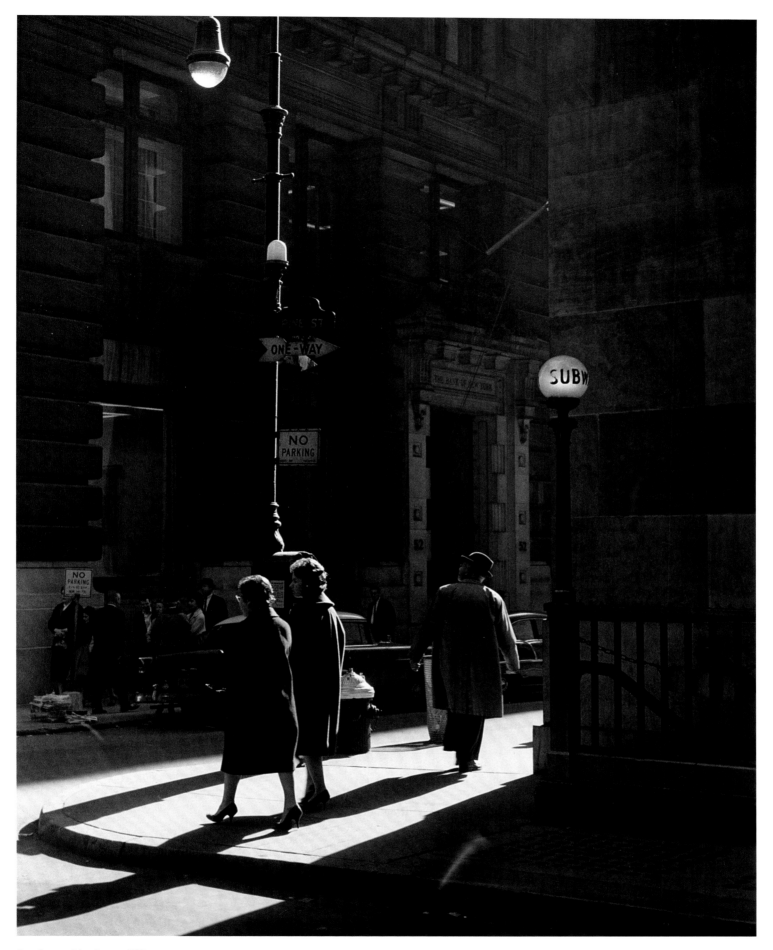

Broadway at Pine Street, 1959

From the Empire State Building
Looking South, 1946

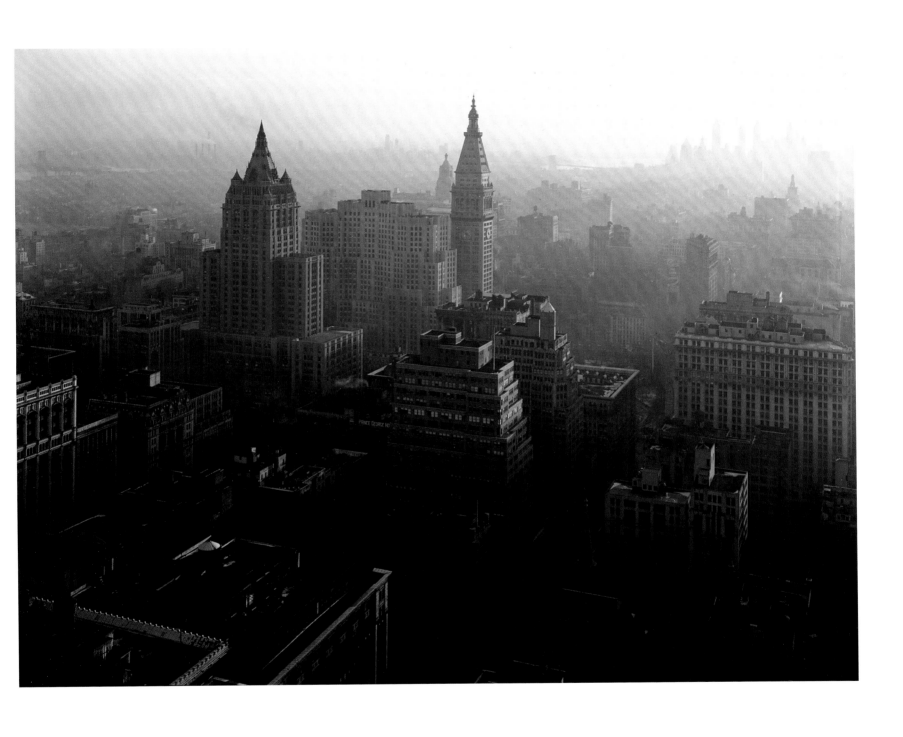

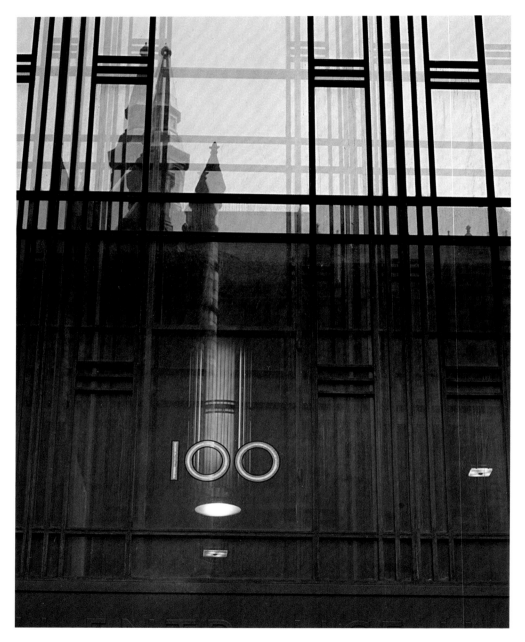

"Number" series, New York, 1946

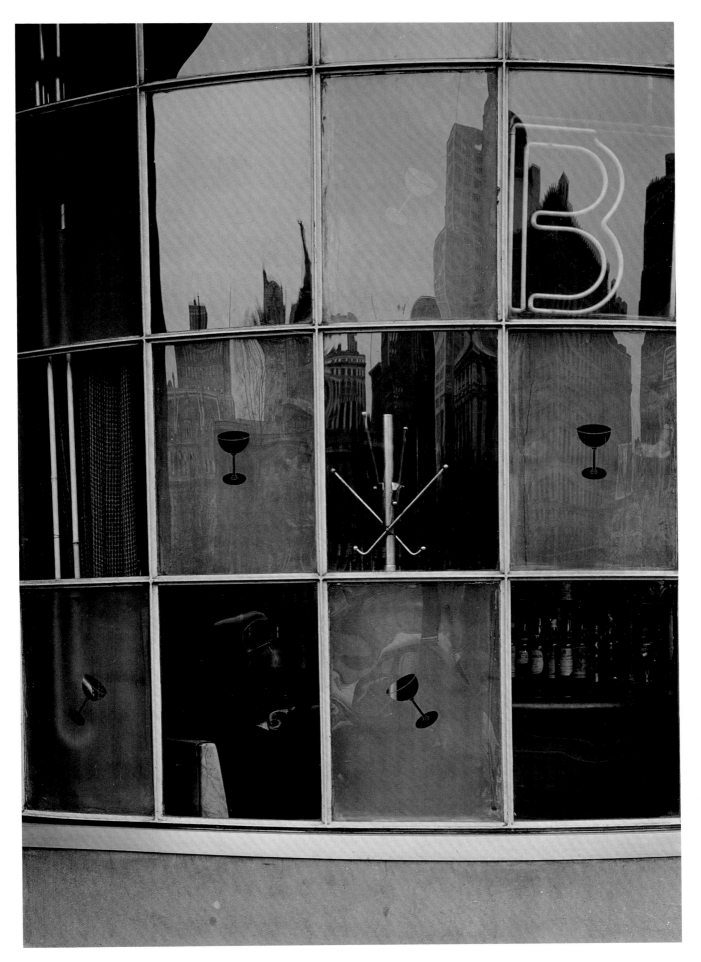

Park Row Window, 1946

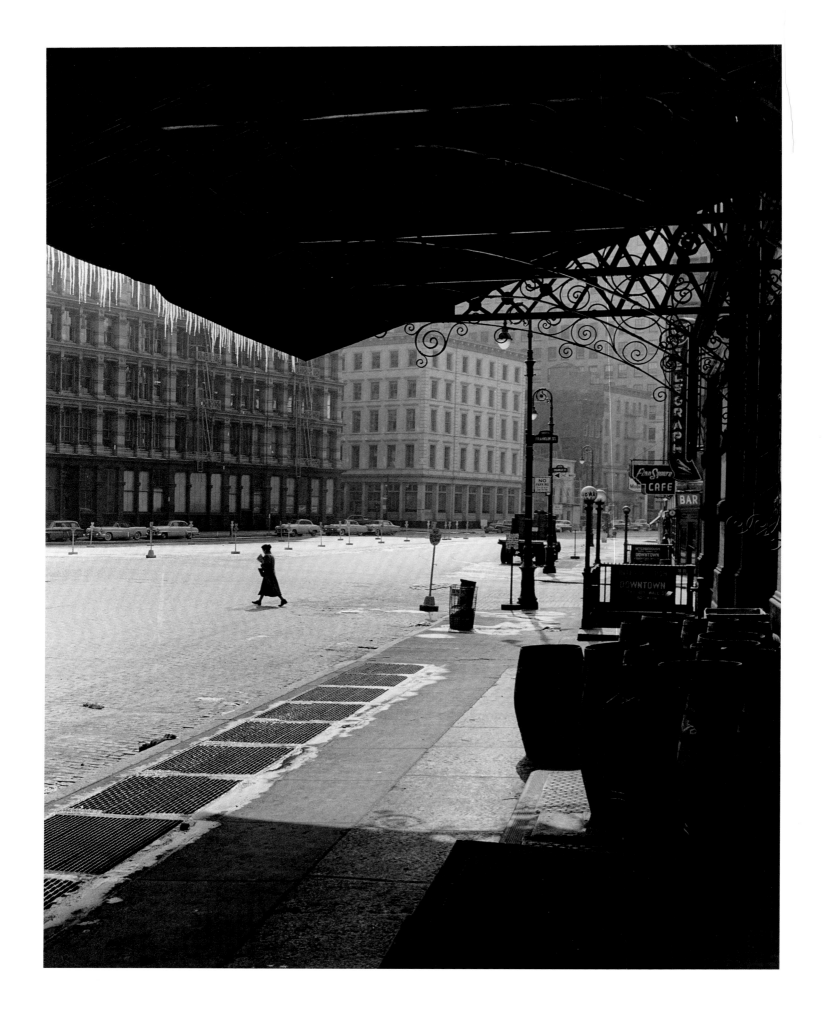

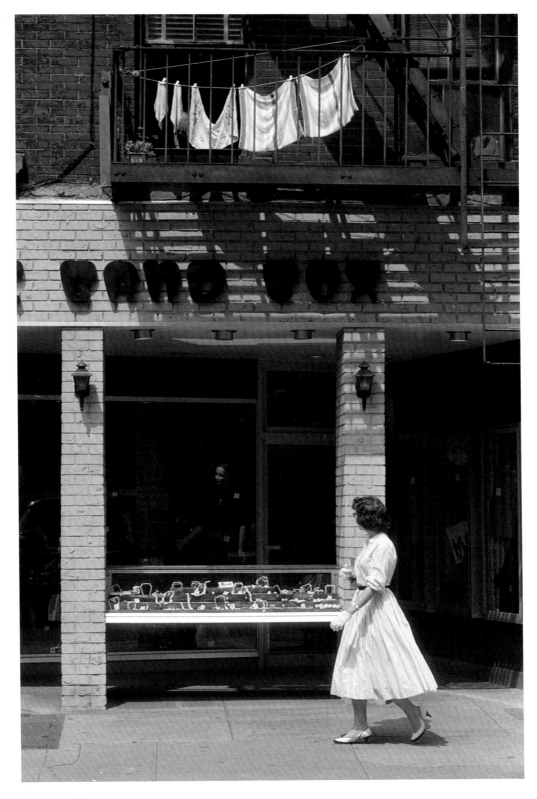

Downtown, 1959

OPPOSITE:
Quiet Day at the Pickle Factory,
Varick Street, 1959

FOLLOWING SPREAD:
New York Skyline, 1946

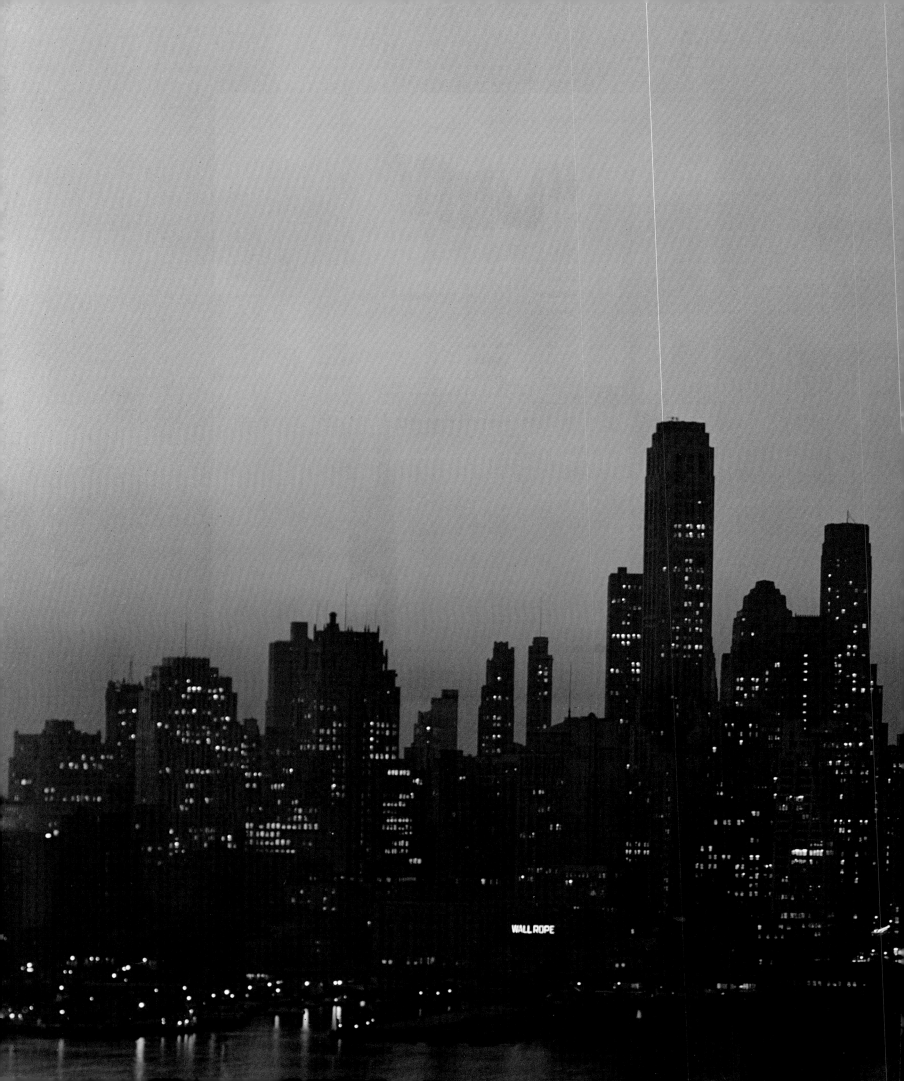

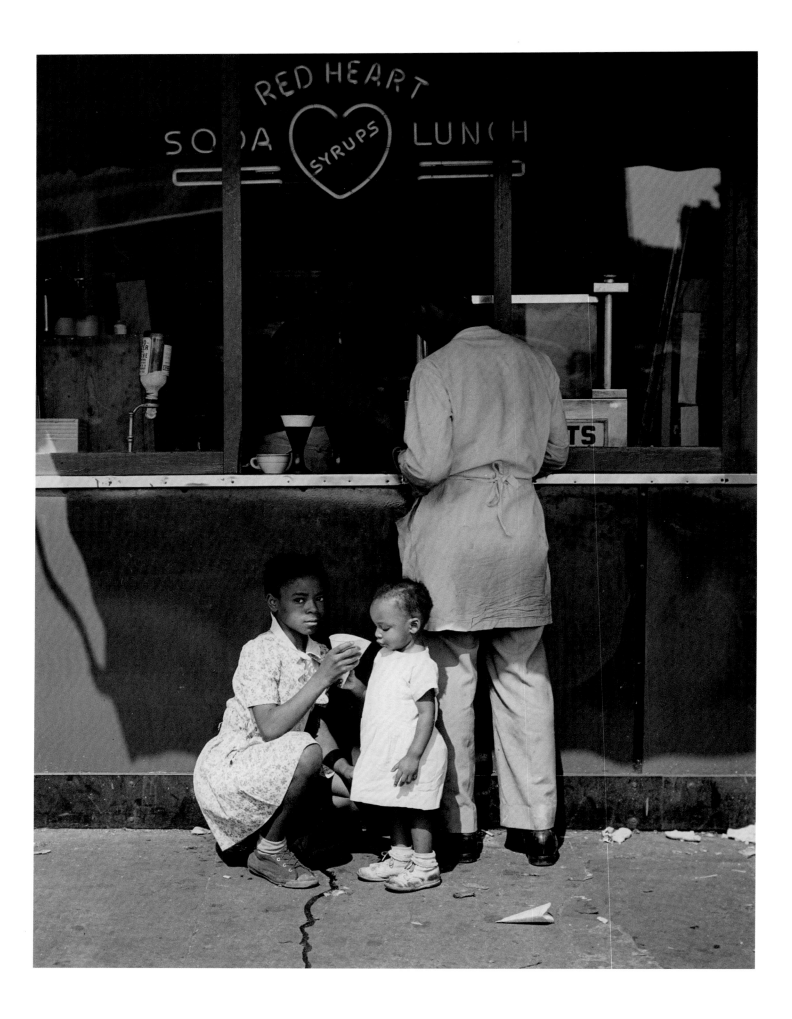

AFTERWORD

BETSY EVANS HUNT

TODD AND LUCILLE entered my gallery and my life in the fall of 1989. I had moved to Maine after having worked in a fine art photography gallery in San Francisco, for photographer Robert Mapplethorpe as studio manager, cataloging the collection at the Addison Gallery, studying American fine and decorative arts at Sotheby's, and stints in the interior design and antiques businesses.

I opened my own photography gallery in Downtown Portland. The Webbs were amongst my first and most loyal visitors. I had the privilege of presenting works by Eliot Porter—"Oh, we knew Eliot"; Eugene Smith—"Oh, Gene used to stay with us in Paris on his way to Spain"; Ansel Adams—"Oh, we knew Ansel before he got expensive and grew his beard"; Robert Frank—"We met him in Paris and ran across him in New York." I finally asked, who ARE you guys?

Thus began a wonderful friendship and partnership, which I would describe as fateful and meant to be from both our points of view.

As it turned out, Todd had been a very good friend of Alfred Stieglitz, and hence Georgia O'Keeffe—I wrote my undergraduate thesis on Stieglitz and his influence on American modern painting, including O'Keeffe, Marin, Hartley, and Dove. I was thrilled to meet such a wonderful pair who embodied so much of the mid-twentieth-century art scene.

Todd and Lucille married "late in life," at ages forty-four and forty-three, and did not have children. My parents were both ailing when I met Todd and Lucille, and the Webbs and I entered first into a business relationship, but then easily one that was more like family. I relished having new elders in my life, and they treated me like a daughter. We had similar sensibilities artistically and socially, interested more in the integrity of the work and its presentation than in commercial opportunity. Nonetheless, we did pretty well and had lots of fun.

In inheriting the responsibility for the estate, my primary goal is to continue to educate the public about Todd and his oeuvre. *I See a City* will go a long way toward doing just that.

Betsy Evans and Todd Webb,
Portland, Maine, 1991

OPPOSITE:
125th Street, September 1946

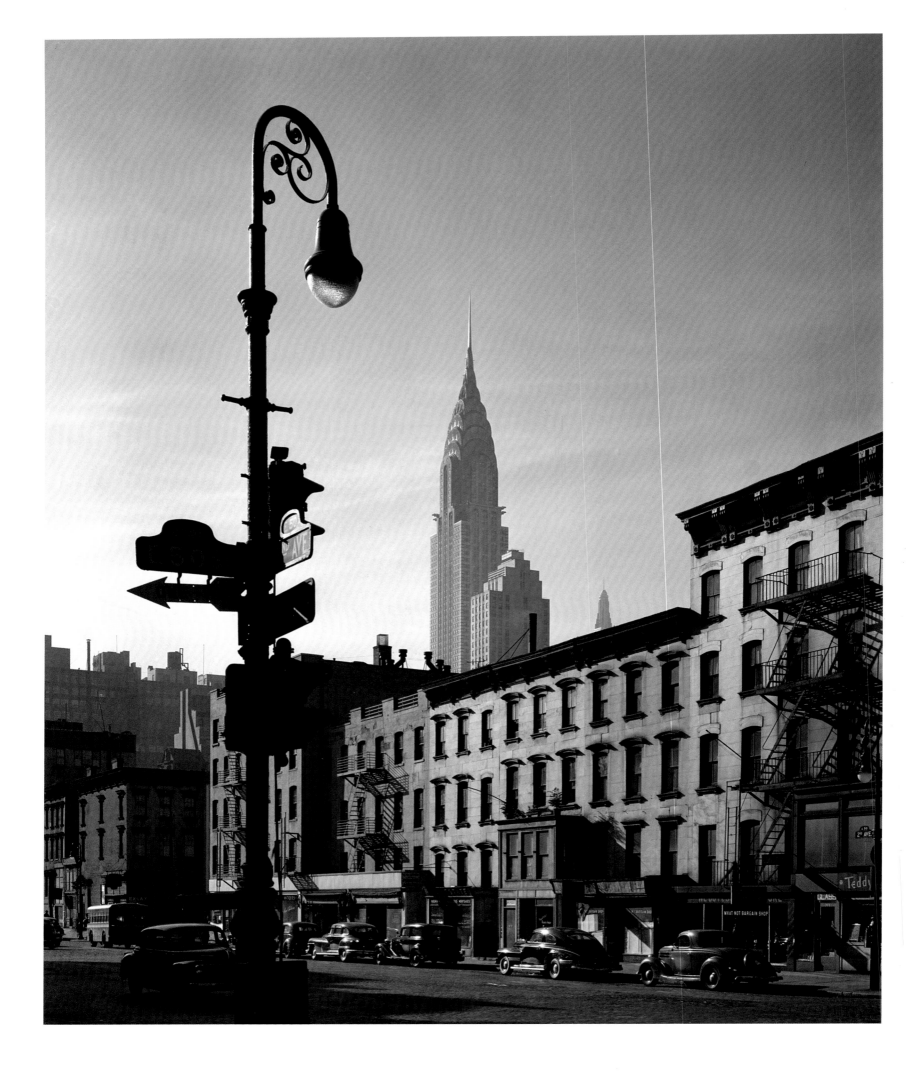

ACKNOWLEDGMENTS

I WISH TO THANK Sam Walker, without whom this book would never have come to light. I will be forever grateful for your help and collaboration.

I am indebted to Christopher Sweet of Thames & Hudson for taking the leap, and to Beth Tondreau for her excellent design and advice.

Thanks as well to John T. Hill, Daniel Eugene Kaminski, and Greta Grant for their artful and timely technical assistance.

Special thanks to Sean Corcoran of MCNY for our many discussions over the years and for mounting a wonderful exhibition, writing a delightful essay, and adding to the scholarship on Todd Webb's work.

Kudos and thanks to Dan Okrent for taking on this project and for his most perfect and endearing essay. Sean and Dan, Todd would have been so pleased!

Thanks also to Jorge Carreira Gonçalves Calado for locating the photograph of Todd Webb on the first page. Good sleuthing!

Thanks also to all the Mainers who have promoted Todd's work over the years, particularly Erin Hyde Nolan, Steve Halpert, James "Huey" Coleman, Juris Ubans, Rose Marasco, Madeline Yale, Carol Pickering, Susan Danly, Aprile Gallant, and Diana Tuite.

And to my New York cheering crowd: Sara Nelson, Sam Radin, Bill Hunt, Edward Mapplethorpe, Jack Gray, Brian Wallis, Michael Mattis, Yancey Richardson, Nancy Lieberman, Bill Shapiro, Ann Moore, Andrea Smith, Peter Rotchford, and James Rotchford.

I'd like to especially thank Andy Verzosa, Christopher Cardozo, Randy Evans, and Dick Curran for gently and not so gently prodding and guiding me to this moment.

Finally, for their enduring and loving support over the years, I am honored to thank my friends and family, particularly my husband, Chris Hunt, and my children, Sage Hunt and Lila and Zack Davies.

OPPOSITE:
**Second Avenue at
50th Street, 1946**

FOLLOWING PAGE:
125th Street El Station, 1946

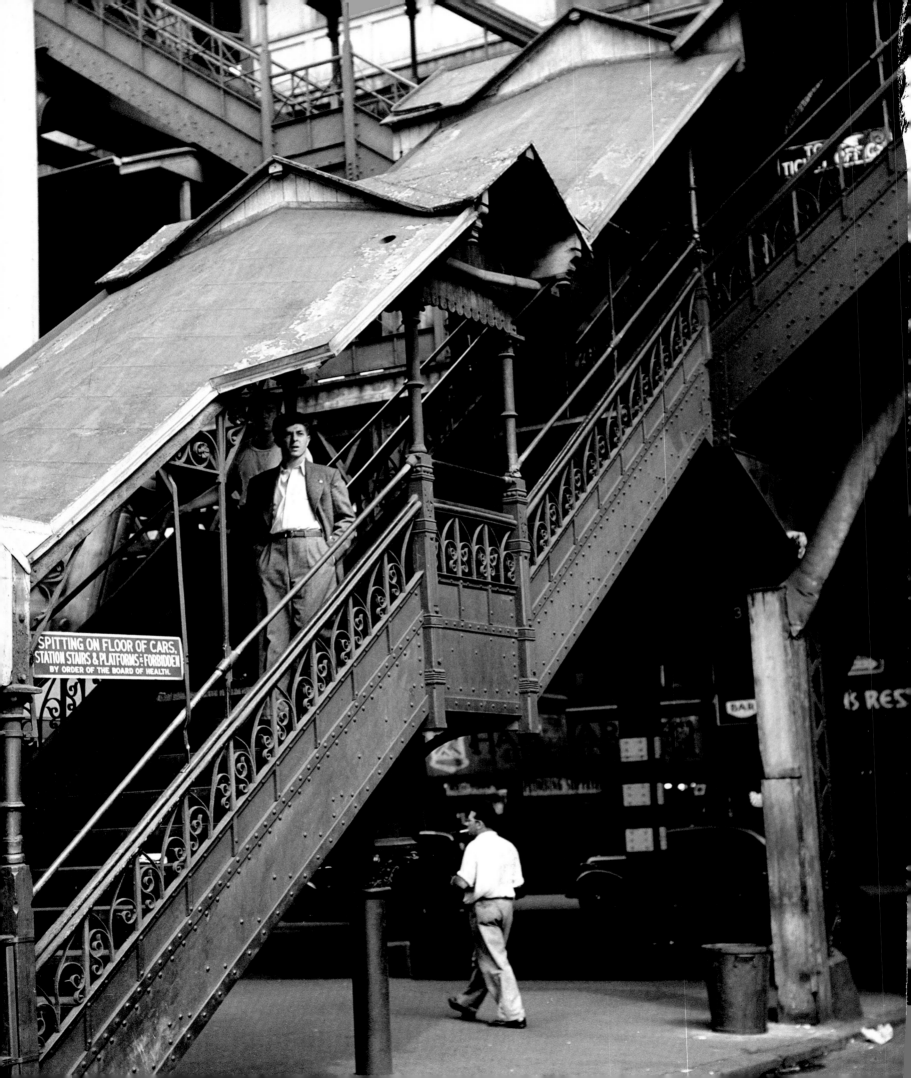

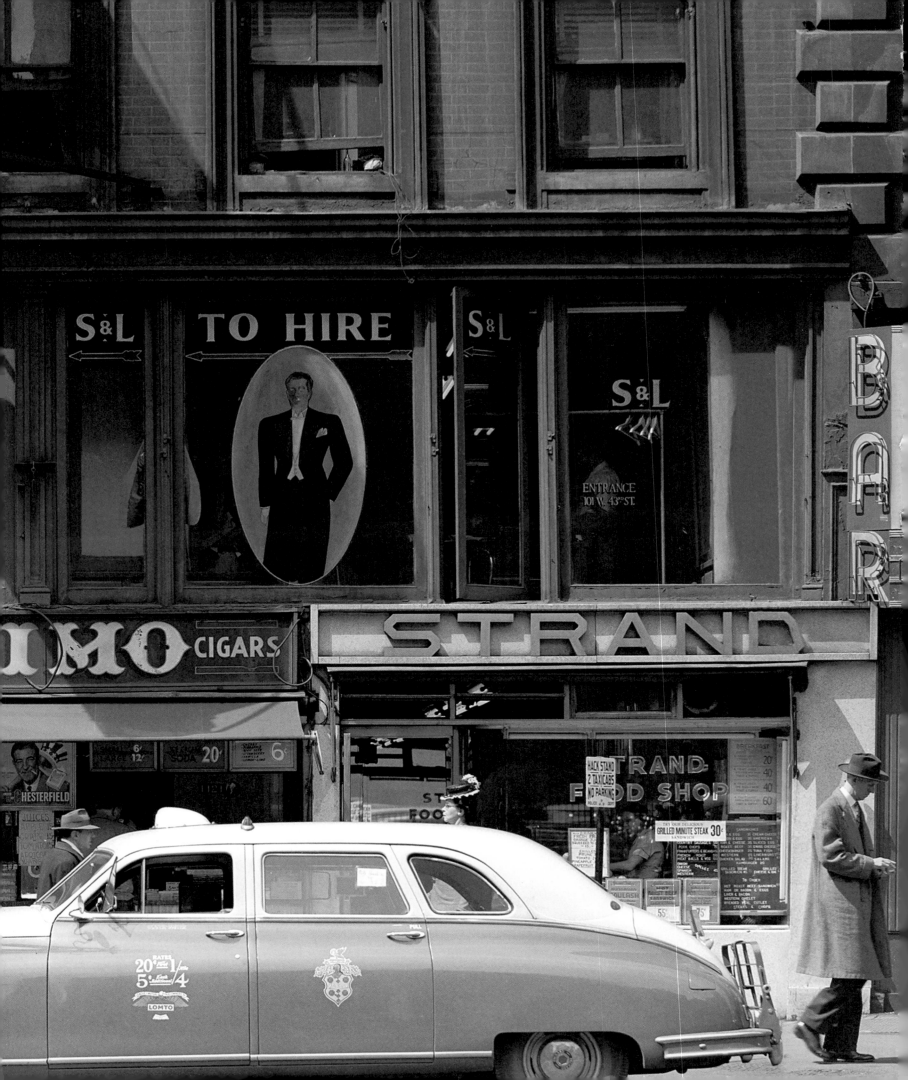